Clifton

History You Can See

Clifton

History You Can See

Maurice Fells

TEMPUS

First published 2007

Tempus Publishing Limited
The Mill, Brimscombe Port,
Stroud, Gloucestershire, GL5 2QG
www.tempus-publishing.com

© Maurice Fells, 2007

The right of Maurice Fells to be identified as the Author
of this work has been asserted in accordance with the
Copyrights, Designs and Patents Act 1988.

British Library Cataloguing in Publication Data.
A catalogue record for this book is available from the British Library.

ISBN 978 07524 4332 4

Typesetting and origination by Tempus Publishing Limited.
Printed in Great Britain.

Contents

Acknowledgements

It is a genuine pleasure to thank the many people who have helped me write this book.

As ever, the staff of both the Reference Section of Bristol Central Library and the Bristol Records Office have shown remarkable tolerance and patience in dealing with my numerous enquiries, some of them, I freely admit, quite unusual. Without their help I am sure that many of the books on the various aspects of Bristol's history would never be written.

I am grateful to Gerry Brooke, editor of *Bristol Times*, the *Bristol Evening Post's* highly respected weekly local history supplement. His detailed information has been extremely useful.

Thanks are also due to Mildred and Francis Ford, who trusted me with the loan of postcards from their extensive collection on old Bristol.

In my quest to find out more about Clifton many a convivial hour has been spent with Simon Fuller, Richard Harris and Dr Paul Thornton, all long-standing and passionate 'locals'. Their suggestions and advice has been much appreciated.

I must pay tribute to the journalists of a century and more ago who chronicled events in Bristol. Searching crumpled and dog-eared newspapers of old in my quest for information was a really enjoyable task.

Thanks must also go to the many people who have given me titbits of information which have helped to flesh out the various stories.

Nicola Guy at Tempus Publishing has been more than helpful in guiding me throughout the research and writing of this book.

I am indebted beyond measure to Janet Pritchard, a wonderful friend, for her unstinting support. She never lost faith in this book when I nearly had. Her encouragement and enthusiasm are greatly appreciated.

Introduction

This is the Bristol suburb that is talked about across the city and, indeed, well beyond. Through the ages people have never tired of talking about Clifton. They speak of its famous artistic and literary associations, its atmosphere, its character, its traditions and its architecture. Poets too, have praised this place, artists committed it to canvas and novelists and historians have written many thousands of words about it.

Clifton is older than Bristol itself. An Iron Age camp was sited upon Observatory Hill about 350 BC and the Romans built a road across the Downs linking their port of Abona (Sea Mills) with Aqua Sulis (Bath). When the Domesday Book was being compiled on the orders of William the Conqueror to give a description of all the inhabited land in the country, the parish of Clifton had a population of about thirty people. They were divided into three classes: serfs (labourers), villanes (farm-servants) and bordars (tenants of farm cottages). Domesday tells us that Lewin, the Provost of Bristou, had held the Manor of Clistone (Clifton) under King Edward, but that Robert Fitz Ralph was tenant of the same manor under the Conqueror. Clifton passed through the hands of various owners until it was bought by the Society of Merchant Venturers.

The first census, or population count, taken in England in 1801 showed that 4,457 people were living in Clifton-on-the Hill although it was still little more than a village. A major social and demographic change was beginning to take shape as Bristol's merchants prospered and decided to move away from the grimy atmosphere of the industrialised city with its glass kilns and shipyards to a more rural aspect. Farmland and fields around Clifton were being swallowed up as property developers covered the area with stone-built villas standing in their own grounds, especially around the edge of Clifton and Durdham Downs.

High society Clifton gathered in the Assembly Rooms, now the home of the Clifton Club, which was the venue for grand balls, banquets and literary readings. The cultural scene was further enhanced when the Victoria Rooms, one of Clifton's finest buildings, opened. Literary society was attracted throughout the eighteenth and nineteenth centuries. The poets Byron, Tennyson and Shelley all visited. So did Charles Dickens, Oscar Wilde and Jane Austen.

Clifton was probably put on the international map by its most famous adopted son, the great Victorian engineer Isambard Kingdom Brunel, who came here to recover from an accident in London. When his suspension bridge was completed it doubtless gave a kick-start to Bristol's tourism industry. It is difficult to imagine how the public authorities coped with the 150,000 people from all over the city who made their way to Clifton to join in the celebrations on the

day the bridge was opened. They were followed by visitors from all over the globe for Bristol could now boast the greatest bridge the world had ever seen.

The Second World War took its toll on Clifton destroying or damaging historic churches and other fine public buildings. By the 1960s this once elegant and leading centre of fashion and culture had become a sad echo of its former glory. The economic depression of the thirties, the war and the austere years that followed meant that many of the Georgian houses had now become distinctly shabby and rundown. The *Western Daily Press* pulled no punches in telling its readers that, 'Clifton had come to look threadbare in parts, some streets positively seedy and the great terraces and crescents tatty'. Many of the houses had become too large for family occupation and the owners could ill-afford the cost of repairs so they began to convert their properties into bedsitters and flats to be rented out as student accommodation.

If Clifton ever needed a publicist surely the job should have gone to John Betjeman, the man who was later to be appointed by the Queen as poet laureate and was also awarded a knighthood. He spent much time in Bristol making programmes for both the BBC and ITV and to say that he loved Clifton is very much an understatement. He wrote two poems about Bristol and Clifton. At various times he described it as 'The handsomest suburb in Europe' or 'the Queen of suburbs', and once said, 'Bristol's biggest surprise is Clifton, a sort of Bath consisting of regency crescents and terraces overlooking the Avon Gorge to the hills of Somerset'.

The grand crescents and squares have been gentrified but one wonders what Betjeman would make of the suburb now. Would he see its identity and character being slowly eroded by new high-density and high-rise residential developments of glass and steel, the proliferation of café-bars, restaurants and public houses – forty-one at the moment in the so-called Clifton Village district. Some developments can hardly be considered wholly sympathetic to their surroundings. The streets are choked the day long with a sea of cars parked alongside the concrete mounting blocks that Cliftonians of a more leisurely era used to step up into their horse-drawn carriages.

This book does not set out to be a definitive history of Clifton. To even attempt to chronicle the minutiae of such a long and colourful past in a publication of this size would be sheer folly. It is more of a social history with glimpses of lives led by our forefathers and how they shaped our environment. It is also a celebration of one Bristol's most fascinating suburbs and takes a fresh look at some of its well-known and not so well-known buildings. This is also a guide to some of the many statues, plaques and other memorials that can be found here. The lives of people associated with Clifton are also explored. Some of those that walk through these pages may be well known while others have hardly, if ever, stepped into the public spotlight. Nonetheless their lives still make fascinating reading and help us to paint a broader picture of the social history of Clifton.

The best way to discover Clifton's history is on foot. At every turn from cul-de-sacs to crescents, glimpses of fascinating and historic buildings suddenly appear.

Maurice Fells
Spring 2007

Bibliography

Bristol School of Artists, Francis Greenacre; City Museum & Art Gallery 1973
Whiteladies Walks, Stephen Jones; Redland and Cotham Amenities Society 1976
Dictionary of Bristol published by J.W. Arrowsmith 1906
Postwar Bristol 1945-65; Bristol Branch of the Historical Society
Commemorative Brochure: Christ Church School, Clifton 150 Years
The Annals of Bristol, John Latimer
Who's Who in Bristol; Redcliffe Press 1991
A University for Bristol, Don Carleton; University of Bristol Press 1984
Bristol Art Gallery 1905-1980, Karin M. Walton; City of Bristol Museum & Art Gallery
The Street Names of Bristol, Veronica Smith; Broadcast Books 2001
Mathews' Bristol Directory

A–Z

ALL SAINTS CHURCH

For many centuries Bristol has been known as the city of church spires and towers; it is almost impossible to walk along any street without being in sight of one. Church-going in Victorian times was such a focal point of family life that it prompted the Bristol morning newspaper, the *Western Daily Press*, to conduct a census of church attendance. It was such a comprehensive survey that every denomination, from Church of England to Roman Catholic and from the Swedenborgian Church to the Red, White and Blue Temperance Army, was included. When the head count was completed the paper was able to announce that on one Sunday in October 1881 exactly 109,452 people had attended a church service in Bristol that day.

The census showed that All Saints church on Pembroke Road was one of the most popular places of worship in the city. It had six services throughout the day starting at 6 a.m. At Matins the priest ministered to 562 people, while 652 attended the main morning service with 820 people packing the pews for evening prayers. For seating accommodation rush-bottomed chairs were used with men sitting on one side of the church and women on the other.

It was to meet the spiritual needs of the fast-growing population in Clifton that All Saints church was founded. The Church of England bought part of a field from the Society of Merchant Venturers, who owned swathes of land in the parish, on which to build it. George Edmund Street, an eminent architect, produced a design in Gothic revival style. He envisaged that worshippers would have an uninterrupted view of the chancel, pulpit and altar. Although it had only a temporary brick nave All Saints was consecrated by the Bishop of Bristol and Gloucester in the summer of 1868. It was another four years before the permanent nave was completed providing the church with a total of 800 seats.

All Saints was one of thirty-one churches across the city which were totally destroyed during the Second World War. It was burnt out by incendiaries in a night time air raid in December 1940 despite brave efforts by local residents and boys from nearby Clifton College to save it. The services were transferred to the parish hall next door.

However, the future of the church was far from certain. For the next two decades or so, arguments raged over whether it should be rebuilt or the site used for a garden of remembrance. The Diocese of Bristol was in favour of demolishing the ruins, transferring the congregation to Emmanuel church, on the other side of Pembroke Road, and then merging both parishes

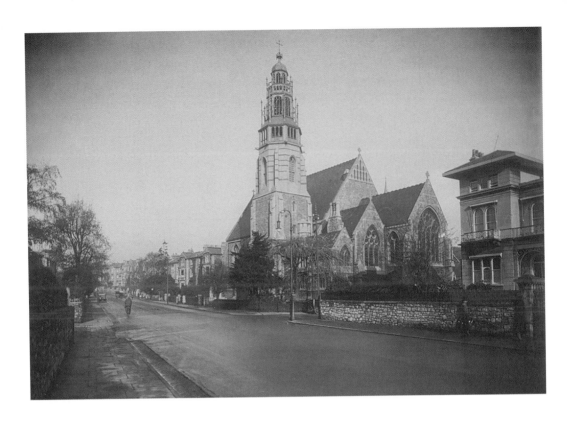

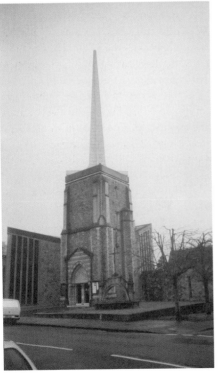

Above: *The original All Saints church.*

Left: *All Saints church in modern style.*

with St Mary the Virgin at Tyndalls Park. This proposed reorganisation turned out to be highly controversial meeting with strong opposition from each congregation wanting to retain their own identity and rituals. All Saints had long been recognised as a centre of Anglo Catholic worship while Emmanuel was strongly on the evangelical wing. A lengthy legal battle culminated with the matter being discussed at a meeting of the Privy Council in London in March 1961. By all accounts there was much rejoicing in the pews when the Privy Council threw out the proposals.

It was back to the drawing board for the diocese and eventually it was decided that All Saints should be rebuilt. An ultra-modern design with glass walls and incorporating the base of the original tower was commissioned. A landmark feature of the new building is its aluminium-clad timber spire rising 138ft into the air from the tower. The largest mobile crane in Europe at the time was brought to Clifton to put the rocket-shaped steeple into position. The spire cost £4,000 and the bill for putting it in place came to another £500.

All Saints with its new look and seating for 478 people, took four years to build and was consecrated in July 1967. But not everyone, it seemed, was happy. The clergyman-editor of Bristol's monthly religious newspaper *Contact* let blast attributing the new building and its design to, 'absence of foresight, selfishness or lack of the right ecumenical climate'. 'Did Christians need an ultra-modern building like this in which to worship?' he asked his readers.

The church had its own highly respected choir school. Amongst its pupils was the Bristol-born pianist Russ Conway who topped the record charts in the early 1960s with his honky-tonk style. Local artist Barrington Tabb, who has been painting the changing landscape of Bristol for the last fifty years or so, was also on the school register. All Saints School closed in 1962 after nearly a century of educating youngsters.

ST ANDREW'S CHURCH

Stroll along Church Walk with its overhead arbour of pleached lime trees and you are treading on truly historic ground. This walkway, often mistakenly called Birdcage Walk, leads from an old drinking fountain in The Fosseway to Clifton Hill cutting through the burial ground of St Andrew's church.

There has been a place of Christian worship on this site since 1145 when St Andrew's stood alone on Clifton-on-the-Hill surrounded by open green fields. From here there was an uninterrupted view down to the harbour. Ecclesiastically, Bristol was then part of the Diocese of Worcester, with the parish of Clifton extending from Durdham Down to Hotwells.

St Andrew's church survived the burning of Clifton on the orders of Prince Rupert during the Civil War but by 1634 the building had deteriorated so badly that it had to be rebuilt.

Amongst the many visiting preachers here was John Wesley, founder of the world's first Methodist church at Broadmead in Bristol. He climbed into the pulpit at St Andrew's in 1739 and afterwards wrote, 'Seeing many rich at Clifton church my heart so pained for them'.

As Clifton's population expanded in the early years of the nineteenth century a much larger church was needed. A Regency Gothic building costing £18,000 was completed in 1822 and consecrated by the Bishop of Bristol in August of that year. The Service of Consecration was marked by a long ceremony at which all but the poorest had to pay 4s for admission. There had always been unease over freehold pews in churches. Sometimes they were kept locked against anybody except their owners and when they moved from the parish the family pews were put up for auction. Records show that one of them at St Andrew's fetched £150. Until 1912 five women were employed at the church as pew openers. By the time of the Second World War only one proprietary pew remained.

St Andrew's was the parish church of Clifton, or the 'mother church' of ten others in the district, until a grim November night in 1940 when the German Luftwaffe reduced it to a pile of rubble. Several hundred worshippers taking part in an evening service made their way into the crypt as flares and bombs began to fall around them. After the church was bombed the congregation gathered in a number of places for worship but it was not until 1952 that the Diocese of Bristol decided that St Andrew's parish was to merge with Christ church. Since then this has been Clifton's parish church.

Remarkably, St Andrew's tower survived the bombing but it was eventually bulldozed to the ground in 1958. All that remains today are stones in the earth which outline the main body of the third church of St Andrew's, a chilling reminder of the horrors of war.

The burial ground contains hundreds of crumbling memorial sculptures and tombstones. Buried here are the remains of Clifton society of years gone by including those of a hospital doctor, a captain in the Indian Army and a one-time vicar of Clifton who later became a bishop. It is just possible to read some of the inscriptions on the weather-beaten tombstones to discover the resting places of a boy who survived just seventeen days and another who died shortly after his first birthday.

Although the church was destroyed, an early eighteenth-century ten-bedroomed house next door escaped wartime damage. This was originally known as Church House, and by 1766 it had become the home of Samuel Worrall, clerk to the Society of Merchant Venturers. Generations of the Worrall family lived there until 1902 when the house was bought by local architect George Oatley, arguably best known for his Wills Memorial Building. More recently, until 2002, it had become known as Bishop's House, the home and office of the Bishop of Bristol. It is now a private residence.

ASSEMBLY ROOMS AND HOTEL

It all sounds like the plot of a film; an architect who designed one of Clifton's most elegant buildings is made bankrupt, later sentenced to death, but transported instead to Australia where he becomes a hero. This is not fiction but the true life story of Francis Greenway who designed the Assembly Rooms and Clifton Hotel in The Mall.

Faced in Bath stone with imposing columns the Assembly Rooms became the centre of Regency Clifton's social and cultural life. It was here that lavish banquets and balls were held and the *literati* gathered to hear well-known writers give public readings of their works.

Greenway designed the building in 1806 and certainly did things in grand style. His scheme included a grand ballroom, seventy apartments, twenty sitting rooms, tea rooms and lobbies. The author of a contemporary guide book lavished praise on it by saying that it had a, 'noble reception saloon, a tea room, highly finished and decorated, and a handsome card room with convenient lobbies'. The Bristol historian John Latimer described the inaugural party in 1811 as, 'the most brilliant ball ever known in Clifton'.

In 1809 the war against France led to Greenway, along with other property developers and speculators working on Clifton's crescents and terraces, becoming bankrupt. He later came to legal grief over what could be described as some creative accounting concerning the financing of a house he was building in nearby Cornwallis Crescent, then known as Lower Crescent. Greenway appeared in court accused of forging a promissory note for £250. He was convicted of fraud and sentenced to death at the age of thirty-five. He spent some time languishing in Newgate Prison, now the site of the Galleries shopping centre, before his death penalty was commuted to a sentence of transportation. In 1813 he was put on a ship bound for the penal colony of New South Wales, Australia.

Above: *Church Walk cuts in half St Andrew's Churchyard.*

Right: *St Andrew's church which was destroyed in the Second World War.*

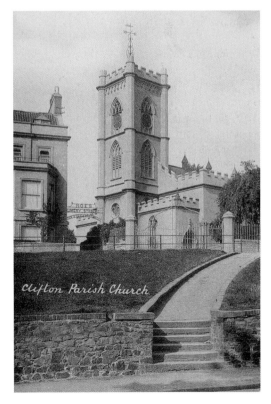

The Clifton Club, formerly the Assembly Rooms and Hotel.

Six months later Greenway was setting up his own architectural practice and beginning to win commission after commission to design many of Sydney's public buildings, including its law courts and churches. One of his projects was the lighthouse at the entrance to Sydney Harbour. The Governor of Sydney was so impressed that he appointed Greenway civil architect and he became known as the 'Father of Australian Architecture'. Some time after his death the government honoured Greenway by putting his portrait on its ten-dollar bills.

Back in Clifton his hotel received the royal seal of approval in 1830 when Princess Victoria stayed there whilst on a tour with her mother, the Duchess of Kent. The young princess stayed in a first floor suite and waved from one of the hotel's balconies to the people of Clifton who had gathered in The Mall below. At the time it was known as the Clifton Grand Hotel, but after receiving such eminent visitors the management decided on a more regal name. From then on it was called the Royal Hotel.

It closed in 1854 becoming partly the Clifton Club, whose history dates back to 1818, and partly shops and dwellings, a situation that still exists. At one time the club had about 350 members, including W.G. Grace, the Gloucestershire and England cricketing legend. Bristol-born Hollywood actor Cary Grant was a guest over the years on his many return visits to the city to see his mother who was living in a nursing home in Clifton

The club was a male-only bastion where the likes of brokers, businessmen and merchants could meet to discuss affairs of the day over coffee or lunch. They could also see the latest world news provided by the Post Office on the club's electric telegraph system.

During the Second World War it became a favourite haunt for visiting military officers and government officials who were working in nearby buildings that had been requisitioned.

The Clifton Club is still a private haven for professional and businesspeople drawn from Bristol and the surrounding countryside. With its dining room, snooker tables, card room, bar and squash courts, it is a living reminder of club life as it was in a more leisurely era. But it has recently broken with tradition with its members voting to admit women.

Francis Greenway died in Australia aged sixty, never having returned to Bristol. Although Sydney has high regard for him in its museums, he is hardly remembered in his home town save for a small plaque near the entrance to the Clifton Club. But even that was not unveiled until 1977 on the bicentenary of Greenway's birth.

THE AVON GORGE

The deep cleft of the Avon Gorge dividing Bristol from Somerset, with Brunel's slender Clifton Suspension Bridge gracefully spanning it some 245ft above the river, is one of Bristol's most symbolic and photographed sites.

There are various legends about the origins of the gorge. One rather engaging tale concerns the brothers Goram and Vincent. Both were giants who supposedly fell in love with the same woman, Avona, which led them to digging out the gorge. The story goes that Vincent is commemorated by the naming of St Vincent's Rocks near the bridge, that the gorge was named after Avona, while Goram threw himself into the Bristol Channel where his body is now Brean Down, his shoulder is the island of Flat Holm and his head, another island called Steep Holm. The reality is less colourful in that the gorge was probably formed during the Ice Age by the river carving its way through the carboniferous limestone. The cliff side of the gorge makes a natural western boundary for Clifton while the wooded slopes opposite form part of the boundary of north Somerset.

The rugged rock face attracts climbers, cavers, botanists and those who just want to admire the stunning scenery. This has been a mecca for naturalists since around the sixteenth century and it is internationally known as a special area of conservation and is also nationally recognised as a site of Special Scientific Interest (SSI). The gorge is one of the best-documented botanical sites in Britain with records dating back to 1562. At least twenty-four rare species of plants have been identified on the rock face. One of them is the Bristol whitebeam, a tree that grows naturally in the gorge and nowhere else in the world. The Bristol rock cress, a delicate wildflower and the pink-flowering Bristol onion are other natives of the city. Some of the plants are so rare that Brunel had individual specimens moved a few yards so that construction work on the bridge would not damage them.

An estimated 50,000 people flocked to the gorge in the 1830s to watch George Courtney, the so-called 'Bristol Birdman' risk his life. Courtney was an actor who did leaps in the gorge, sliding a rope over the chasm and flying across with 'wings' fluttering at his wrists and ankles. He survived all his leaps and died an old man at his home in Jacobs Wells Road.

The scenery of the gorge has changed over the last 200 years with extensive quarrying and the building of railways on both sides and the construction of the Portway road linking Bristol with the docks at Avonmouth.

The River Avon itself is treacherous and unforgiving with its twists and turns on its 6-mile course through the gorge and out into the Bristol Channel at King Road. Many a vessel, both passenger and cargo, have been wrecked here after hitting the river bank and turning over. Some had just left the Bristol shipyards on their maiden voyages. White-painted lights on each bend of the river are now used as an aid to navigation. One ship sailed into the history books by making both her first and final journey on this part of the river. This was

Brunel's SS *Great Britain*, launched in 1843 and towed back on a pontoon in 1970. She was being returned to her birthplace in Bristol Docks where she is being painstakingly restored. Many thousands of cheering people lined both sides of the gorge as the hulk, described by one leading Bristol councillor as a 'rust bucket', was brought back beneath Brunel's bridge. This was the last lap of a 9,000 mile voyage from Sparrow Cove in the Falkland Islands, where the SS *Great Britain* had been beached for many years, to Bristol.

THE 'BATTLE OF BOYCES AVENUE'

A small metal gate across a pathway in the heart of Clifton recalls what must have been one of the most unusual disputes ever to reach the law courts. On one side of this nineteenth-century argument was Bristol Corporation supported by Clifton residents and on the other was the man they nicknamed 'The General'.

It was centred on the pathway under Arch House which leads from Boyces Avenue into Victoria Square, then known as Ferney Close. William Mathias lived there and he was adamant that carriages would not drive along the path despite much support for this by his neighbours. He maintained that it was to be used only by pedestrians.

Mathias's campaign, which became known as the 'Battle of Boyces Avenue', cost him a fortune and eventually he lost his liberty. To keep carriages out he had a wall built. But as quickly as it went up it was knocked down, normally under cover of darkness. Matters came to a head when Mathias had the archway built and an iron gate placed across the path. However, the local postman was told to drive his horse and cart through the archway to set a legal precedent. Mr Mathias, though, fought back by digging a trench across the Victoria Square entrance to the pathway. The landlord of the nearby Albion public house joined the battle claiming that his inn could no longer be seen by potential customers or easily accessed because of the arch.

Mr Mathias was continually involved in court cases to defend what he claimed were his rights. He was summonsed for assault and was prosecuted for digging a trench in a public road. In 1873 Mr Mathias appeared before the Court of Chancery where he was jailed for six months for contempt of court, although he was then aged ninety-two. There does not appear to be any trace of Mr Mathias after he left prison. However, his arch still stands and the pathway and gate survive to this day – although it is still pedestrians only. A fairly modern feature of the arch is a sculptured face of a young Queen Victoria. She only came to Bristol though once as queen, three years before her death, and once as a princess when she stayed in The Mall.

Boyces Avenue was named after Thomas Boyce, a wigmaker, who came to public attention when Felix Farley's *Journal* of 20 June 1772 told its readers that he had, 'fitted up three elegant buildings for lodging rooms'. Presumably, they were for visitors to the spa. Attached to the properties was a pleasure garden, three summer houses, ten coach-houses and stables large enough to accommodate thirty-four horses.

His houses, on Clifton Down Road facing down Princess Victoria Street, cost Boyce £8,000 which led to his bankruptcy. However, he has the distinction of building what was probably the first terrace in Clifton. Today the houses, with Boyce's monogram carved in the pediment, adjoin a block of ultra-modern flats and a supermarket. The contrast between a fine example of Georgian architecture and a twenty-first-century design could not be greater.

It's pedestrians only through Boyce's Arch.

BERKELEY SQUARE

You will not hear a nightingale sing in Berkeley Square now. This corner of Clifton has lost the rural charm it had more than two centuries ago when it was a field overlooking the city. The first house was built here in 1786 but it was some years before the rest were completed around a central garden. They were erected on three sides with the fourth being left open. A guide book of 1794 describes the square as being 'lately erected' and says that, 'on a clear day from the houses one could clearly see Devonshire Place, Bath'. By 1828 there were thirty-five houses in the square and it had become a fashionable place for lawyers to live.

The poet John Addington Symonds was born at No. 7 but the square's most famous resident though was probably an inventor from Scotland, John Loudon McAdam, who lived at No. 23 between 1805 and 1808. He transformed the country's main roads from nightmare tracks into level stretches with his smooth Macadamised road surface. As the inventor of Tarmac, the House of Commons awarded him a grant of £10,000. But from the Bristol authorities there was no recognition whatsoever. A plaque that was later fixed to the front of his home was put there by a later resident of the house at his own expense.

In the late 1920s Berkeley Square had become a haven for clergymen with six vicarages there.

During the Second World War, a number of houses in the square were damaged and families living there frequently sought refuge in their own air-raid shelter which had been built on part of the garden. It stood alongside an emergency water tank.

The garden is home to an unusual chunk of Bristol history, the top part of a nineteenth-century copy of the city's High Cross. The original was erected in 1373 at a spot where Wine Street, High Street, Corn Street and Broad Street met. It was to mark the creation by Edward III of Bristol as a county in its own right, separating it from Gloucestershire to the north and Somerset to the south. It meant that Bristol had more independence in running its own affairs and in legal matters decisions could be made without referring back to the King every time. The High Cross was moved several times and eventually ended up in Stourhead Gardens, Wiltshire, where it can still be seen.

A replica was commissioned from John Norton, the architect who added the spire to Christ church. He was faithful to the original monument and included figures of four past monarchs: Charles I, Elizabeth I, Henry VI and James I, in the niches. It was erected on College Green but taken down in 1951 when the site was lowered to enhance the view from the new Council House. The replica made local newspaper headlines about five years later when the city council said it was willing to give the remnants of the cross to anyone who cared to collect them for £50. This sparked several conservation and amenity societies to launch a restoration campaign. Their efforts paid off and eventually the top part of the cross was resited in a corner of the Berkeley Square garden.

It is difficult to imagine the square's once rural atmosphere now that a combination of commerce, the leisure industry and traffic have taken over in a big way. As families died or moved out architects and lawyers along with university departments started adapting the interiors of most of the houses into office accommodation. Sadly, the elegant Georgian architecture is marred by a sea of commuters' parked cars.

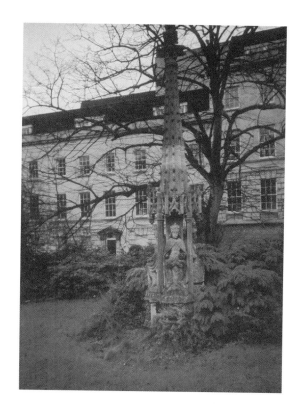

Right: *The replica of part of the Bristol High Cross now in Berkeley Square.*

Below: *A summer scene on College Green in 1950 before the replica Bristol High Cross was removed.*

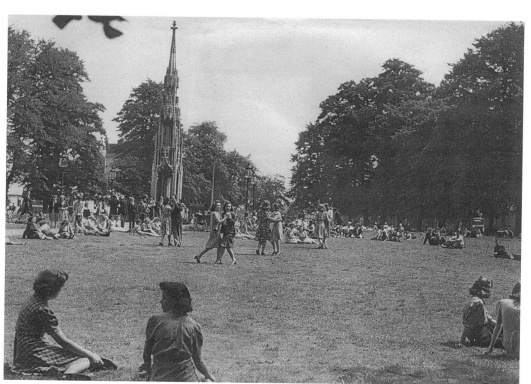

BRIDGE HOUSE

Clifton, it seems, has long capitalised on the local tourist industry. Many of the houses on the steep hills rising up from Hotwells were built by speculators to provide lodging rooms for those who came to take the waters at the Spa. There have always been plenty of hotels, too. The York Hotel, which stood on the corner of Gloucester Row and Sion Place, checked in its first guests in 1790. Shortly afterwards a writer in *Mathews' Bristol Directory* described it as having, 'an elegant ballroom with a good organ and commands a picturesque view of Leigh Woods and the Downs … the whole building is a capital hotel handsomely fitted up'.

It was here that Isambard Brunel enjoyed breakfast before walking across to his bridge for the ceremony marking the laying of a foundation stone for one of the piers.

During the 1860s the York Hotel was demolished and replaced by the six-storey Clifton Down Hotel. Reporting on its opening in July 1865 the *Clifton Chronicle* stated:

> the front of the hotel, though not extravagantly decorated, presents a very handsome and striking appearance … upon the first, second and third landings are suites of apartments and the fourth floor is devoted to the bachelors … the arrangements of the whole hotel are admirable and complete. The offices are on the ground floor. There is a lift on the same principle as those in the London hotels to take visitors' baggage to the top of the building and also a machine supplied by Mr Palmer of Clifton for raising water to the upper rooms.

The hotel had eighty-two rooms and could accommodate 150 guests with a set of servants for each floor. Communication to the manager's office was made by means of acoustic tubes which were fitted throughout the building.

The hotel's entrance was in Sion Place with an impressive stone carving of the Bristol coat of arms above the door. Much use had been made of Bath stone and marble in the building of the hotel. Spanish mahogany, walnut and birch wood were used for some of the fixtures and fittings. Altogether it cost £15,000 – £1,000 above the original estimate.

The Clifton Down Hotel got off to an impressive start with most of the rooms being booked by visitors to the National Archery Meeting which was held in Bristol. One of its later guests was Sir Henry Stanley, the British explorer who led an expedition to Africa in search of Livingstone. He described his stay at the hotel as 'exceedingly comfortable'. But not everyone was happy with their stay at the hotel. Some guests caused the manager to complain to the Downs Committee that the bleating of sheep was annoying them.

After the hotel closed the building became known as Bridge House and during the Second World War it was taken over by the Army. It was later used as regional offices for civil servants from various government departments. However, Bridge House is probably best known to many Bristolians as a driving test centre throughout the 1960s, 1970s and 1980s. More recently, part of the ground floor was used as a visitor centre for the Clifton Suspension Bridge.

The building is getting another lease of life, this time as a block of eighteen luxury flats due for completion in 2007. Craftsmen have been painstakingly restoring many of the original features.

Clifton Down Hotel with the observatory in the top left hand corner.

BRUNEL'S BRIDGE

Isambard Kingdom Brunel changed the face of Clifton and the life of the West Country with his bridges, railway and ships. But none of this may have ever happened if he had not been in Clifton recovering from injuries he suffered while working for his father in the Rotherhithe Tunnel under the River Thames. As he was convalescing Brunel heard about a competition to design a bridge that would span the Avon Gorge. His imagination was fired. Indeed, he submitted not one but four designs each one of them having a spectacular grace that was breathtaking to a Victorian Bristol. There were nearly two dozen designs for the Selection Committee to study but it was one of Brunel's that was eventually chosen.

His Clifton Suspension Bridge, ranks amongst the finest Victorian engineering feats in the land. Brunel described it as 'My first child, my darling', but unfortunately he never lived to see it completed. Work on the bridge started in 1831 and the foundation stone of the south pier was laid in 1836 but it was abandoned for a long time because of the first of a series of financial crises. At one stage a stout iron bar with a basket suspended from it was placed across the gorge. This unusual form of transport took the workmen from one side of the gorge to the other. It may have been a precarious way of travelling but that did not deter thousands of visitors who were charged for the journey. Time and time again work on the bridge had to be abandoned through lack of funds. It was finally completed in 1864, but Brunel had died five years earlier at the age of fifty-three.

At the time this was the largest single-span suspension bridge that had ever been built in the world, stretching 702ft between its two piers. It was built when steel was practically unknown and cost more than £100,000.

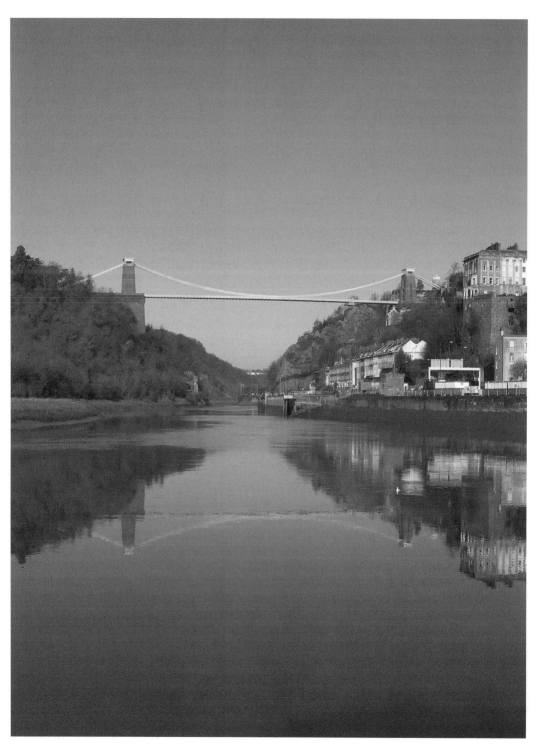

The Clifton Suspension Bridge at night.

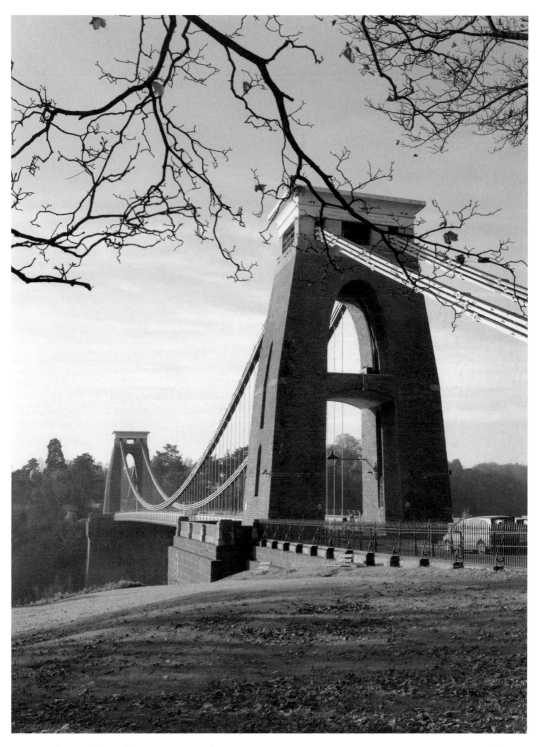

A close up of Brunel's great engineering feat.

Its history though goes back to 1754 when a wealthy Bristol wine merchant, William Vick, left the Society of Merchant Venturers a legacy of £1,000. This was coupled with the instruction that it should be left to accumulate interest until the total fund reached £10,000. Then, and only then, said Mr Vick could it be used to build a stone bridge across the gorge. He also stipulated in his will that the bridge should be toll free. By 1829 Mr Vick's fund had reached £8,700 and with other donations and a gift from the Merchant Venturers £30,000 was eventually raised – enough to start work on the bridge.

One of its unusual features is that the road level on the Leigh Woods side is 3ft lower than that on the Clifton side. Brunel believed that the configuration of the cliffs would have the effect of causing a level bridge to appear to be out of level so to counteract this he adopted the height difference.

In all its 142 years the bridge has remained exactly as it was on the day it opened but now it has never been busier. Although it was designed for pedestrians and horse-drawn traffic the bridge was so ingeniously constructed that it now carries around four million cars a year. The cost of maintaining it is ever increasing which means that William Vick's dream of a toll free bridge is never likely to become reality.

The bridge was first lit up as part of the celebrations to mark its opening in 1864 but since then it has been illuminated on a number of occasions helping to mark historical and national events. These included the Jubilee in 1935; the Festival of Britain in 1951; the Coronation of Queen Elizabeth II in 1953; the centenary of Brunel's death in 1959; the bridge's centenary in 1964 and in 1977 to mark the Queen's Jubilee. Since then the bridge has been permanently illuminated.

The bridge has been something of a magnet for daredevil pilots who fly their aircraft underneath it. Frenchman Maurice Tetard was the first to fly into the record books in 1910 with his Bristol Boxkite, built by Sir George White's Bristol and Colonial Aeroplane Co. at Filton. A successful flight by a jet fighter was made in 1953 but four years later a Royal Air Force pilot lost his life when his vampire jet crashed at 400mph on the Leigh Woods bank. More aviation history was made by Concorde 002 in November 2003. On the plane's final flight from Heathrow Airport to Filton, the pilot flew at 2,000ft above the bridge to much applause of thousands of spectators.

The bridge's history though has been marred as it has built up a reputation as a suicide spot with on average about a dozen people taking their lives each year. It is very rare for a person to survive a fall from the bridge but in 1885 when twenty-two-year-old Sarah Ann Henley threw herself off after being jilted by a lover she was saved by her billowing skirt which acted as a parachute. She went on to live to the age of eighty-five. Eleven years later, two sisters aged three and twelve, were thrown off the bridge by their father who had travelled from Birmingham. However, a strong wind and high tide helped break their fall. A nineteen-year-old-man also survived a fall in 1983 after his duffle coat acted as a parachute.

CHRIST CHURCH

A church rate, a local form of taxation, was introduced to help finance the building of Christ church on the edge of Clifton Down. The site cost £500 and the church itself cost £10,000. It was designed by Charles Dyer, the architect son of a Bristol surgeon, who also had an architectural practice in London. He made his mark in Bristol with a number of prominent buildings including Camp House (now known as Engineers House) and Litfield House both on the Promenade and the imposing Victoria Rooms in Queen's Road. He also designed

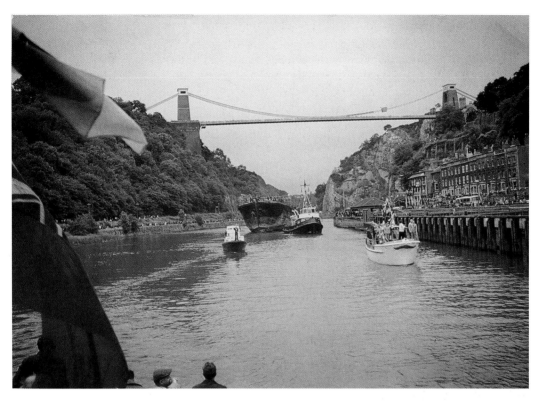

Brunel's SS Great Britain *being towed under his bridge on her way back home to her original berth.*

St Paul's church on Coronation Road, Southville, which was destroyed in the Second World War.

Christ church stands on a mound which was created when an old cattle pond was filled in. The church was consecrated by the Bishop of Gloucester and Bristol in 1844 but the building then was far from as impressive as it is today. Its tower and landmark spire were not added until 1859. It is said that when this was completed one of the workmen was so delighted that he did a headstand on the quarter-ton capstone at 212ft above street level. He certainly had a head for heights as he would then have been 477ft above sea level, making it the highest point in Bristol. The church's aisles were added twenty years later to accommodate the growing number of people moving into the district. By then there was room for well over 1,000 worshippers.

Disaster struck the church in the winter of 1872 when a storm brought one of the pinnacles crashing down through the organ and through the gallery into the floor below. Fortunately, no one was hurt. As a precaution against further incidents the pinnacles were filled up with concrete.

Christ church's first incumbent was Canon John Hensman who served the congregation for three years until 1847 when he made the short journey to St Andrew's church where he was the vicar for the next seventeen years. Hensman's Hill, nearby, is named after him.

Christ church started life as a chapel of ease but it became the Parish church for Clifton after St Andrew's was destroyed during the Second World War.

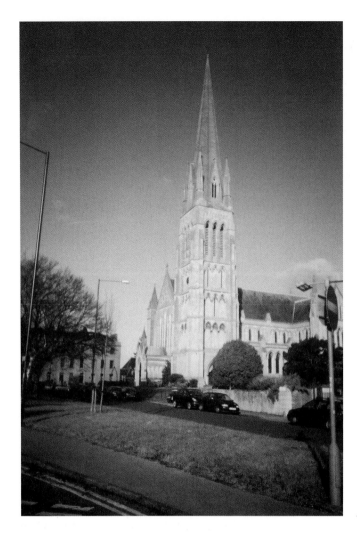

Christ church on the edge of Clifton Down.

CHRIST CHURCH SCHOOL

Besides ministering to the faithful of the parish, Christ church clergy were also committed to running a school. This opened in premises in Princess Victoria Street in 1852. The building was converted into what the church authorities described as a 'centre of religious education for the children of the industrial classes of Clifton'. The boys' section was upstairs where a curtain divided a large room into two classrooms. Girls had their lessons downstairs.

Christ Church School was funded by public subscription with the first donation being made by a servant girl who gave £30 (more than a teacher was then paid in a year). The donor said she wanted to remain anonymous but explained to the clergy that she had given her life savings so that children of the parish could have a better start in life than she had. Over the years several attempts have been made to discover the girl's identity but all have been unsuccessful. It seems likely that she will remain anonymous for ever.

This was one of the first Church Day Schools and it was subject to regular visits from inspectors, a forerunner of the present government education watchdog, Ofsted. In 1887 one

inspector's report noted, 'the well disciplined and organised boys, whose singing deserves special praise'. He also highlighted, 'the orderly and well-behaved girls whose handwriting is far from satisfactory and spelling is poor'. He found though that their 'needlework has improved'.

From 1910 onwards it seems that there was lots of talk about moving the school to a larger site. The Princess Victoria Street building was no longer big enough to accommodate the number of pupils wishing to attend the school. The following year an architect reported that the building could 'no longer be regarded as permanently suitable for a school'. He cited several problems including the fact that there were few exits in the event of a fire and that the busy street outside was being used as a playground.

Fifty years later the school's accommodation was still on Bristol City Council's agenda. It hit the newspaper headlines in 1954 when one alderman told a committee meeting that the school was, 'almost a museum piece of what was tolerated 100 years ago for the children of servants'. Although Bristol Education Committee earmarked a new site in Royal Park, close to the church, the following year, it was not until 1966 that building work started. Seven large Victorian houses were demolished. The new school, built from pre-fabricated units, was ready in just twelve months. There was a ceremonial official opening with the Bishop of Bristol in attendance.

The old building is now Clifton Library but the school's name can still be clearly seen carved in the stone façade.

CLIFTON CATHEDRAL

Three cloud-piercing spires which rise above the neighbouring rooftops in Pembroke Road announce the presence of a cathedral. The ultra-modern design of this hexagonal building, both internally and externally, provides a dramatic contrast to other faith buildings nearby and would probably astound Bristol's medieval church builders.

This is the Cathedral church of Saints Peter and Paul, better known as Clifton Cathedral. It is the seat of the Roman Catholic Bishop of Clifton whose diocese takes in not only Bristol but also spreads across the surrounding counties of Somerset, Gloucestershire and Wiltshire.

The architects chose reinforced concrete for the cathedral as having great durability while its mass reduced external noise and assisted thermal storage. Clad in large panels of Aberdeen granite of a pinkish-brown colour it was designed to blend in with the Bath stone and Brandon stone of surrounding homes. Part of the architect's brief was to devise enough space to seat 1,000 people who would be able to see the altar without obstruction or columns. This is a lofty cathedral, light and as open as a vast concert hall and is crowned by those three spires rising 167ft from the top of a lantern tower. The building was named by the Concrete Society as the best concrete building completed in England in 1973.

It was consecrated on 29 June that year by the then Archbishop of Westminster, Cardinal Heenan, during a day of much pomp, pageantry and ceremony. It was the first cathedral to be built in the West Country since the war, and was also the fastest such project undertaken in Britain since the Middle Ages, being completed in just over three years. In his sermon Cardinal Heenan referred to the £600,000 cost as 'the ecclesiastical bargain of the century'.

However, there was some dissent. Having criticised the design of the rebuilt All Saints church 200yds up the road six years earlier, Bristol's monthly church newspaper now set its sights on Clifton Cathedral. On seeing the plans the editor of *Contact* asked his readers if such 'splendour and comfort' was needed for worship. He called for the building to be abandoned before work had started. In a front-page column the readers were left in no doubt about the editor's opinion:

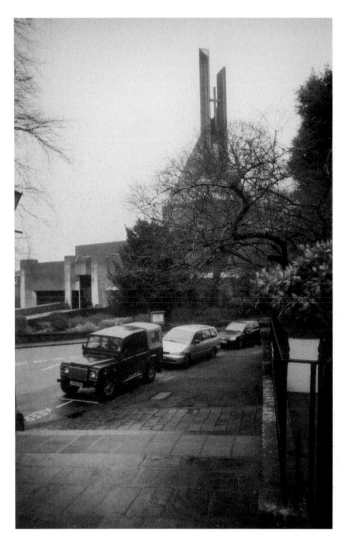

A futuristic architectural style for Clifton Cathedral.

This is the latest example of the terrible short-sightedness that affects us all. Just how much longer must all of us contribute towards the giant monuments of our selfishness? These monuments scream out our indifference to an astonished and hungry world.

He was not the only person to hold such a view. On their way into the Service of Consecration churchgoers were met by demonstrators protesting about the cost of the cathedral when there were homeless families in the city. Cardinal Heenan challenged them by asking in his sermon if a cinema or hotel was being opened would they have staged a similar protest?

Clifton Cathedral replaced the church of the Apostles at Park Place near The Triangle. Work started on this in 1834 but was held up by lack of funds and problems caused by the steep 15-acre site. It was not until September 1848 that the church was completed and dedicated in honour of the Twelve Apostles. Two years later when the Diocese of Clifton was created by Pope Pius IX it was designated a Pro-Cathedral. Such a title was given to express that it was only to be in the place of a cathedral until one could be built and consecrated.

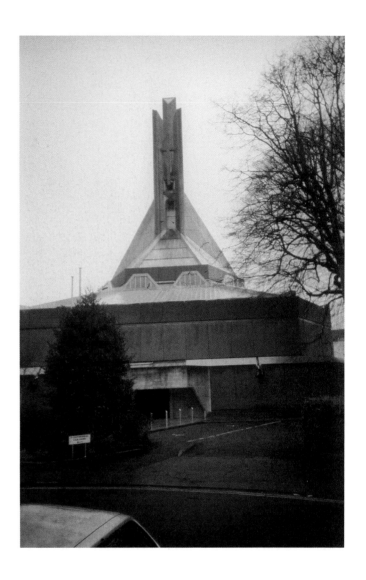

The spires of Clifton Cathedral make a distinctive landmark.

In the 1960s major work costing between £80,000 and £100,000, was needed to make the Pro-Cathedral generally stable. However, architects and builders could not guarantee that even if the work was done more would not be needed twenty years later.

The church's prayers were answered in 1965 when a group of businessmen made a generous financial offer that could not be refused. A plot of land in Pembroke Road was bought and the rest, as they say, is history.

Meanwhile, an auction of fixtures and furnishings at the Pro-Cathedral attracted bidders from as far away as San Francisco. Stained glass windows, the Victorian pulpit, confessional boxes and statues were among the many lots that went under the auctioneer's hammer.

The building itself, an architectural *mélange* of the classic and gothic, has had a chequered life ever since. At one time it was partly being used by an independent school and partly by a café. However, for many years it has been abandoned to the twin evils of erosion and vandalism. A new lease of life is now planned for the building with a £12 million mixed development scheme of flats, offices, town houses and a restaurant.

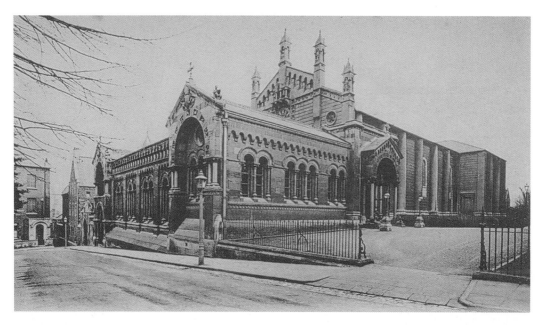

The Pro-Cathedral at Clifton.

CLIFTON COLLEGE

One of England's most famous public schools can be found in the leafier parts of Clifton and next door to Bristol Zoo. Clifton College's first prospectus states that the school was founded for the, 'purpose of providing for the Sons of Gentlemen a thoroughly good and liberal education at a modest cost'.

A provisional committee which had been formed, 'for the purpose of taking the preliminary steps for the establishment of the institution' met at the Clifton Club in May 1860. The 400 shares of £25 each that were offered by Clifton College Co. were quickly taken up by prominent citizens. This meant that 13 acres of land, at a cost of £14,000 could be bought as a site for the school and its playground.

The college opened on 30 September 1862 – it was incorporated by royal charter fifteen years later – with a special service in Big School. The Revd Dr John Percival, Fellow of Queen's College, Oxford, who was the first headmaster, preached to sixty-nine boys who were on the register for the first term. Dr Percival was only twenty-five years old but had worked under the famous Dr Arnold of Rugby School. Dr Percival set out to build a school that would turn out boys who would be, 'brave, gentlemanly, Christian and classically educated'. It quickly gained popularity for by 1880 the number of pupils had risen to 600.

Dr Percival stayed at the college for seventeen years, leaving to follow a career in the Church of England. He was later appointed Bishop of Hereford. At his own request Dr Percival was buried in Clifton College chapel, although his remains could have been interred in Hereford Cathedral.

Initially, the school had just a few buildings, including Big School and the Headmaster's House. Expansion followed throughout the nineteenth and twentieth centuries as pupil numbers grew. One of the school's architectural glories is its chapel which was built in 1867 from stone quarried on the spot. This was the gift of the widow of Canon John Guthrie, the first chairman of the college's council. He is also remembered in the naming of one of the roads that runs alongside

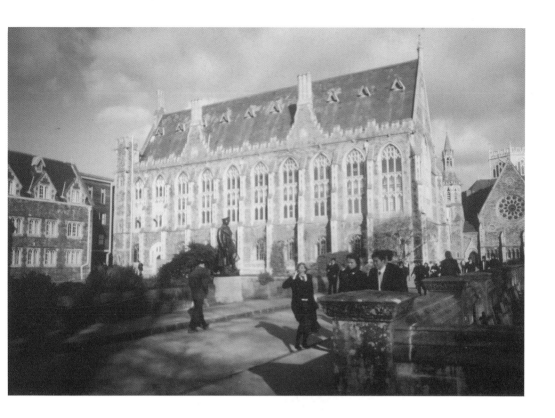

Above: *Clifton College.*

Right: *Cloisters, courtyards and towers form part of the Clifton College landscape.*

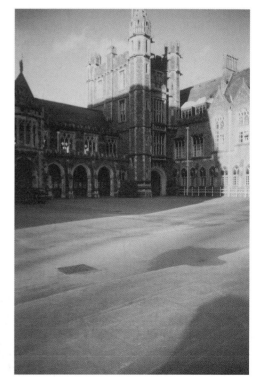

the school. An ornate tower and gateway, providing space for expanding school departments, was added two years later. Styled the Wilson Tower, it was built in memory of the Revd J. Wilson, Clifton's second headmaster, who contributed £2,000 towards the cost.

Many of the pupils went on to become famous men. One of them was Douglas Haig whose statue stands in the college grounds. Haig left Clifton for Oxford and then followed a military career, graduating from the Royal Military College, Sandhurst, and eventually rising to become Commander-in-Chief in France during the First World War. After military service he presided over the Royal British Legion. The bronze statue of Haig in School House Garden has him in battle dress. It was unveiled by his daughter in 1932, four years after he died.

Bristol-born Sir Michael Redgrave, who became one of Britain's greatest classical actors, was an 'old boy' of the college. He is commemorated by its Redgrave Theatre in Guthrie Road. Two other well-known actors, Trevor Howard and John Cleese, were also educated at Clifton. The novelist Sir Arthur Quiller-Couch, and poet Sir Henry Newbolt, both developed their love of the English language at the school. It was Newbolt whose poem *Vitai Lampadi* immortalised not only the lines 'Play Up! Play Up! And play the game' but also Clifton's cricket ground, The Close, with its 'breathless hush'.

It was on this pitch that the world's biggest cricket score was made and has never been equalled or surpassed. The player who went down in the record books was a thirteen-year-old pupil, A.E. Collins. He was at the crease for five afternoons in a junior house match in 1899 scoring 628 not out. As he piled on the runs people from all over Bristol made their way to the school. The cricket writers arrived too, with *The Times* running a headline 'Collins Still In'. His score has been recorded in *Wisden*, the cricketer's bible, and *The Guinness Book of Records*. Two years later Collins knocked up a century for his school in a match against Old Cliftonians.

Not much seems to be known about his academic ability but he was certainly a sporting all-rounder, also playing tennis for the school. In the army at Woolwich Barracks Collins won a bronze medal for boxing. He was commissioned in the Royal Engineers and was posted to India and afterwards went to France with the British Expeditionary Force. Collins was killed while serving as a captain on the Western Front in the first year of the First World War. He was aged twenty-eight.

A plaque recording his cricketing feat can be seen on the back of a brick-built bomb shelter at The Close in Guthrie Road.

CLIFTON HILL HOUSE

Bristol University's campus sprawls across Clifton into nearly 400 buildings. Many of them are purely functional serving as lecture theatres, academic departments or offices but Clifton Hill House has to be one of the jewels in its property portfolio.

This Palladian mansion house at the top of Clifton Hill was built in 1747 by the famous architect Isaac Ware for Paul Fisher, a wealthy linen draper and ship owner. His own coat of arms can be seen on the façade. Just over 100 years later the house became the home of an eminent physician, Dr John Symonds, a lecturer in Forensic Medicine and one of the founders of the Bristol Royal Infirmary.

His son, John Addington Symonds inherited the mansion and is commemorated by a plaque outside. He lived there with his wife and four daughters. It was for one of the girls that Edward Lear wrote *The Owl and the Pussy Cat*.

Symonds became known as a critic, poet and prolific writer publishing many books on travel and history, especially that of the Renaissance, several volumes of verse and studies of Greek

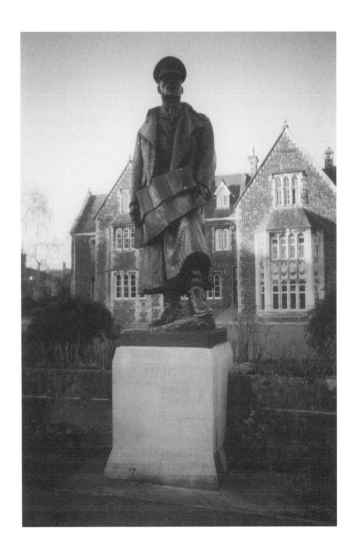

Cast in bronze: Earl Haig, one of Clifton College's 'old boys'.

poets. Another of his interests was in education and it is more than likely that early meetings to discuss the formation of both Clifton College and University College were held in the drawing room at Clifton Hill House. Despite his great love for the house ill-health forced Symonds to leave Clifton in 1877 for Davos, Switzerland.

Clifton Hill House was acquired by Bristol University in 1909 and after adding extensions, it became its first hall of student residence. Initially, only female students were admitted – just fifteen of them – but men were later welcomed.

The house has welcomed many literary and artistic visitors. Singer Jenny Lind, known as the 'Swedish Nightingale' shattered a vase on a mantelpiece while aiming for the high notes during a concert there. Britain's own Dame Clara Butt, a soprano whose family moved to Bristol when she was a child, also sang here to launch the building fund for Manor Hall, a nearby residential block for students.

THE DOWNS

Clifton and Durdham Downs, to give this vast open space its proper title, is often called 'Bristol's Green Lung' or the 'city's playground'. To most Bristolians these 440 acres of wooded and open country in the north-west corner of the city are colloquially known as the Downs.

Prehistoric farms have left their mark on the landscape in the form of remnants of field systems that can still be seen. Three hundred years ago this was a dangerous and desolate place frequented by highwaymen and footpads. One of the most notorious was Jenkin Protheroe, a dwarf who lurked about ingratiating himself with kind-hearted passing travellers. Having gained their confidence he would then attack and rob them. On one occasion his victim died and Protheroe was gibbeted for murder. His body was left to twist in the wind on the gibbet which stood at the top of Gallows Acre Lane (now Pembroke Road) the highest point of the Downs. Some people say his ghost has haunted this spot ever since.

Down the centuries lead, calamine and stone have been quarried on the Downs. There was a big demand for stone to build the large villas on the edge of the grassland for the prosperous Bristol merchants who were moving away from the industrial grime of the town.

In the eighteenth century many sporting attractions, ranging from boxing to cockfighting contests and from cricket to horse racing, took place near the Sea Walls. By all accounts the races, held from 1718 until 1838, were the most popular event attracting large numbers of spectators. A contemporary report said, 'The carriages were very numerous and filled with beautiful and elegant females which presented one of the most delightful scenes the imagination could portray'. Alexander Pope, the satirist and poet talked of the Downs 'fine

A popular walk on the Downs.

turf' and the 'delicious walking and riding there'. Much of it though, was thin with outcrops of limestone often breaking through the surface. Owners and riders of horses were rewarded with trophies and cash prizes, sometimes as much as one hundred sovereigns. One inscribed silver trophy is still among the treasures kept by the Society of Merchant Venturers at its Hall on the edge of the Downs.

A slice of cricketing history was made in 1862 when Gloucestershire staged what was probably their first county match, on the pitch of Clifton Cricket Club which had been in use since 1835. The Gentlemen of Gloucestershire beat the Gentlemen of Devonshire by an innings and seventy-seven runs. The following year there was a three-day match when an All England Eleven took on a team from Bristol with the home side winning. When he was only fifteen, W.G. Grace played for Bristol against an England XI on the Downs in 1863. Unfortunately, the records of the Clifton club were destroyed in the blitz on Bristol in the Second World War.

Whether the sound of bleating sheep had any effect on the batsmen's stroke has never been recorded. But the Downs Commoners had rights to graze up to forty sheep each, all of them branded with a distinguishing mark. At one time there were 2,000 sheep. However, large scale grazing was brought to an end by an outbreak of sheep scab in 1924. The Commoners, including Bristol University, keep their ancient rights alive by occasionally putting a couple of sheep out to graze in what has become a traditional ceremony.

Until 1861 Clifton and Durdham Downs were owned by the Society of Merchant Venturers and the Lords of the Manor of Henbury respectively. The Merchants though, were keen that the Downs should be made available for the pleasure and recreation of the citizens of Bristol in perpetuity and gave their share to Bristol Corporation. The Lords of the Manor of Henbury

Sheep and snow on the Promenade part of the Downs in 1908.

The Downs are not just a playground for people but a favourite spot for man's best friend.

followed suit in giving up their part but in return for £15,000. An agreement enshrined in the Clifton and Durdham Downs Act of Parliament of 17 May 1861 ensures that it, 'shall for ever hereafter be kept open and unenclosed as a place of public resort'. In common parlance this means that no one can build on the land and that it is solely for the enjoyment of the public for ever. Mini tombstones that marked the boundary between the two areas are still there.

The Downs are administered by a committee of six Merchant Venturers and six Bristol City councillors. Amongst other things they regulate how the area is used. Agricultural and flower shows have long been part of the Downs calendar with the Bath & West and Southern Counties show first visiting in 1864. The show, which now has a permanent home at Shepton Mallet, Somerset, made three other visits up to 1903. The prestigious Royal Society staged its annual show in 1878, with the circumference of the enclosure being nearly a mile and a half. The Prince of Wales was among the 121,851 visitors.

Bristol's 'Green Lung' has also played a major part in Britain's aviation industry. Some of the aircraft built at the Bristol and Colonial Aircraft factory set up at Filton in 1910 made their test flights here.

A tradition dating back more than a century can be witnessed every Saturday in winter when more than 500 men and youths turn up to play in the Downs Football League. This must be one of the country's most unusual leagues with more than fifty teams playing in four divisions at the same time and on the same site.

Friendly matches played by clubs from all over the city can be traced back to the 1880s but it was not until 1905 that the fixtures became formalised and the Downs League created. Two clubs, St Andrews and Sneyd Park, both taking their names from Bristol suburbs, were among the thirty initial teams and, remarkably, they are still playing today. Sneyd Park has achieved the

enviable distinction of never dropping out of the top division. Another club, Clifton St Vincents, has been a stalwart of the league since the second season.

Some players later turned professional; Eddie Hapgood went on to captain Arsenal and England in the 1930s, while others signed papers for Bristol City, Bristol Rovers and West Bromwich Albion. Several footballers, including Wally Hammond and Jack Crapp also represented England at cricket.

The Downs today are much-loved by walkers, sunbathers, kite fliers, dog walkers and picnickers. There's no longer any fear of meeting footpads or coming to an untimely end at the Sea Walls. It was at this vantage point that a number of people fell to their deaths over the unprotected cliff edge until 1746 when John Wallis built at his own expense the wall as a safety measure.

EMMANUEL CHURCH

The 110-ft high tower of Emmanuel church is still a significant landmark in Guthrie Road although the rest of the church has long been reduced to rubble. It was built as an alternative place of worship for those who did not want the high Anglo-Catholic style of nearby All Saints

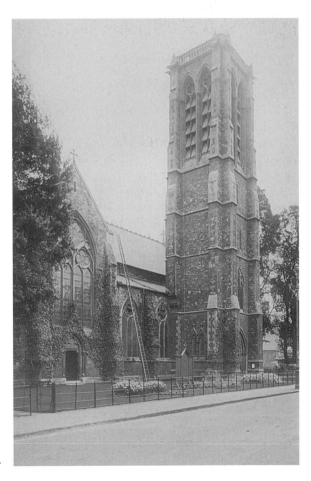

Emmanuel church in Guthrie Road.

church where services follow the Church of England faith but incorporate Catholic traditions. Emmanuel church was constructed of stone quarried on the site and cost £3,500 which was met by private subscriptions. When it was consecrated in 1869 the church had room for 614 worshippers.

It survived fire bombing in the Second World War but fell into the mouth of the bulldozer after the Diocese of Bristol declared the church redundant in the late 1960s. Its tower was kept and has been incorporated into Emmanuel Court, a £600,000 block of flats for elderly people. Its shape and size are similar to that of the former church. The flats were officially opened by the Duchess of Kent in 1982.

One of Emmanuel church's claims to fame is that it was here on Christmas Eve 1914 that twenty-four-year-old Agatha Miller from Torquay married twenty-five-year-old Archibald Christie from Guthrie Road. On their wedding certificate she is described as a spinster and he as a captain in the Royal Flying Corps. Using her husband's surname the bride went on to write more than seventy detective novels featuring the Belgian detective Hercule Poirot or the village spinster Miss Jane Marple. The Christie's marriage lasted fourteen years.

FOUNTAINS

A modest man with simple needs, the Revd Urijah Thomas could hardly have dreamt that his life would be commemorated by a grand memorial on a landmark site. By calling, he was a congregational minister and the first incumbent of Redland Park church on Whiteladies Road. He served that church for forty years until his death. The Revd Thomas not only came to public attention for the pastoral care of his flock but also for his educational and charitable activities.

On discovering the plight of so many people on what he called 'the verge of pauperism' the Revd Thomas founded the Penny Dinner Society which provided meals for them. So great was the need that in its first year in 1884 the society dished up some 52,000 dinners at seven bases across the city. Those who were fed had little means by which to pay for their meals so Revd Thomas reduced the cost by half.

Under his guidance the society later set up a holiday camp for youngsters whose families could not afford for them to have an annual break away from home. It was established at Winscombe at the foot of the Mendip Hills in north Somerset. Although initially it was a very basic affair with wooden buildings serving as dormitories, Revd Thomas reasoned that if nothing else the youngsters would benefit from fresh country air and exercise from walking the hills.

When he died in 1901 at the age of sixty-two, Bristol witnessed the biggest funeral procession it had ever known. Streets were closed as huge crowds lined the route from Redland to Brislington as the funeral cortège slowly made its way to the cemetery at Arnos Vale. The bells of Bristol Cathedral were tolled, too.

A grateful city wanted succeeding generations to be aware of Revd Thomas's contribution to society and so a drinking-water fountain was erected in his memory. No ordinary fountain this for it must be one of the city's most ornate memorials. It has four sides and is surmounted by a clock tower supported by marble columns. The monument is set in the midst of flower beds and its prominent location in the middle of Whiteladies Road near its junction with the Downs could not be more appropriate. Revd Thomas spent much of his time working amongst the quarrymen who lived in the hovels that once packed the courtyards nearby, and his church, of course, is only a few hundred yards down the road.

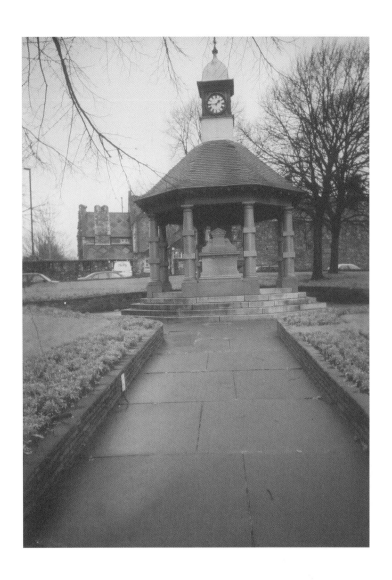

An ornate memorial to a Clifton clergyman.

An extract from a lengthy inscription on the fountain says it was erected, 'in grateful recognition of the catholic spirit and generous ardour with which he gave most of the public in service and especially to his wise and tender care for the children of the city'.

More than 100 years after it was founded the Penny Dinner Society is still going strong although it is now known as the Bristol Children's Help Society. It may no longer serve up food – but Barton Camp as it is known is still providing holidays for around 1,500 youngsters each year.

Revd Thomas's church was opened in 1861 for the many families who were then settling into new homes nearby. It was totally gutted by incendiaries and a high explosive bomb which hit the building in 1940 during the Bristol Blitz. It was another seventeen years before Redland Park Congregational church was replaced by the present building. A marker stone in the boundary wall tells us that it is exactly one mile to the top of Park Street.

Another ornate drinking-water fountain stands on the grassland of the Promenade near the Mansion House on Clifton Down. It was built by local architects George and Henry Godwin on

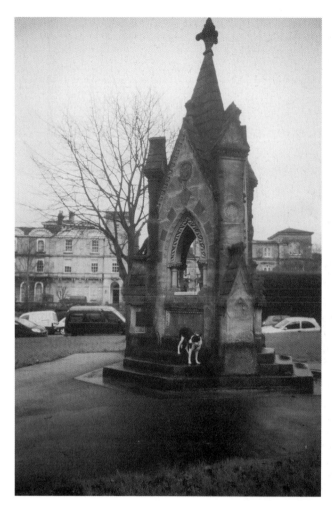

Alderman Proctor's fountain.

the instructions of Alderman Thomas Proctor, who had built the Mansion House and later gave it to the city. The fountain was one of his many benefactions to Bristol and commemorates the gift of the Clifton part of the Downs to the city by the Society of Merchant Venturers in 1861.

For more than a century the fountain stood at the top of Bridge Valley Road but was moved to its present site, about 100yds away, in 1988 being considered a traffic hazard.

The fountain at the foot of a tall stone column on Stoke Road, which crosses the Downs, was the gift of a grateful Bath & West of England Agricultural Society which had staged one of its shows on the Downs in 1874. The fountain itself stands on a plinth of lime and sandstone with a granite basin. It is a Grade II Listed Building.

GOLDNEY HOUSE

Thomas Goldney was one of the wealthiest men in eighteenth-century Bristol. A merchant and entrepreneur he was a founder of the second bank to open in the city and took an interest in Abraham Darby's ironworks and Richard Champion's clay factory. He also had a stake in the

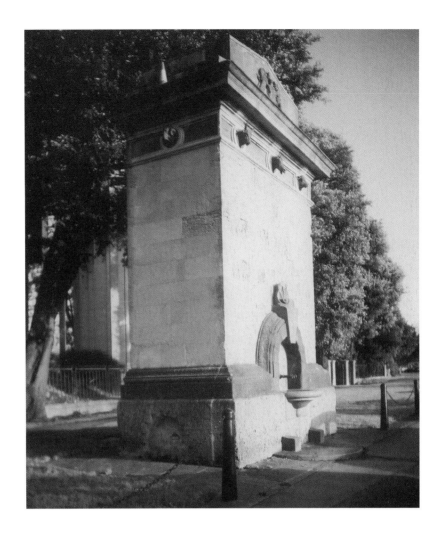

Monumental fountain on the Downs.

privateering voyage of the ships the *Duke* and *Duchess* which sailed under Capt. Woodes Rogers who lived in Queen Square. His ships came back to Bristol having rescued Alexander Selkirk, a Scotsman, who had been marooned on the south Pacific island of Juan Fernandez for four years. Selkirk's story inspired Daniel Defoe, whom he met in the King Street area, to write his novel *Robinson Crusoe*. The ships also returned with 'loot' for Thomas Goldney.

Testament to his wealth is Goldney House which, with his son, also Thomas, he turned into a grand mansion with a famous grotto and gardens. He lined the dining room walls of his mansion with mahogany, at the time a new wood which had been brought back from the West Indies. Detailed attention was given to the creation of the gardens which stretch for 12 acres. Not only were flower beds laid out, but statues erected and dramatic water features like bubbling fountains installed. Goldney also built a tower to house a steam engine which pumped water to the garden canal. The *pièce de résistance* of Goldney House however is its underground grotto, reached through a long tunnel. Its walls are decorated with exotic sea shells, tiles, sparkling quartz, crystals, coral, rocks and fossils brought back from islands in the South Sea. From nearer home Goldney included the so-called Bristol diamond, a crystalised stone that glistens like a diamond and is found on St Vincent's Rocks near the suspension bridge.

When John Wesley, the founder of Methodism, visited the house it was reported that he noted with a groan that Goldney's son had spent twenty years and a large sum of money in arranging the decorations for the grotto.

Goldney House has changed hands several times. It passed from the Goldney family to, firstly, Lewis Fry, of the chocolate family and later to Sir George Wills, of the tobacco family. It eventually was handed down to his daughter and after she died the mansion and its grounds was sold to Bristol University in 1955.

This is now a student hall of residence but the house, gardens and grotto, a Grade I Listed Building, remain largely untouched and still have that eighteenth-century air of refinement. Goldney House, hidden behind a nondescript high wall curving around Clifton Wood Road and the top of Constitution Hill, is open to the public several times a year.

GRAND SPA

The Grand Spa and Hydro opened in 1894 and was advertised as a venue for those wanting to partake of the healing waters from the Hot Well which had been forced some 200ft up through the Avon Gorge via a deep bore. This was the spa water which originally gave rise to the name Hotwells. Although the popularity of the famous spa there had ended around a century earlier, there had long been much talk of the need for such a feature in Clifton. Besides the spa, patrons could also listen to lunchtime concerts. The spa and hydro was developed by entrepreneur and publisher Sir George Newnes who seems to have spared no expense in bringing the project to fruition. When the spa opened one newspaper report described it as, 'one of the best in the kingdom'. Its medical director visited continental spas and baths to bring to Clifton the latest ideas.

As befitted such an ambitious scheme a formal dinner, hosted by Sir George, was held to mark the opening of the Pump Room. The chief guest of honour was the Mayoress of Bristol who was joined by 700 citizens, many of whom had been invited because they circulated in influential and wealthy social circles from which patrons would be drawn. In an after dinner speech Sir George told them that the Society of Merchant Venturers insisted the spa should be built if he was to be given the concession to construct the adjoining Clifton Rocks Railway which was already running.

Excavating through the limestone rock to pump up the water was no easy task. More than 8,300 tons of it had to be blasted. Installing the piping was another major job. There was enough of it to stretch to a more famous spa city, Bath, thirteen miles away. After a sumptuous dinner followed by the speeches guests were entertained with music from the 1st Band of the Life Guards and singing from Madame Strathearn.

The baths were duplicated throughout, giving continuous treatment for men and women in their own suites of Russian, Turkish, douche, hydro, mist, steam, spray, massage and electrical baths for general treatment. There were special treatments for those suffering from particular ailments.

The directors of the Clifton Grand Spa and Hydro boasted that its grand Pump Room, used for receptions, was the, 'most highly decorated and finest in the kingdom'.

A 1902 guide book mentioned that the Pump Room had, 'twenty massive pillars of Cipollino marble and on one side an alcove where the water of the old Hotwell spring is pumped up'.

Newnes also converted one end of Princes Buildings into the Grand Spa Hotel. Each of its bedrooms had electricity installed and radiators providing 'comfortable' heating although there were grates for those who preferred coal fires. It was all set in magnificent grounds, overlooking the

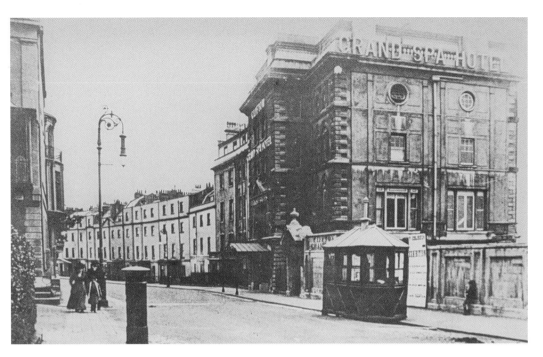

The Grand Spa Hotel with the Princes Buildings behind in 1909.

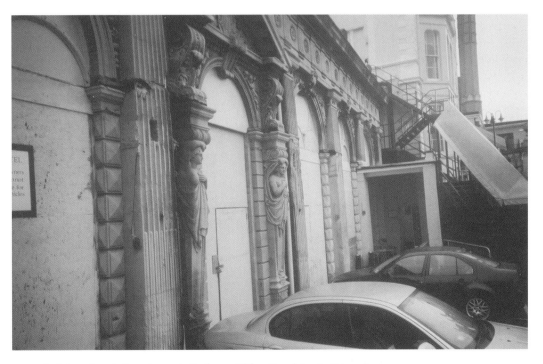

Sculptures decorate the entrances to the former Clifton Grand Spa in Princes Lane.

River Avon. There were promenades for visitors and their guests, bowling greens, and for the more energetic, badminton and tennis courts. Players were sheltered from all but the westerly breeze.

By the end of the First World War popularity of the spa was on the wane. The Pump Room became a cinema in 1920 and six years later it was a ballroom. With its fifteen-piece Grand Spa Band it became one of Bristol's most popular dance halls. In the 1970s the *Last Waltz* was played for the final time and the management closed the doors. The Pump Room is still there with its marble Corinthian columns and ornate plasterwork, which are thought to be largely intact. The decorated entrance to the spa can still be seen in Princes Lane at the back of the building.

The hotel was known as the Grand Spa until 1975 when it became the Avon Gorge Hotel. Four years earlier it made national newspaper and television headlines when its then owners applied for planning permission to build an eight-storey hotel block on the rock face of the Avon Gorge itself. This created such a public furore in Bristol and nationally, especially as stunning views of the suspension bridge were threatened. Petitions and letters were sent by their thousands to local and national politicians. Local amenity groups were stirred into action and public meetings held. The environment secretary called in the outline planning application and a public inquiry lasting nine days was held. The most influential protestor was John Betjeman, later to be appointed poet laureate. He told the inquiry inspector that the proposed hotel, 'was old fashioned and a monster and utterly unsuitable for this site. The Avon Gorge is a natural piece of unique scenery and should not be spoilt.' The scheme was eventually thrown out.

HIGH RISE CLIFTON

The face of Clifton dramatically changed with the construction of a skyscraper block of flats in The Triangle. Clifton Heights was marketed as providing prestigious accommodation but the block divided local public opinion. There were those who thought that such a 'mass of concrete' was hardly fitting for the Clifton skyline while others said that changing architectural styles had to be accepted. There were forty-eight flats spread over ten floors in a tower block rising 150ft all of which was crowned by two penthouse suites offering stunning panoramic views of Bristol and the surrounding countryside. All the living accommodation was built on top of showrooms at street level and two floors of offices.

Clifton Heights was built over three years by a London property development company and was completed in September 1964 amid much publicity at a cost of £400,000. Rents ranged from £350 a year for a one-bedroomed flat to £750 for a three-bedroomed flat on the top floor, exclusive of rates and service charges. The publicity material boasted that each flat was equipped with all the latest household appliances from hob and cooker units to breakfast bars with built-in cupboards. But it seems that Bristolians did not want, or could not afford, to live the high life. Despite a massive advertising campaign Clifton Heights attracted just two tenants in separate flats. For company they had a caretaker, previously bosun on the *Queen Mary* liner, and his wife, who occupied a third flat.

Four years later Clifton Heights had a new owner, a millionaire businessman from London. The tenants had left, and he ripped out all the kitchens and bathrooms. Partitions, heating and lighting systems were re-arranged at a cost of £3 million and Clifton Heights was then put on the market as an office block. In the early 1990s there was another revamp of the block. Today bars and restaurants are at street level and offices occupy the upper floors.

The 1960s and 1970s was the time when purpose-built blocks of flats were becoming the fashion. One of the first in Clifton appeared in the winter of 1962. This was a seven-storey block of thirteen homes known as Harley Court, near the suspension bridge. Although the phrase

'location, location, location' had yet to enter the estate-agents' vocabulary it would certainly have applied to Durdhamside, three blocks of flats which rose a few years later from the edge of an old quarry on the Downs.

INNS

Inns, taverns, public houses, hostelries, call them what you will, are veritable treasure troves of any town's history. They have long played a part in the English heritage. In Chaucer's *Canterbury Tales* the pilgrims stopped at various inns, and Charles Dickens wrote endlessly about them.

They are so often at the heart of the community like the Coronation Tap. Three hundred years ago this was the farmhouse of Clifton Farm supplying people living in the hamlet of Clifton with their milk and vegetables. It has long been better known as a cider house where judges and barristers rub shoulders at the bar with students and builders. The Tap, as it is affectionately known, has always been on the same site and traded under the same name. A document of 1806 described it as, 'a beer house with cottage adjoining'.

During the 1960s and 1970s the 'house rules' devised by the then landlord, Dick Bradstock, became the talk of the town. He would not allow women, for example, to be served pints. There was the fear that such a large volume of cider would have impairing effects on them. Drinkers were barred from referring to cider by its popular nickname of scrumpy and the landlord ruled that no one should move the pub furniture around to suit their convenience. Couples were prohibited from showing any signs of affection for each other, even holding hands. Wines and spirits were not sold at the Tap then, only cider and beer. The pub had its own cricket team although it never had a pitch of its own on which to practise or stage return matches. The Tap is unusual in that it has two entrances, both in different streets.

A few hundred yards around the corner is the Royal Oak, a traditional English pub of which the high-back settles, dark oak beams and an old bread oven are redolent of a more leisurely age. For many years it traded under the sign of the St Vincent's Rocks Inn, and its landlords can be traced back until 1863. For many years its address was Portland Place but the street name was changed in 1962 to The Mall.

Tucked away at the end of a 90ft-long cobbled cul-de-sac off Boyces Avenue is the Albion public house. No definite record can be found of when it was built, but a sign at the entrance says it was probably named after a ship called the *Albion*, a 200-ton vessel built in one of the Bristol shipyards in 1778.

When the pub underwent a major restoration in 2005 seven Georgian fireplaces which had been bricked up were rediscovered. Windows from the same period which had been filled in, probably to avoid payment of the window tax which was brought in by the government in 1696, also came to light. The interior looks as if it has not been materially altered since it was built. Outside, the cul-de-sac which once had stables on both sides with servants' quarters above, is now a popular seating area for drinkers and diners.

The Blackamoor's Head, built about 1756, stood in a really unusual position – across the middle of Whiteladies Road, not far from where it meets Clifton Downs. Around 1830 its name was changed to the Black Boy Inn. Despite a persisting legend this was not a reference to Bristol's involvement in the slave trade. Nor were slave markets held nearby. When the road was widened to provide better access for coaches making their way to the Downs the inn was demolished. However, its name still lives on. After a gap of more than a century it reappeared in 1988 when the Elephant and Castle, 100yds or so down the road, was refurbished and became the Black Boy Inn.

A cobbled courtyard leads to a Georgian pub.

Straddling Whiteladies Road is the Black Boy Inn, 1870.

The Coach and Horses, a three-storey inn in Highland Square behind the original Black Boy is still quenching the thirsts of those who climb the steep hill to reach it. The church building at the top right hand of the picture is still there. This was the Zion chapel of the Reform Methodists but in the latter part of the twentieth century it became the Mount of Olives Pentecostal church and is now a fitness centre.

KING'S BAZAAR

Architect Joseph King was certainly a man of vision. He designed an early version of a luxury shopping mall. His two-storey Bristol and Clifton Bazaar was an arcade of shops linked by a sweeping staircase, graced by neo-classical columns.

King had thought of everything including providing a glass roof to protect shoppers from inclement weather. The arcade cost him £10,500 and was completed in 1878. But it was not

A 'rose window' carved of stone dominates Clifton Arcade.

for another century and more that it opened as a shopping centre. Hard times forced King to abandon the scheme before any customers could set foot inside the building. As part of the Bazaar, King designed a Winter Garden occupying some 20,000ft in front of the arcade. This was on the site now occupied by a rank of eight shops on a raised patio.

The nearest King's arcade ever came to trading was when the building, tucked away in Boyces Avenue behind flats, shops and offices, was taken over by the Bristol firm of Knee Brothers and used as a storehouse. They shut up the shops and packed the place with items of furniture which had been left in their depository.

In 1989 a developer set about restoring the arcade as a shopping centre and it eventually opened as such five years later. It is believed to be the only Victorian arcade in the country in its original condition. One of its features is the ornate rose window that King carved in stone. The arcade now houses a collection of jewellery, antique and arts and crafts shops along with a café.

King is not only remembered by his arcade but also in King's Road that runs alongside it. It was here that George Cross ran his 'Clifton Stock Exchange'. One of his adverts told potential investors that he transacted business in 'local and other stocks and shares' and special business was done in 'Arnold, Perrett and Co's Brewery shares'.

LIDO

Tucked away in the labyrinth of narrow streets and back-to-back houses behind the Victoria Rooms is the Victoria Open Air Pool. This is the United Kingdom's oldest Grade II Listed such building. It was opened as a private subscription bath, initially for men only, at 6 a.m. on the morning of 19 July 1850. Admission cost 1s per person and this included the use of two towels. It was another twenty-one years before women were welcomed into the lido.

Lidos (literally 'shore') take their name from the first open air pool and sunbathing area in Venice, the *Lido di Venezia*. They were all the fashion in this country before swimming at the beach came into vogue or local authorities provided public baths. Visiting the Clifton lido had become so much a routine of family life that *Chilcott's Guide to Bristol*, published in 1909, said, 'the establishment is admirably conducted and the swimming bath is capacious'. Another guide published nearly eighty years later noted that the city had nine swimming pools across Bristol but said that, 'Clifton's open air pool was one of the most popular'. It was especially busy in 1976 when the sun seemed to blaze down all summer and long queues of swimmers and sunbathers passed through the turnstiles.

Soon afterwards the popularity of lidos started to fall off especially as leisure centres offering various sporting activities including swimming were being developed. The Victoria Open Air Pool had been privately run until 1997 when it was taken over by Bristol City Council. The turnstiles clicked for the last time three years later when council officials said that the cost of repairing a bad leak and relining the pool was prohibitive. The pool was drained and since then the lido has fallen into a pitiful state of dereliction. It was one of 300 lidos across the country which have been closed during the last three or four decades. However, a new lease of life is promised for this particular lido by a local businessman who has been given planning permission to revive it. Not only will the pool came back into use but other leisure facilities will be provided. The lido will join dozens of others around the country that are now being restored as people realise what their heritage has to offer.

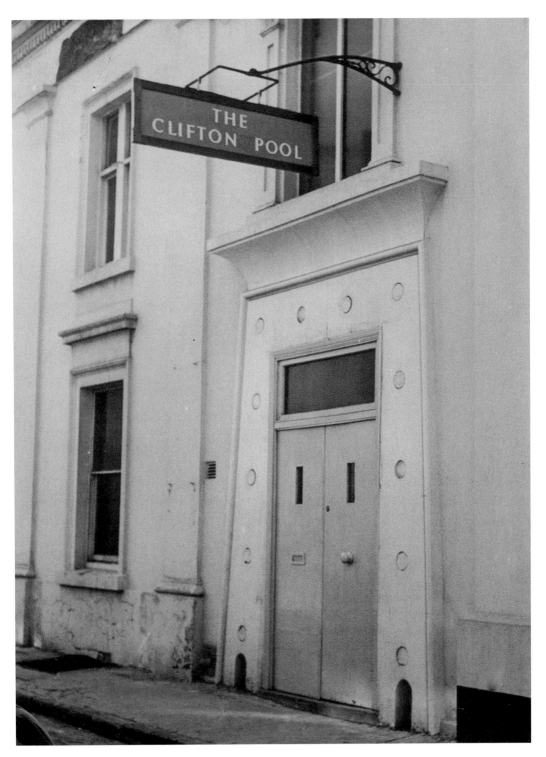

The open-air swimming pool waiting to be given a new lease of life.

LITERARY CLIFTON

Writers not only visited Clifton to give public readings of their works some of them settled here, even if only for a short time. Novelist Emma Marshall (1830-1899) is probably worth a story herself. Born in Norwich, she came to Bristol when she was nineteen and married the son of the vicar of Christ church. The couple moved around the country but returned to Clifton in 1882. Emma wrote more than 200 stories, some of them set in the last years of the nineteenth-century in Bristol. It is said that she became so prolific in order to pay the household bills after her husband's bank crashed. Her pen turned out romances, historical novels and children's works. She gave one of her books, *Bristol Diamonds*, the sub-title *A Story about the Hot Wells in the Year 1773*.

Emily Hilda Young (1880-1949) was born in Northumberland but married a Bristol solicitor in 1902 and lived for a while in Saville Place off Regent Street. By all accounts she could often be seen strolling the streets near her home and kicking up the leaves as she made her way across the Downs looking for settings for her books. All seven of her Upper Radstowe novels are set in Clifton.

Novelist Maria Edgeworth (1767-1849), who lived in Princes Buildings, wrote witty and improving stories for children, some of them with a local setting. Her most famous novel for adults was *Castle Rackrent*. She was a friend of Bristol-born poet laureate Robert Southey, Hannah More and Dr Thomas Beddoes.

Arguably, the best known of the 'Clifton writers' was Hannah More, who was also a dramatist, philanthropist and social reformer. She was born in Fishponds in east Bristol and spent the last years of her life at No. 4 Windsor Terrace where she died at the age of eighty-eight. A plaque commemorating this is on the front wall of the house.

Books of her ballads, religious tracts, essays and childrens' stories proved very popular in the 1790s. This led to her becoming one of the highest-earning writers in Britain. But it was for her criticism of social problems, especially in the West Country, that Hannah More is probably best remembered.

The poet T.E. Brown joined the staff of Clifton College in 1863 as second master. He wrote several poems about the school, and penned the immortal line, 'A garden is a lovesome thing, God wot'. He gave his name to the school's Brown's House.

THE MANSION HOUSE

Not many people build a home, or to be precise a mansion, and then give it away. But that is exactly what Alderman Thomas Proctor did. He bought a plot of land at one of the most prestigious sites in Clifton in 1865 and commissioned local architects George and Henry Godwin to design his house. They used stone quarried on the spot to build a twenty-two-roomed gentleman's residence with a spacious drawing room, billiards room, galleries on its three floors and a lift from the kitchen to the dining room. Two years and £2,500 later Alderman Proctor was able to move into Elmdale House on the corner of the Promenade and Canynge Road.

Proctor lived here for about seven years until in 1874 he announced his intention to give it to Bristol Corporation on 1 May, his wedding anniversary. Such a generous gift came as a surprise to the city fathers who were further taken aback to discover it came complete with fixtures, fittings and furnishings. Mr Proctor also threw in a £500 cheque to help cover the cost of any repairs and decorations.

The corporation decided to make Elmdale House the official residence of the Mayor and Mayoress during their term of office. It was renamed the Mansion House. Apart from London,

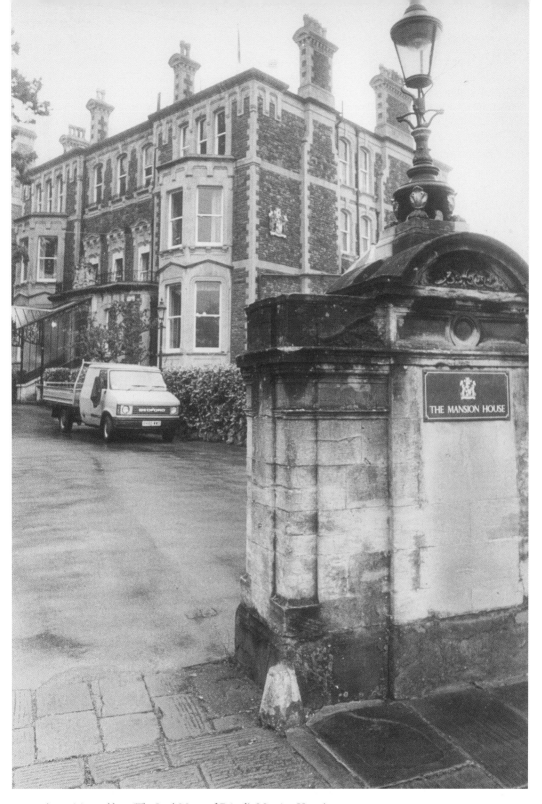

A prestigious address 'The Lord Mayor of Bristol's Mansion House'.

Bristol is one of the few cities in the country to provide accommodation for its leading citizen enabling him or her to entertain important guests with dignity. Bristol's own flag is flown from the building when the 'First Citizen' is in residence.

Mr Proctor's generosity was typical of the man who became wealthy through his chemical, manure and fertiliser business and property development. His many gifts included paying for the restoration of the North Porch of St Mary Redcliffe church. He did this keeping his identity a secret when sending donations to the vicar by signing himself as *nil desperandum*, in other words, worry not.

Although he was a native of Birmingham Mr Proctor immersed himself in Bristol's civic affairs, becoming an alderman and high sheriff. Ill-health, however, prevented him from taking up the office of Mayor. When he died in 1876 at the age of sixty-four, flags were flown at half mast on many of Bristol's public buildings.

The office of Lord Mayor is held in high esteem by city businessmen who in 1979 formed the Guild of Guardians. Their role is to, 'enhance the good name and standing in the city of both Bristol and the Mansion House'. The guild came into being after one businessman thought that the Lord Mayor's cutlery and glassware were not good enough for the building. He recruited the support of colleagues to raise the funds to replace them.

Treasured paintings along with historic civic insignia are held at the Mansion House for safe keeping. They include the court sword and gauntlets worn by Herbert Ashman, the last Mayor of Bristol in 1898, when he was knighted by Queen Victoria on the steps of the Old Council House in Corn Street. The following year Sir Herbert became the first Lord Mayor after the Queen granted the city the right to use the title.

The visitor's book makes fascinating reading with the signatures of the Queen and Duke of Edinburgh and other members of the Royal family who have been entertained at the Mansion House while on official visits to the city. Local folk can also visit this treasure trove of history when the Lady Mayoress throws open its doors for one of her frequent 'At Home' receptions.

ST MARY THE VIRGIN

This church in Belgrave Road at Tyndalls Park was consecrated in 1874 although it was not completely finished at the time. It was built of local red sandstone and had a thriving congregation. The £10,000 original cost was raised by public subscription.

St Mary's could seat 750 people but over the next ninety years attendances dwindled. There was an attempt to merge the church with two others but eventually St Mary's was declared redundant in 1976.

The church stood empty for several years until it was bought by the neighbouring BBC. A second floor was added and for twenty years it housed props for television programmes. However, St Mary's has now gone full circle becoming a place of worship once again, this time under the banner of the Woodlands Christian Centre.

MERCHANTS' HALL

An imposing mansion with a brightly painted coat of arms carved in stone on the broad sweep of the Promenade is the home of one of Bristol's most historic and controversial organisations. The Merchants' Hall is really two houses knocked together and is the home of the Society of Merchant Venturers founded by royal charter of Edward VI in 1552, although its origins

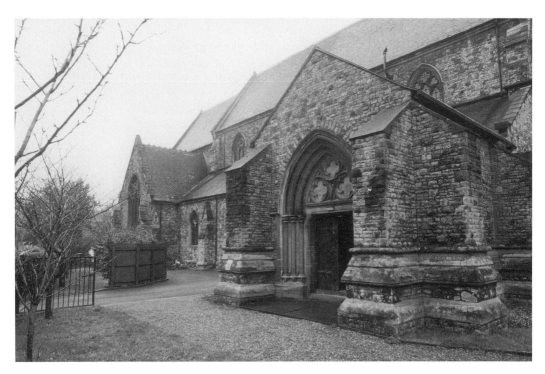

St Mary the Virgin is once again a place of worship.

date back to a thirteenth-century merchant organisation. Its original purpose was to secure a monopoly on overseas trade by merchants sailing from the Port of Bristol.

This is a society which Bristolians seem to either love or loathe. Its members profited from slavery in the 1700s and played a key role in the trade. Although it was a legal activity at the time this is now viewed with much abhorrence and is a long-running sore with many citizens. The Merchants' have also long been accused of being a secretive cabal recruited from wealthy families with roots deeply entrenched in the area. There have been claims, strongly refuted, that behind the closed doors of its Hall the Society uses its influence to manipulate the life of the city.

The original seventeenth-century Hall stood near the corner of Marsh Street and King Street in the centre of the city until it was destroyed in the Second World War. As a temporary move the society acquired Fern House, a large semi-detached mansion on the Promenade. Four years later the next door property, Auckland House, came on the market and the Merchants knocked the two together thus creating their new Hall which is used for banquets, meetings and receptions. One of its features is the broad corridor which runs the length of the building and contains many historic portraits. Besides its royal charters one of the Society's treasurers is a saddle cloth which belonged to Elizabeth I when she rode into Bristol in 1574. The blue velvet cloth was originally given to a High Sheriff but somehow it came up for sale in 1947. Sir Foster Robinson, twice Master of the Merchant Venturers bought it and presented it to the Society.

It no longer looks after the port but the Society's main job is now acting as trustee to endowment funds for several leading charitable organisations, including St Monica's home for the elderly on the Downs, and schools endowed by the benefactor Edward Colston. It also helps community groups and provides volunteers to serve on Bristol University's decision-making bodies and the city's Downs Committee.

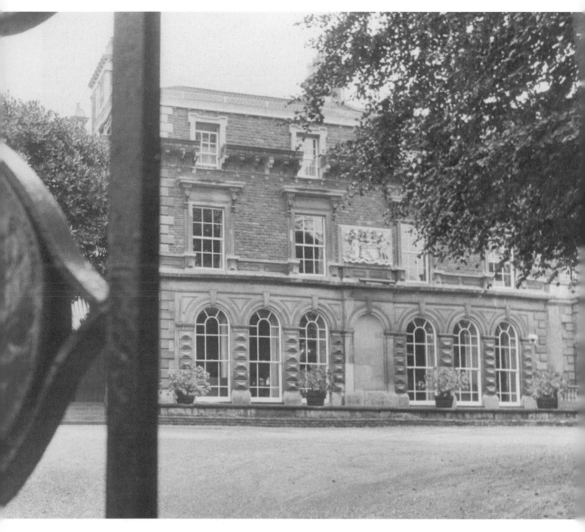

The Merchants' Hall on the Promenade at Clifton Down.

Although its membership has never been published the society has invited various prominent people to become honorary members including the Duke of Edinburgh, and four Princes of Wales, the last being Prince Charles. Politicians Edmund Burke and Sir Winston Churchill were also admitted as honorary members. Of its seventy members only three are women – if former PM Margaret Thatcher, who was made an honorary member in 1989, is included.

The Merchants are loyal custodians of traditions and ceremonial practices laid down hundreds of years ago. Its Court of Officers still forms the executive body and is elected, along with a new Master and wardens, on 10 November each year, a date set by a charter of Charles I granted in 1639. On this day the new Master takes office for the ensuing year. Together with two wardens, twelve assistants and the treasurer he is sworn in at Merchants' Hall. This follows a Charter Day service at Bristol Cathedral attended by pupils from the Colston schools who are given buns following a tradition laid down by Edward Colston himself.

The Merchants' coat of arms on the gate of their Hall.

MONUMENTS AND MEMORIALS

There are probably more memorials and plaques in Clifton than any other suburb in the city. It seems that hardly a Clifton street does not have a plaque commemorating a politician, author, social reformer or even a music-hall entertainer. Two elaborate monuments, an obelisk and a cenotaph, which stand on Clifton Down were commissioned by Lt-Gen. Sir William Draper for the grounds of his own mansion. He lived in Manila Hall which stood on what is now the site of Manila Road.

Sir William, born in Bristol in 1721, was elected a fellow of Kings College, Cambridge, but chose a military rather than an academic career. He was responsible for raising the 79th Regiment of Foot for service in the east during what became known as the Seven Years War. Draper commanded a force which captured the Spanish colony of Manila in the Philippine Islands. After the regiment was disbanded Draper built the cenotaph which he dedicated to its men and officers.

The obelisk, which stands a few yards behind the cenotaph, was designed by Draper to commemorate the memory of William Pitt, Earl of Chatham. Part of the inscription, composed by Draper, says that Pitt as prime minister, 'planned and inspired the victorious campaigns' of the Seven Years War. As a result the British replaced the French as rulers in India and Canada.

After retiring from military service, Sir William was given by the Society of Merchant Venturers authority for the 'keeping in order of Clifton Down' as its conservator.

After he died the ownership of Manila Hall changed several times eventually becoming a Roman Catholic nunnery for the Dames de la Mère de Dieu. The nuns ordered the removal of both monuments in 1873 and they were resited on Clifton Down near Christ church where they have stood ever since. Meanwhile, Manila Hall was demolished at the start of the twentieth century.

After fighting in the first Afghan wars with the East India Co., one of Britain's great generals retired to Clifton. Sir Abraham Roberts lived on Royal York Crescent where he died in 1873 aged seventy-nine. His son, the hero of Kandahar, unveiled a plaque commemorating him outside No. 25.

Gen. Draper's monuments with cenotaph in the foreground and the obelisk behind.

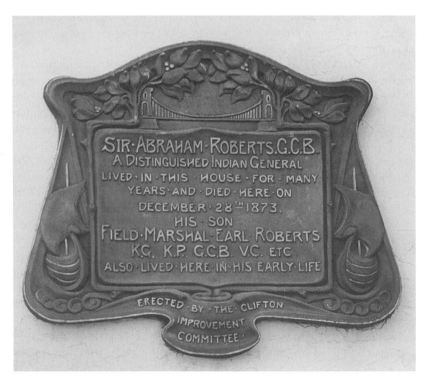

SIR·ABRAHAM·ROBERTS.G.C.B.
A·DISTINGUISHED·INDIAN·GENERAL
LIVED·IN·THIS·HOUSE·FOR·MANY
YEARS·AND·DIED·HERE·ON
DECEMBER·28TH·1873.
HIS·SON
FIELD·MARSHAL·EARL·ROBERTS
K.G.·K.P.·G.C.B.·V.C.·ETC
ALSO·LIVED·HERE·IN·HIS·EARLY·LIFE

ERECTED·BY·THE·CLIFTON
IMPROVEMENT
COMMITTEE·

*A leading
military man
remembered
on Royal York
Crescent.*

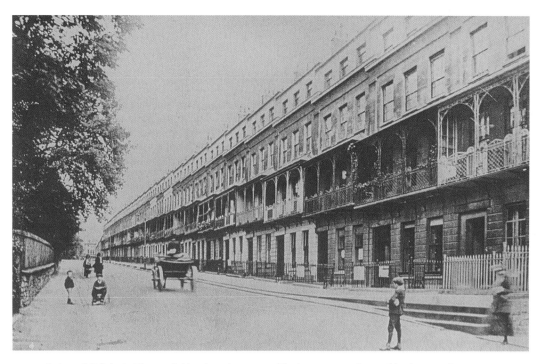

A view of Caledonia Place, probably taken about 1908. The houses are rarely seen like this nowadays as cars are parked on both sides.

Another plaque recalls the days that poet, historian and MP Lord Thomas Babbington Macaulay (1800-1859), lived in Caledonia Place. He moved to Clifton in 1852 for his health. Lord Macaulay was probably best known for his vast *History of England*.

Although the legendary cricketer Dr W.G. Grace only lived and practiced in Victoria Square for two years, the time he spent there is marked by a plaque on the wall of No.15. He sent his daughter Bessie to Clifton High School.

Randolph Sutton, born in Anglesea Place, a narrow street not far from the Downs, became one of the country's biggest music hall stars. His singing career began when he joined the choir of his local church. He went on to achieve national fame with his infectious tunes and catchy words of songs like *On Mother Kelly's Doorstep* and *The Sun Has Got His Hat On*. Sutton's records were big hits and in show-business circles he was regarded as Britain's premier light music hall comedian. He later made his living as a stage and radio performer. The life of Randolph Sutton, who died at the age of eighty-one, is recalled by a plaque on his birthplace.

An unusual slice of Clifton's social history is recorded in a blue plaque above the door of the ladies' toilet on Stoke Road, one of the roads that crosses the Downs. The plaque marks the work of Victoria Hughes (1897-1978) who was a toilet attendant there, although she insisted that she was a 'loo lady'. Her official duties involved issuing tickets, cleaning the premises, and selling sanitary supplies for which she was paid two guineas a week – always in cash, every Thursday.

Victoria, who worked at the toilet from 1929 to 1962 found unexpected national fame at the age of eighty as the author of *Ladies Mile,* a book about her personal reminiscences. In it she revealed that she had become a confidante of the prostitutes who plied their trade behind the trees on the part of the Downs known as Ladies Mile. The women used Victoria's toilet and discussed their way of life with her. Victoria's book revealed a hitherto hidden aspect of social

A blue plaque above the entrance to this ladies toilet honours a former attendant there.

life in this middle-class area of Clifton. The book reportedly shocked civic dignitaries when it was published in 1977 and was serialised in a newspaper but it has since been acknowledged as a valuable contribution to social history. The plaque was unveiled in 2003 by Bristol City Council as tribute to Victoria's social work.

The valuable job of perpetuating the memory of famous, and not so famous people, by erecting commemorative tablets or plaques was largely the work of the Clifton Improvement Association which was founded in 1900. A successor organisation, Clifton and Hotwells Improvement Society, now happily carries on that task as, of course, does Bristol City Council.

MUSEUM & ART GALLERY

The municipal museum and art gallery in Queen's Road was yet another gift of the generous Wills tobacco family. Sir William Henry Wills gave it to his fellow citizens in 1905. His cousin, Sir Frank Wills, was commissioned to design it and the building cost around £40,000. It was built by the well-established Bristol firm of William Cowlin & Son who were appointed without competition.

Originally, it was known as Bristol Art Gallery & Museum of Antiquities although the actual museum was housed in the neighbouring building designed in Italianate style. At the time it was thought that archaeology and anthropology were more akin to 'art' than the natural sciences which then took up space in the museum.

In its first four months nearly 300,000 people visited the first loan exhibition. They could look at nearly 400 pictures and seven pieces of sculpture displayed in five galleries.

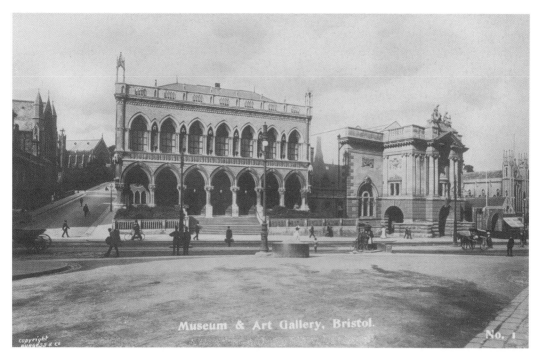

The original city museum, now a restaurant, is on the left of this postcard view. The neighbouring building now houses the combined Museum & Art Gallery.

After the King and Queen had dined at the museum in 1908, after opening the Royal Edward Dock at Avonmouth, some 20,000 people toured the building just to see the decorations that had been installed for the benefit of the royal couple. Their visit caused the council to close the museum for a fortnight so that it could be cleaned and decorated.

The art gallery became so popular, with visitor numbers fluctuating between 200 and 400,000 every year, that it had to be enlarged in 1930; once again the Wills family enabled this to happen. By now Bristol Art Gallery was regarded as such an important institution in the country that Sir William Llewellyn, president of the Royal Academy, decided to open the extension and give the inaugural speech.

Early art collections were built up mainly through gifts by generous Bristolians and with purchases from local collections. It was not until 1922 that regular purchasing funds came into being through the H.H. Wills Fund. There was a major boost when the Bristol City Council voted in 1946 that the rates should provide an annual grant. When Sir William Wills died in 1911 his niece gave up her life interest in his paintings so that they could be given to the gallery.

Medieval and Georgian Bristol can be rediscovered in the paintings of the Bristol School of Artists, the most well-known being Francis Danby (1793-1861). Their landscapes of the Avon Gorge are on display in the gallery.

The museum next door was extensively damaged in an air raid in 1940. Its surviving collections were moved into the Art Gallery to form what is now known as the City Museum & Art Gallery. On display is everything from monetary curiosities, such as an early coin minted in Bristol to a replica of the 1910 Bristol Biplane or 'Boxkite', built at the Filton aircraft works, and suspended from the ceiling of the main hall. There is also a stuffed gorilla which used to be Alfred, one of Bristol Zoo's most popular residents.

After it was bombed the old museum building was bought by Bristol University and rebuilt as a refectory and senior common room. It is now a restaurant.

NURSING HOME

The uninterrupted view of greensward with sheep grazing was probably a relaxing tonic for the ninety patients at one particular hospital. They could have been in the countryside but the Queen Victoria Jubilee Convalescent Home was on the edge of the Downs, just two miles or so from the centre of industrialised Bristol with its bustling docks, shipyards and metal-bashing workshops.

This elegant building had been a private school and was bought for £20,000 by Sir E.P. Wills and adapted to meet the needs of a convalescent home. It was equipped with steam laundry and all the necessary arrangements for steam heating and cooking, and furnished at a cost of about £10,000. The alterations were largely funded by public subscription as a tribute to Queen Victoria's sixty years on the throne. The citizens of Bristol were so generous that by the opening day £100,000 had been donated or promised. It was the monarch herself who was asked to officially open the hospital. On the appointed day, 15 November 1899, Bristolians welcomed her with much style. From the moment she stepped off her train at Temple Meads station she found every street through which her carriage passed was decorated with golden eagles carrying laurel wreaths and hundreds of elaborate floral arrangements. The royal procession to the Downs included nine carriages, mounted police and soldiers.

As part of the celebrations there was a fireworks display which cost £300. Another £1,500 was set aside for medals and refreshments for 60,000 schoolchildren, many of whom lined the processional route. On the Downs, the Queen was welcomed by a choir of 26,000 children singing the *National Anthem*.

However, Queen Victoria did not leave her carriage to carry out the official opening ceremony. Instead, she pressed a button to which an electric wire was attached. The next morning the *Western Daily Press* reported, 'This brought into operation an electric-magnet with sufficient power to raise a clutch on a door and the released door flew open. The same current set going the turret clock'. The Queen was reported as describing the new building as 'noble' although she had not set foot inside it.

For her efforts she was presented with a gold and jewelled paper weight, enamelled with her coat of arms, her monogram, Bristol's coat of arms and a view of the Council House, then in Corn Street.

Having declared the hospital open Queen Victoria returned to Temple Meads for the journey back to Windsor Castle but the celebrations in Clifton continued well into the night. The suspension bridge was lit by some 3,000 light bulbs, and a reception for 1,000 invited guests was held in the Victoria Rooms. Many people had private parties in their homes.

During the First World War the convalescent home served as a military hospital, and later still it became a maternity hospital until a new one was built on St Michael's Hill. The building, now known as Queen Victoria House, still looks as elegant as it ever was although inside the hospital beds have been replaced by work stations and computer keyboards for office workers.

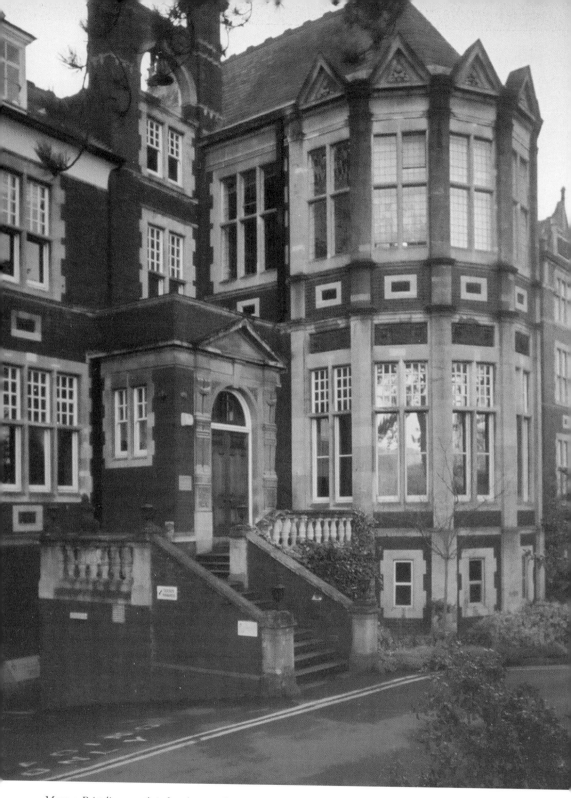

Many a Bristolian saw their first dawn at Queen Victoria Hospital.

OBSERVATORY AND CAMERA OBSCURA

Clifton Observatory and Camera Obscura stands on the site of an Iron Age camp which was also used by the Romans as part of their system of fortification. This round stone-built tower, overlooking the suspension bridge, must be one of the city's most unusual buildings. Strategically placed on the highest piece of land in the city at 337.8ft above sea level, it was originally a windmill built by James Waters on land that he leased from the Society of Merchant Venturers. This was his family home until the mill was burnt down in 1777, apparently, the sails having been overdriven in a gale.

The building remained derelict until 1828 when local artist and amateur astronomer William West rented the ruins for 5s a year. He built a house on the spot and rebuilt the tower. West fitted this up with telescopes, a wind gauge and various astronomical instruments. At the top of the tower he installed a camera obscura with 5in-diameter lens and a mirror. This still reflects a 360-degree panoramic view of Clifton taking in the Avon Gorge, the suspension bridge and even people passing by, onto a white 5ft-diameter bowl-shaped viewing table in a darkened room below. A 1930s advert said that, 'to the unaccustomed the camera obscura has a magic effect and affords a high gratification to the observer'. It is thought to be the only one in England open to the public.

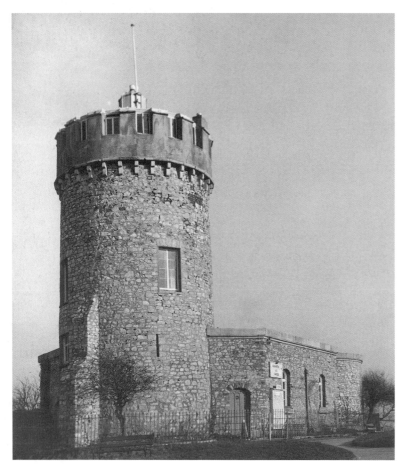

The Clifton Observatory and Camera Obscura on Clifton Down.

The entrepreneurial West excavated a passage underneath the observatory to create a link to a cave which overlooks the Avon Gorge, and commands an extensive view. This 200ft-long passage, which took two years to blast through, was opened in 1837. When West reached the rock face of the gorge he built a viewing platform which is still a popular attraction.

A chapel dedicated to St Vincent once stood near this spot. It was described by William Wyrcestre, a fifteenth-century Bristol-born writer, as being 27ft long and 9ft wide. Wyrcestre, who travelled around England measuring churches and streets, said that the only access was by way of a 'steep and perilous path' down the cliff face. It took him '124 paces to reach the cave'. The cave may have once been occupied by a hermit.

William West died in 1861 but his relatives continued to live at the observatory until 1943. The Merchant Venturers have since sold it and recently the building was undergoing a privately financed restoration.

In 1840 the land around the observatory was the scene of excavations by the Merchant Venturers who were planning to construct a reservoir, supplied by a spring, to supply the people of Clifton with water. The Merchants, however, abandoned the idea and sold the spring to the newly formed Bristol Waterworks Co. for £18,000.

OPEN DOORS DAY

This is the day – usually in the second weekend of September – when some of Bristol's hidden historical treasures, many featured in this book, unlock their doors to the public. Bank buildings with fine architectural interiors, churches, offices in restored Georgian houses and even a retirement home put out the 'welcome' mat. Bristol was one of the first cities in 1994 to stage this scheme that has now been adopted nationally. In its first year just twenty-eight buildings took part, now the number is well over double that.

The main attraction, of course, is the opportunity to get beyond doors which are normally closed or into parts of buildings which are not usually public areas. The imposing late-Victorian Gothic Great Hall of Bristol Grammar School in University Road has become a popular attraction. Once up to eighteen classes would be taught here at the same time. The late nineteenth-century church on the opposite side of the road which has been home to the Orthodox community since 1967 is also open. Visitors can see Russian and locally made icons. Not far away in Tyndall Avenue, is Royal Fort House, one of the finest Georgian houses in the city with outstanding plasterwork on its walls and ceilings. The Old Baptist College in Woodland Road, with its splendid Arts and Crafts interior, welcomes visitors, too. It was designed by local architect Sir George Oatley and it is now part of Bristol University.

There is also access to the top station of the fascinating Clifton Rocks Railway next to the Avon Gorge Hotel. Over on the Downs there is a chance to see St Monica's retirement home, with its chapel, hall and 23 acres of gardens. It was founded in the 1920s by H.H. and Dame Monica Wills as sheltered housing for the elderly and disabled.

It is not just access that curious visitors are given but also guided tours, printed information and the like. Open Doors Day is organised by the Architecture Centre, Bristol City Council and Business West with sponsorship from local firms. It has become a massively popular event with an estimated 50,000 people visiting the various sites in 2006.

ST PAUL'S CHURCH

The original church on this site in St Paul's Road was consecrated in 1853 but was almost totally destroyed by fire three years later. It was rebuilt by the architect Charles Hansom in Early Decorated style. He finished it in just one year at a cost of about £7,000. It was consecrated in a special ceremony by the Bishop of Gloucester and Bristol. The stained glass windows were gradually added up to the middle of the twentieth century.

An interesting feature of the church is the mosaics which are really memorials. One of them recalls W.K. Thomas, who died in 1927 having served as a church warden for thirty years, sidesman for twenty-seven and a chorister for sixty. Another worshipper who was a member of the choir for thirty years is remembered in another mosaic.

St Paul's church is one of the most popular in Clifton and is now used by the University of Bristol chaplaincy.

POOH CORNER

For many years lovers of A.A. Milne's creation, *Winnie the Pooh*, had their own special corner of Clifton. This was the cake shop and tea garden at No. 1 Wellington Terrace, affectionately known by its customers as Pooh Corner, after a painting of the bear that was prominently placed over the entrance. The oil painting, oval in shape, 3ft tall and just over 2ft wide, was the work of E.H. Shepherd, illustrator of Milne's Pooh books. It is said that he painted it especially for the café around 1930. He depicted Pooh with bees buzzing around his head peering into a pot of honey. The café closed in the 1950s and since then the building has been private accommodation.

For a while the painting seems to have disappeared but it has turned up in auction houses three times since 1977, the last in 2000. A private buyer successfully bid £124,000 for it.

Wellington Terrace consists of just eighteen properties which open out onto a raised pavement about 20ft above street level. For many years there was a mix of residential accommodation, shops and public houses. Two pubs, the Gaping Goose, now a house, and the Portcullis, where pints are still being pulled, were doing business almost next door to each other in the 1820s.

PRINCESS VICTORIA STREET

This busy thoroughfare is the hub of what estate agents like to call 'Clifton Village'. *Mathews' Bristol Directory* of 1877 lists the eastern part of the road as Victoria Street or Lower Nelson Place, and that nearest to the bridge as Princes Place (not to be confused with nearby Princes Buildings). It is now named after Princess Victoria who visited Clifton when she was eleven years old.

It has long been a mix of homes, shops and commerce. At the start of the twentieth century it was the saddler, the basket maker, the livery stables and the independent greengrocer who traded here. Their premises have largely been converted into coffee bars, off-licences and restaurants. It seems to be a case of history repeating itself for Princes Place once had five public houses or taverns including the Suspension Bridge House. In the 1970s this hostelry became a restaurant run by Keith Floyd before he gained fame as a television chef. Further along on the same side of the street, Nelson House, now a private residence, recalls an inn of that name that once stood there.

The building that housed Christ Church School for more than a century is now Clifton Public Library. The school's name can still be seen carved in stone on the façade. The wine bar that curves

around the end of Princess Victoria Street into Clifton Down Road maintains an unbroken link with the liquor trade dating back to at least 1886 when wine merchants Charles Tovey & Co. were in business there. One of Bristol's best known wine shipping firms, Morans, took over the premises from 1928-1950 trading as the Quadrant Wine Co. The firm's boss, Bertie Moran, was listed as proprietor. It later became a public house, and it is now owned by the Small Pub Co.

In today's society of supermarkets and shopping malls it is difficult to believe that when Clifton's first supermarket opened in Princess Victoria Street in 1959 it brought a storm of protest from local people. Newspapers devoted many column inches to the row that erupted when the Bristol-based Gateway Stores announced that it was bringing a 'self-service one-stop shopping experience' to the suburb. One woman was quoted in the *Western Daily Press* as saying, 'We don't want one of those dreadful supermarkets here'. Another told the paper's reporter, 'It will spoil the atmosphere of Clifton', and someone else protested that 'price-cutting by supermarkets was rather vulgar'. Other housewives wanted the store's manager to know that, 'Clifton ladies like to take their time when they shop, and that they like their orders delivered, and like having an account. None of these services could be offered by a supermarket'. One trader who ran a second hand furniture store weighed into the debate saying, 'With the duchess upstairs and the charwoman in the basement, Clifton is as near to Chelsea as you can get outside of London. Thank goodness it's not suburban'.

Despite the protests the supermarket opened and its check-out operators are still being kept busy serving Clifton shoppers.

QUEEN ELIZABETH'S HOSPITAL

Little could John Carr, a prosperous merchant and soap maker, have envisaged that the school he founded in 1586 would still be running more than 400 years later and maintaining the traditions that were set out in its early days.

His school has moved three times with its present premises being built in 1847 on a prestigious 4-acre site on a slope of the Brandon Hill. Despite problems with the excavation of rock and soil the architect took advantage of the slope by creating a dramatic flight of steps to his mock-Tudor edifice with its impressive 400ft frontage. The school partly stands on what 700 years ago was a Jewish cemetery. Some of the gravestones have been used in the base of the building.

When Carr died at the age of fifty-two he left a substantial legacy for the purpose of providing an, 'hospital or place for bringing up of poor children and orphans'. His will directed that the 'hospital' should be run after the manner of Christ's Hospital, London, and made the Mayor and commonalty of Bristol, 'patrons, guiders and governors of the said hospital for ever'.

Queen Elizabeth I granted the school a charter on 21 March 1590 confirming its title and rights. Her charter includes the school motto, *Dum tempus habemus operemur bonum* (While we have time, let us do good) and ends with the words, 'The hospital shall be everlasting and shall be named after her' (Elizabeth I). An illustration on the charter shows the Queen, enthroned, delivering it to the Mayor and aldermen of Bristol who in their scarlet robes are knelt before her. A number of boys in school dress are also depicted. The school was also privileged to have been granted by the College of Heralds its own coat of arms

This historic document is in safe keeping in the office of the QEH governors. The granting of it is commemorated at a special Charter Day service in Bristol Cathedral each spring. This is an occasion when the public can see the school's boarders wearing traditional dress of long bluecoats, yellow stockings and highly polished buckle shoes. Both the charter and the coat of arms are on show on Open Doors Day in September.

Queen Elizabeth's Hospital maintains close links with the Lord Mayor's chapel. By tradition it provides a choir for special civic occasions including the special service on Mayor Making Day each May.

RODNEY PLACE

This terrace of houses near Christ church was built in the late eighteenth century and is named after Admiral George Brydges Rodney. He had led the British Navy to a victory over the French at the Battle of the Saints, off Dominica during the American War of Independence. This saved Jamaica from invasion and thus protected the interests of the Bristol merchants. When Lord Rodney visited Bristol to receive the Freedom of the City he was greeted by a torchlight procession.

The terrace has had some eminent residents. Dr Thomas Beddoes, who was running the Pneumatic Institution down the hill in Dowry Square at Hotwells, lived at No. 3 Rodney Terrace from 1798 until 1805. He conducted various experiments at his Institution and was using wind from cows to treat tuberculosis. Beddoes employed Sir Humphrey Davy, inventor of the miners' safety lamp at his Institution. Davey also resided at No. 3.

It was here too that Beddoes' son, the romantic novelist Thomas Lovell Beddoes was born in 1803. His aunt, the novelist Maria Edgeworth, was a regular visitor from her home in Princes Buildings.

A plaque on the façade tells us that John Lambton, the first Earl of Durham and one-time High Commissioner and Governor-General of British North America, also lived at No. 3, as a one-time pupil of Beddoes. One of Lambton's reports inspired the subsequent British Colonial policy.

Rodney Place.

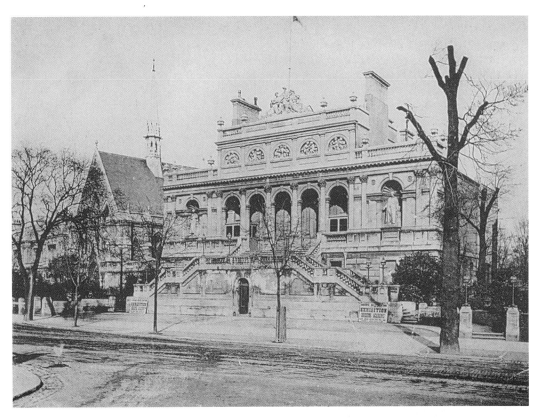

The Royal West of England Academy in its early days when it was known as the Bristol Fine Arts Academy.

ROYAL WEST OF ENGLAND ACADEMY

On her death Ellen Sharples left Bristol a magnificent memorial. This is the building with the Italianate façade on Queen's Road, almost rubbing shoulders with the Victoria Rooms. It is the home of the Royal West of England Academy, Bristol's first art gallery. Four years before she died Mrs Sharples, an amateur artist, gave £2,000 towards the cost of building an academy, originally known as the Fine Arts Academy. In her will she bequeathed another £3,645 as well as nearly 100 pictures, enabling the academy to open in 1858.

The life-story of Mrs Sharples could well be the stuff of novels. She was born in Bath and attended an art class where she fell in love with her tutor, James Sharples, and married him. They emigrated to America where they stayed until his death, when Ellen returned to England with her children and settled in Clifton. They had various addresses including Sion Spring House, opposite the site of the Clifton Rocks Railway, St Vincent's Parade, Hotwells, and Canynge Road, where a plaque outside records that the mother and daughter artists lived there between 1821-1832.

Land for the academy was bought from the Tyndall family, founders of the Tyndall Estate which covered much of east Clifton before it was sold off for Victorian housing. The academy was altered in 1911 when two flights of balustraded steps either side of the main entrance were removed, a new foyer built, and the building extended. King George V visited the academy in 1913 to acknowledge its enlargement and to grant it a royal charter. The academy's royal

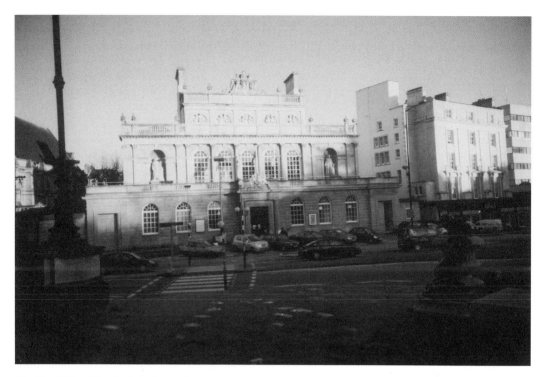

The Royal West of England Academy today.

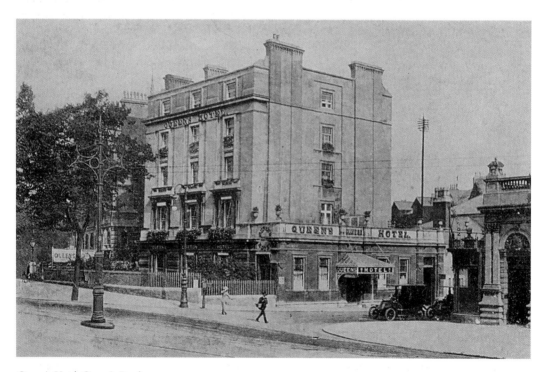

Queen's Hotel, Queen's Road.

connections though go back much further. It can proudly boast that Queen Victoria's consort was a member himself through subscription. Indeed, he was the academy's first life member

Ellen Sharples daughter, Rolinda, is best known for her scenes of Bristol's social life in the nineteenth century. Her first major work was *The Cloak Room, Clifton Assembly Rooms*, which she completed in 1818. Other paintings show the annual St James Fair and horse racing on Durdham Downs. Some of Rolinda's works can be seen in the Bristol Museum & Art Gallery.

The academy now houses a large and fine permanent collection, stages touring exhibitions and mounts an annual show of its members' work. This follows a tradition that started in 1858 and raises Bristol's cultural profile.

A new neighbour for the academy appeared in 1854 when the Queen's Hotel was built on the corner of Queen's Avenue. It later became Church House, the administrative headquarters for the Diocese of Bristol. Eventually it was renamed Beacon House, and it is now the premises of a house furnishing store.

ROYAL YORK CRESCENT

The grand set piece of Clifton must be Royal York Crescent, reputed to be the longest crescent in Europe at nearly a quarter of a mile in length. Work on this prestigious development started in 1791 but came to a halt two years later. This was at the time of the Napoleonic wars which caused a depression, and the developer, along with many others involved in Clifton projects, became bankrupt.

An advert appeared in Felix Farley's *Journal* in 1800 stating that 'the pile of buildings called Royal York Crescent with adjoining land' was being offered for sale. It turned out that no one was interested. However, eight years later the government bought the site, along with the unfinished part of the crescent, with the intention of erecting military barracks. That plan, though, was thwarted by strong opposition from local people. Work later resumed on developing the crescent as homes with the scheme being completed in 1820. The builders turned out to be superstitious folk for they did not include a No.13, preferring No. 12a instead. At one time the crescent had its own beadle who, by all accounts, discouraged outsiders from promenading along the raised pavement.

Eugenie Montijo, later to become Empress of France, and her sister Paca, later Duchess of Alba, lived on the crescent for a while. These daughters of a Spanish nobleman arrived from the family home in Paris to attend a boarding school run at Nos 1–3. This establishment was run by a Mrs Rogers and her daughters. Of her time at Clifton – just three months from April 1837– the young Eugenie said, 'Do not think there are any public amusements here. Everyone stays at home, and one never sees a fashionable man in the street'.

Eugenie returned to Paris and met Louis Napoleon who was to become Emperor of France. The couple married in 1853.

Eugenie's time at Clifton could not have been that bad for she returned to review the scenes of her early life for a couple of days in 1889 when she booked into the St Vincent's Rocks Hotel. Her old school closed in 1855. The building, converted into flats in the second half of the twentieth century, is now known as Eugenie House. Its developers won a Civic Trust Award for their 'sensitive conversion'.

A directory of 1875 gives a breakdown of the occupiers of the houses on Royal York Crescent. The armed services were well represented with a general, a captain and a colonel living there. Their neighbours included two titled ladies, several clergymen and a couple of surgeons. Fifteen

Royal York Crescent.

of the houses were described as lodging places. In the early nineteenth century Messers Carter & Brown were brewing strong beers and ale at their Royal York Crescent brewery.

After the Second World War the crescent had become shabby and rundown. Many of the owners could not afford repairs. Houses were sold off, bought for flats and the whole crescent was gentrified.

STREETS OF HISTORY

What's in a name? Quite a lot it seems when it comes to those of streets. Behind many a Clifton street nameplate lies a fascinating story.

Princes Buildings, for example, originally had a much grander name, Prince of Wales Crescent. This rank of houses, completed in 1800, was named after the Prince Regent, who later became George IV. His feathers and motto *Ich Dien* can be seen on the pediment of one of the houses. Nearby Regent Street was built in the early years of the nineteenth century. W.H. Smith opened their first shop in Bristol here in 1905. Profits for the first seven months were £80. The manager of the shop earned £100 a year and a cut of the profits. A guide book published in the middle of the nineteenth century mentions, 'Here were the first handsome shops erected in Clifton, having plate glass fronts and commodious interiors; it is the principal thoroughfare'.

Canynge Road and Canynge Square both bring to mind the fifteenth-century Bristol merchant prince, William Canynge, who did so much to restore St Mary Redcliffe church, reputedly described by Elizabeth I, as 'the fairest, goodliest and most famous parish church in England'. Canynge was five times Mayor of Bristol.

The Crimean War was the inspiration for the naming of Alma Road and Alma Vale which were built on a deer park. These roads commemorate the famous battle in 1854 which was fought by the River Alma and was one of the more successful campaigns as far as the British were concerned.

All streets with the appellation Pembroke honour the Earls of Pembroke, who in the sixteenth and seventeenth centuries were Lord Lieutenants and High Stewards of Bristol.

Regent Street in 1914.

Generations of Bristolians have known the top part of Whiteladies Road – it was named as such by Bristol Corporation in 1857 – as Blackboy Hill. However, you will search in vain for a street nameplate bearing that legend. The colloquial tag for the stretch of road that leads steeply from Apsley Road to the Downs has been in common use since about the 1860s. It is so popular that it can even be found on bus destination boards. The name is thought to have come from the Black Boy Inn which once straddled the road. Whiteladies Road could have been named after a Carmelite nunnery which was once there and whose members wore white robes. Another school of thought says the name came from the thatched White Ladies pub which did brisk business until it was closed after a servant was murdered there in 1749. It stood near the Clifton Down shopping centre and is identified on Donne's plan of Bristol, 1804.

Mortimer Road, near Christ church, recalls Mortimer House, which in the late nineteenth century was the home of the Sheriff of Bristol. By all accounts the house had a plantation and extensive gardens at the rear.

THEATRICAL CLIFTON

The fortunes of two white villas at the top of Pembroke Road overlooking Clifton Downs underwent a dramatic change when they were put up for sale in 1956. Their new owners converted the houses into the Bristol Old Vic Theatre School where the burgeoning talents of some of the country's finest actors have since been developed.

The school's list of graduates reads like a Who's Who in show business including Daniel Day Lewis, Jeremy Irons, Miranda Richardson, Amanda Redman, Brian Blessed, Jane Lapotaire, Patricia Routledge and Stephanie Cole. Many have won top acting awards including Oscars and Tonys, and have achieved an international reputation on stage and screen. Countless others have become directors, designers, casting directors and agents.

The first students were enrolled at the school in 1946 when it was based in several rooms above a wholesale fruit warehouse in Queen Charlotte Street in Bristol's city centre. This was just around the corner from the country's oldest working playhouse, the Theatre Royal in King Street, where the curtain went up for the first time in 1776. A stalwart of the acting profession, Laurence Olivier cut the tape and welcomed the first intake of students.

It was a piece of theatrical serendipity that brought about the school's move to Clifton. A musical, *Salad Days*, which had its premiere at the Theatre Royal in 1954 and later transferred to the West End for 2,288 performances, before moving on to Broadway, was so successful that it provided a financial windfall for the school. This, along with a grant from a charitable trust, enabled the purchase and conversion of two semi-detached Victorian villas at Downside, Clifton.

Dame Sybil Thorndike, accompanied by her husband Sir Lewis Casson, performed the opening honours at Downside in June 1956. Since then the school's reputation has attracted around 1,500 students (not just those who want to tread the boards but also those seeking to work backstage) from all over the world. They are given the opportunity to perform at the Theatre Royal and various other venues across the West Country.

Ever grateful students still perform *Salad Days* as a tribute to its creators, the actress Dorothy Reynolds, and Julian Slade, who at the time was the Bristol Old Vic's musical director.

During its sixty-year history Bristol Old Vic Theatre School has developed and extended its accommodation. It has now acquired more property in Downside, and Jeremy Irons has launched a £4 million appeal to fund alterations.

TRAINS

Tucked away behind a shopping centre and virtually hidden from all but those aware of its existence, is the unprepossessing Clifton Down Railway Station. It was developed on land that was once a nursery and became part of the Clifton Extension Railway. The station was operated jointly by the Great Western Railway and the Midland Railway Companies and for many years was an important travel centre.

Although there was no official ceremony to mark the opening of the station on 1 October 1874 hundreds of people thronged its booking hall. Indeed, there were so many people that the railway clerks had to stop issuing tickets well before the first train steamed away at 9 a.m. The *Western Daily Press* described the £20,000 station's architectural style as 'modified Gothic' and said it was, 'one of the best stations in appearance for many miles around'.

Five years later an hotel hoping to attract business from some of the hundreds of travellers arriving at the station each day, opened next door. The North Clifton Hotel Group invested some £18,000 in building and equipping The Imperial Hotel, complete with a ballroom and public bar.

In the early years of the twentieth century Clifton Down Station was welcoming royalty and international politicians. The Prince of Wales travelled by special train from here to Avonmouth on 5 March 1902. He was officially starting work on a new dock at Avonmouth by cutting the first sod of earth. Five years later a host of overseas prime ministers, including those of Canada, New Zealand and Natal, arrived at the station en route to Avonmouth to see the dock under construction. The Prince of Wales was back in 1908, now as King Edward VII, when he was accompanied by Queen Alexandra. The royal couple arrived at the station in a horse-drawn carriage after a tour which took in the city centre, Park Street and Whiteladies Road. The King was on his way to declare the Royal Edward Dock officially open.

Clifton Down Station decorated for the visit of King Edward VII in 1908.

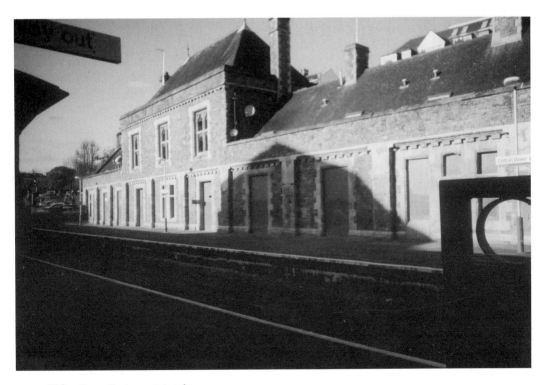

Clifton Down Station as it is today.

Clifton Down was one of the busiest suburban stations in Bristol with thousands of holidaymakers leaving here for Weston-super-Mare on the north Somerset coast. During the 1950s and 1960s more than 300,000 day-trippers, many from South Wales, arrived at the station on the so-called 'monkey specials'. They were on a day trip to the zoo and botanical gardens at Clifton.

The station's heyday has long gone. A combination of various factors including the growing popularity of the motor car and the opening up of motorways led to a decline in the number of travellers using it. Redevelopment of its extensive site came in the mid-1960s when part of it was decked over with prefabricated units as part of a half-a-million pound scheme to build the present Clifton Down Shopping Centre. A block of flats was erected on the site of the goods yard which had been used mainly by wagons carrying coal. The original waiting room, ticket office and station master's house have since served as a night club, fittingly called Platform One, and are currently part of an Australian theme pub. Trains still call at this unmanned station but the services are mainly for commuters making their way to the mainline rail centre at Temple Meads.

Part of the line goes through a tunnel, just twenty yards short of being 1-mile long, which was excavated under Durdham Downs. Cut through solid limestone rock and with a maximum depth of 165ft, the tunnel starts near the station and emerges near the Portway below the cliffs at the Sea Walls. Two tunnel vents in the shape of towers are on the Downs, one opposite Pembroke Road and the other in woodland at Wallcombe Slade.

The Imperial Hotel has also had a chequered life. In 1915 it was taken over by Bristol University but during the years of the First World War it was used as a hostel for women recruited in the South West to the Women's Auxiliary Army Corp. While there they learnt about army etiquette and discipline and were issued with their uniforms. After the war the building became a hall of

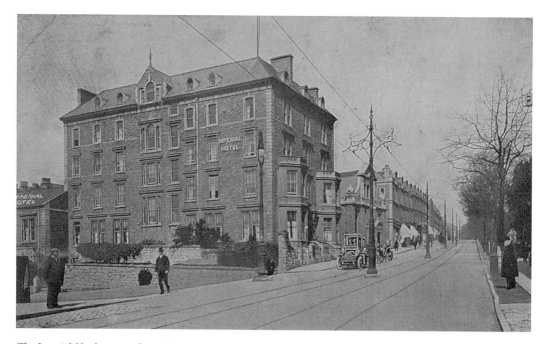

The Imperial Hotel, next to the station.

residence for male students and is now the university's Department of Social Medicine and has been renamed as Canynge Hall.

TRAMS

Bristol Corporation's announcement that the first horse-drawn trams in Bristol would run from Perry Road near the Bristol Royal Infirmary to St John's church on Whiteladies Road, caused consternation in Clifton. The residents feared that hordes of working class people would arrive in the suburb. Churchgoers also objected believing that trams would encourage workers to seek out sinful pleasures.

Despite these concerns Bristol Tramways ran its first horse-drawn tram into Clifton on 9 August 1875. This historic event drew huge crowds and in the first month more than 100,000 passengers had made the journey. Impressed by the response the tramway company extended the service later that year to St Augustine's Parade, which ever since has become known as the Tramway Centre.

Electric trams arrived in the city in 1895 and eleven years later Bristol Tramways & Carriage Co's first motor bus ran on a route from the suspension bridge to the Victoria Rooms via Merchants Road and Victoria Square. The bus had seating for nineteen passengers upstairs, sixteen inside and two beside the driver.

Motor buses were succeeded by electric trams in the city and eventually the network extended to 31 miles around Bristol and south Gloucestershire. It was flexible too for in 1913 the Royal Show was held on the Downs and 225 trams were diverted to take more than one and a half million visitors to it.

UNDERGROUND CLIFTON

Thousands of motorists pass by the Clifton Rocks Railway each day without knowing it is there. This unusual feat of engineering was built, with much difficulty, inside the cliffs of the Avon Gorge in order to protect the spectacular visual impact of its surroundings.

Behind the entrance to the Lower Station on the busy A4 Hotwell Road is a tunnel cut through the limestone rock which emerges near the Upper Station on Sion Hill, Clifton, which was once stables. The railway was the brainchild of wealthy publisher, entrepreneur and MP George Newnes who wanted to provide a luxury form of travel for people wishing to make the journey from Hotwells to Clifton quickly and easily. He was spurred on by the success of his funicular railway running from Lynton to Lynmouth in North Devon.

His 500ft-long tunnel through the Avon Gorge rocks forms a straight and direct connection between the two stations. It rises a distance of 240ft climbing at a vertical rise of one foot for every 2.2ft. It took two years for the builders to blast and cut through the limestone, install the track and construct the stations. This was twice as long as expected and the bill of £30,000 – being paid for solely by George Newnes – was three times the estimated amount.

The water-powered railway opened on 11 March 1893. On its first day more than 6,200 people passed through the turnstiles for the return trip. It took just forty seconds to go from top to bottom. At the end of the first six weeks the railway had become such a popular attraction that more than 100,000 passengers had travelled on it. By the end of its first year of operation 427,492 people had bought a ticket. A through ticket from Clifton to the Tramways Centre in the middle of Bristol, via the Rocks Railway and the Hotwell tram service cost 2d.

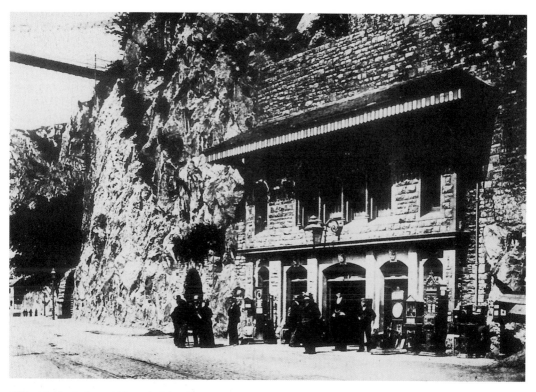

Clifton Rocks Railway at the end of the nineteenth century.

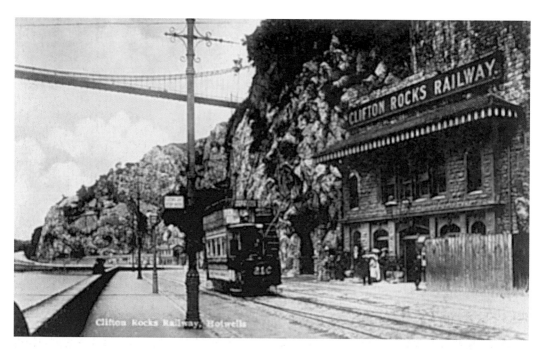

A postcard view of the Lower Station at Hotwells.

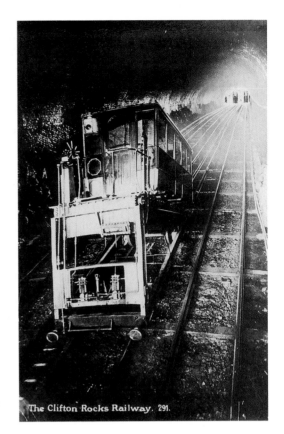

The Clifton Rocks Railway. 291.

Right: *One of the railway's four carriages.*

Below: *The Clifton, or Upper Station of the Rocks Railway is being restored.*

For nearly four decades the light blue and white railway carriages decorated with gold lining, ran their diagonal trip up and down the tunnel. However, the popularity of the railway soon declined. This followed the closure of the Port and Pier Railway (running from Avonmouth to nearly underneath the Clifton Suspension Bridge) severing the train link to the Rocks Railway. The widening of the Portway road made access to the Hotwells Station even more difficult. In 1934 the railway closed and the carriages were lowered to the Hotwells Station and later removed.

But the closure did not mean the end of a useful life for the tunnel. During the Second World War it became a transmission base for the BBC which built its headquarters there in case Broadcasting House in London should be bombed. The tunnel was adapted to provide a recording room, transmitter room and a studio equipped for music and drama productions. To make sure the acoustics were just right the full BBC Symphony Orchestra, nearly 100 musicians in all, were brought to the tunnel and played under the baton of Sir Adrian Boult. The corporation had a lease on the tunnel with rental fixed at 1s a year for twenty-one years. Its transmitter was used as a booster station until 1960 when the BBC finally moved out.

The British Overseas Airways Corporation, later to become British Airways, used the top part of the tunnel for storage, and in an unplanned use, hundreds of Bristolians used part of the tunnel as an air-raid shelter.

This fascinating part of Bristol's industrial and transport history could now be resurrected thanks to a band of volunteers who want to re-open the railway. They envisage linking it up with a ferry service running from Hotwells into the centre of the city. Although it is a project which could cost anything up to £20 million their enthusiasm remains undiminished. The Clifton or Upper Station, which for many years has been a derelict eyesore, is already being restored. It may be that eventually the only underground cliff railway in the world will run once again.

UNIVERSITY OF BRISTOL

This seat of learning has its roots in University College, founded in 1876 in Georgian premises (long demolished) on Park Row, to teach the arts, sciences, law and engineering. Thirty male students and sixty-nine women were registered for the first term. They studied a total of fifteen subjects with two professors and seven lecturers on the teaching staff. Towards the end of the century the college was able for the first time to admit students who wanted to study medicine. This happened as Bristol Medical School, founded in 1833, had become fully incorporated as a faculty of the college. University College rightly took much pride on being the first educational institution in the United Kingdom to offer places to women students on the same footing as men.

Meanwhile, a campaign to get university status for the college was being stepped up. Its inaugural meeting involving many influential and wealthy local families was held in the Victoria Rooms in 1874. The campaign was given a major boost in 1908 when Henry Overton Wills promised £100,000 towards the endowment of a university for Bristol and the West of England, provided a charter was granted within two years of the date of his offer. A charter was, in fact, granted by Edward VII the following year and the university authorities appointed Henry Wills as its first chancellor. One of his successors was Winston Churchill who became chancellor in 1929 and continued in the office for more than a quarter of a century. He was given the Freedom of Bristol by the city council in 1945. It was not until 1971 that the university had its first woman chancellor. Dorothy Hodgkin, who had earlier been awarded the Nobel Prize for chemistry, was chancellor for seventeen years. A university building has been named after her.

The main buildings of the university are still in the triangle bounded by Queen's Road, Woodland Road and University Road although its campus now spreads across a large part of Clifton with nearly 400 buildings. Some of them date back to the mid-eighteenth century.

A distinctive feature of the university's ceremonial dress is that all academic hoods are of a colour known as university red. This is a shade of red that supposedly recalls 'Bristowe red', a bright red dye made in Bristol in the sixteenth century.

The university has expanded tremendously since it first opened its doors in Park Row. With its 11,500 undergraduates and 5,000 postgraduates it is regarded as one of the top research universities in the country. Judging by the number of applications for each place it is generally thought to be the most popular in the United Kingdom for students, both from home and abroad.

VICTORIA ROOMS

Architect Charles Dyer's magnificent Victoria Rooms occupy what must be the finest site in Clifton, looking down from Queen's Road to the university's Wills Memorial Building. It was completed at a cost of £28,000 with all bar £3,000 being contributed by what the local press described as, 'a body of Conservative gentlemen concerned that Bristol has no such accommodation to meet its needs'.

The Victoria Rooms, known fondly as the Vic Rooms, were opened in grand style in May 1842 with a dinner presided over by the Mayor and attended by 300 guests. There was much praiseworthy comment about the façade with its handsome portico, Corinthian columns and pediment carvings. Early prints show that high railings enclosed a broad flight of steps leading up to the building. Fields at the back of the Victoria Rooms were used to put farm animals on show when the prestigious Royal Society staged its annual agricultural exhibition that same year.

It was at the Victoria Rooms that a large part of Clifton (and Bristol's) cultural life was played out. Charles Dickens and Oscar Wilde both visited to give readings of their works while actress Sarah Bernhardt read extracts from some of Shakespeare's plays. On another occasion Dickens also teamed up with novelist Wilkie Collins and brought a company of actors to the Victoria Rooms in November 1851 to perform Lytton's *Not So Bad As We See* and *Mr Nightingale's Diary*. By all accounts they played to a packed house and gave a repeat performance two nights later. The Victoria Rooms, with its main room 118ft long and 55ft wide, made it a suitable venue for banquets. A notable one was held in honour of cricketer W.G. Grace.

The forecourt was redesigned in 1913 to make room for the ornamental fountains and the imposing statue of Edward VII in his coronation robes. He is looking towards the university for which he granted a charter four years earlier.

Unfortunately, the Victoria Rooms were never a financial success. Around 1919 it was converted into the Clifton Cinema, a venture that was only to last two years. Sir George Wills came to the rescue and bought the building for the university so that it could have, 'a common room in keeping with its size and dignity' for the students.

A major fire in 1934 destroyed the main hall including its large and powerful organ which once graced the Panoptican (an early cinema) in London's Leicester Square and later St Paul's Cathedral. In the blaze the roof collapsed and insurance assessors put the cost of repairing the damage at around £45,000. The damage might have been far more serious had it not been for a taxi driver who saw smoke pouring from the building just before 6 a.m. and raised the alarm. Apparently, the fire had started just hours after revellers had left a big dance. Local architect Eustace Button was commissioned to restore the Victoria Rooms. However the organ was omitted from the plans.

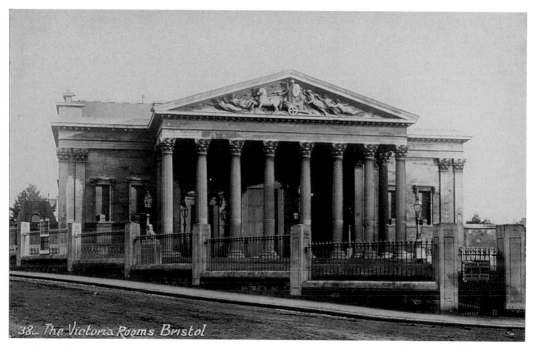

The Victoria Rooms shortly after it opened.

A statue of Edward VII along with fountains now stand in front of the Victoria Rooms.

The building is now used by the University's Department of Music. It fell out of use as a students' Common Room in the mid-1960s when a purpose-built students union was constructed further along Queen's Road.

ST VINCENT'S PRIORY

Its name conjures up visions of an ancient religious foundation with its hallowed walls echoing to the sounds of monastic chanting. But St Vincent's Priory is a private house and the likelihood is that it was built as such and probably conceived as an architectural folly.

However, the property gained a certain amount of fame around the mid-1970s when its then owner, George Melhuish threw open its doors to visitors. Mr Melhuish, a writer, artist and philosopher, claimed that it was the smallest private house open to the public who were able to view his paintings and furniture.

His official guide to the house on Sion Hill, opposite the Avon Gorge Hotel, informed visitors:

> The façade is noteworthy for its many bays and numerous sculptures. The upper ground floors traditionally gothic windows are crowned with four sculpted stone caryatid figures. These strange cavorting figures are similar to some small carvings in St Mary Redcliffe church; they support the largest of the bays. The second floor bay is crowned by four small sculptured wood figures of somewhat grotesque appearance. Gables above the roof support elaborate crosses on the centre of the side wall of the house and on the façade.

Mr Melhuish bought this gothic five-storey revival house in 1967 for £3,495 and lived there until his death in 1985. He left his home to Bristol City Art Gallery & Museum which declined the offer, saying that it did not fit into their plans.

Its owners since then have taken great care to restore the house very carefully and have made the most of the period features, although it is no longer open to visitors.

St Vincent's Priory was built around 1810 and legend has it that it stands on top of caves which were once a Christian sanctuary.

In the mid-nineteenth century the house was owned by Tom Provis, a convicted horse thief, who tried to convince a jury at the old Gloucestershire Assizes that he was the true heir to Ashton Court Mansion and all its lands on the other side of the Avon Gorge. The court did not believe his claim and Provis was transported to Australia for twenty years.

WARTIME CLIFTON

There is one corner of Clifton where the American flag can always be seen flying each 4 July – Independence Day. It proudly recalls the major role that Clifton College played in the planning for Operation Overlord, or D-Day as most people know it.

During the early years of the war, with Bristol being extensively bombed, the headmaster evacuated most of the boys and staff to Bude in Cornwall and Butcombe in Somerset. In their place came Gen. Omar Bradley and the United States First Army in October 1943. Their mission was to plan the massive invasion of the Normandy beaches.

Gen. Bradley used the housemaster's drawing room in School House as his own office. With his team he turned the college's Council Chamber into a top secret war room packed with maps,

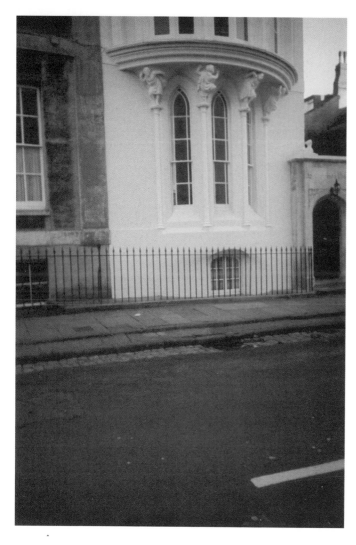

St Vincent's Priory with some of its sculptures.

troop dispositions and other military data. Operations and intelligence officers were based in and around the college's Wilson Tower, where technicians received interceptions of Nazi radio messages.

As D-Day approached the general called his staff together for their last ever meeting at the college. The corps and division commanders met in the Council Chamber Room while the headquarters staff gathered in the college chapel.

Away from military duties the Americans found time to make use of some of the college's sporting facilities. Its famous cricket pitch, The Close, was used for a baseball match when one of the spectators was Queen Mary who was staying with the Duke of Beaufort at his Badminton estate in south Gloucestershire during the war.

Before he left the college Gen. Bradley gave the stars and stripes flag which had flown from the Wilson Tower, to a small group of preparatory school boys who had stayed at Clifton during the war. The flag has become a treasured item and is kept in a locked display case – only brought out to be flown on Independence Day.

During the war Bristol became the fifth most heavily bombed city in the country. Little was written about it at the time and the reports that did appear in the newspapers about bombing attacks on the city referred to it as a 'town in the West Country'. Across the town 1,299 people were killed and a further 3,305 injured. Nearly, 90,000 properties, including 9,000 homes, were damaged or destroyed. A major attempt to consume the city by fire came on the night of 24 November 1940 when its main shopping thoroughfares in the Castle Street and Wine Street area were totally wiped off the map.

A report prepared by the Air Raid Precautions Committee said that in the Clifton division, buildings and streets destroyed included the museum and part of the art gallery, parts of the university including its treasured Great Hall, the nearby Prince's Theatre, St Anselm's church on Whatley Road, Clifton Parish church, Bristol Grammar School's Preparatory School, Freemason's Hall in Park Street and the Triangle Picture House. St Anselm's church was never rebuilt; a health centre now stands on the site. The picture house on Triangle West was replaced by shops.

The report said, 'Shopping districts presented scenes of indescribable desolation. Lennard's building (on The Triangle) and many premises in Queen's Road became nothing more than heaps of rubble'. There were many air raids during which homes in Cornwallis Crescent, Royal York Crescent and Pembroke Road, among others, were extensively damaged. A department store, garage and other properties on the corner of Regent Street and Merchants Road were brought down to the ground by a high explosive bomb. The roof of the Pro-Cathedral in Park Place was also struck.

WEST OF ENGLAND HOME SERVICE

It was a quiet autumn afternoon in the 1930s when two officials from the BBC were walking around Clifton looking for suitable premises which could be converted into radio studios. They spotted an empty villa on the corner of Whiteladies Road and Tyndalls Park but it being a Sunday no estate agents were available with a bunch of keys. So the intrepid executives made their way into the building through a coal cellar. They liked what they saw and the rest, as the saying goes, is history.

Although this villa became the cornerstone of BBC broadcasting in the West Country, it had earlier been making programmes in a temporary studio above a bank not far away in the commercial and shopping area known as The Triangle.

The programmes produced in Bristol came under the banner of the BBC's West Region of the Home Service. However, the name seemed a bit of a misnomer for it covered what must have been one of the biggest geographical areas in the country. The news bulletins carried stories from an area stretching from the Forest of Dean in Gloucestershire across to the villages on Salisbury Plain in Wiltshire, down to the south coast at Brighton and over the English Channel to the Isle of Wight.

One of the first radio broadcasters at Whiteladies Road was John Betjeman, at the time an architectural critic. He later described the studio as, 'rather like a dentist's house in a provincial town'. Betjeman talked on air about the heritage and changing fortunes of West Country towns. He went on to make numerous broadcasts from these studios and later became a familiar face on both regional and national television. Betjeman was later appointed poet laureate and was also honoured by the Queen with a knighthood.

Over the years neighbouring houses in Whiteladies Road and Tyndalls Park Road were acquired by the BBC to provide space for its growing radio and television projects. The rapidly expanding site became the headquarters of the corporation's internationally renowned Natural History Unit.

The Clifton studios quickly gained a reputation for being a hotbed of talent. The microphone made household names of broadcasters like Derek Jones and Alan Gibson who, arguably, were amongst the earliest disc jockeys with their Saturday morning chat and records programme. Derek Jones was also known for his natural history programmes and Alan Gibson for his cricket commentaries. In the 1960s and 1970s the television cameras made personalities of people like antiques expert Arthur Negus and animal lover Johnny Morris, best known for his walks around the grounds of Bristol Zoo. Johnny was the creator and presenter of *Animal Magic* for twenty-one years; the first big television hit show featuring animals. He also became known as 'the hot chestnut man' for the televised stories he told youngsters while he stood beside his chestnut stall.

The BBC's West Region as such eventually disappeared with the introduction of local radio stations across the country. BBC Radio Bristol went on the air for the first time in September 1970 broadcasting from a converted house in Tyndalls Park Road.

WHITELADIES PICTURE HOUSE

The Whiteladies Picture House on Whiteladies Road was one of the busiest cinemas in Bristol. It was not only families from Clifton and neighbouring districts who queued to see the famous Hollywood film stars on celluloid, but people from all across the city.

Building work started early in 1921 and it was completed by November of that year. It stood on the site of an old nunnery but immediately before conversion into a cinema the building was the home of the Young People's Evangelistic League.

The Whiteladies Picture House.

The picture house was officially opened in a blaze of publicity by the Duchess of Beaufort who was joined by the Archdeacon of Bristol, and a minister from the Free Church. The morning newspaper The *Bristol Times and Mirror*, reported that The Whiteladies had the largest auditorium in the West of England. There were seats for 1,016 people on the ground floor and another 282 in the balcony. Its impressive foyer featured ten columns of marble from Italy and a marble staircase lined with mahogany panelling. According to the newspaper there were:

> many features of beauty and interest including the walls which were embellished with carvings and sculptured cherubs ... the whole of the interior is decorated in dainty colours, reminiscent of a bright day in autumn, all the decorations being specially designed for the building by the Bristol architects Messrs. La Trobe and Weston.

They had designed not just a cinema but an early version of a leisure complex for it included a café which prided itself on serving luncheons, teas and dinner and there was even a 'grand' ballroom. The development had been financed by a consortium of local businessmen.

By 1978 the picture house was owned by the national chain, Associated British Cinemas. Around this time the big cinema operators were starting to turn their houses into what became known as multiplexes – buildings with two or more screens. The Whiteladies was no exception with its balcony being converted into a mini-cinema while the ground floor was revamped to make room for two screens.

The owners claimed in 2001 that the cinema was no longer viable and the film projectors were switched off for the final time. This was the last of Bristol's pre-war cinemas to be shut down.

The Grade II Listed Building, once one of more than forty cinemas in the city remains boarded up. Much of the original building, including its plaster work and decoration, is believed to be intact. Local people have been enthusiastically campaigning for the cinema to be reopened but the future of the building is still in doubt. Its original name can still be seen carved on the tower above the entrance.

WILLIAM WATTS AND WINDSOR TERRACE

No one knows for sure how William Watts came to invent a new method of making lead shot, although legends abound. One of the most engaging is that he conceived the idea of making totally round shot in a dream. It involved pouring molten lead through a perforated pan from a great height so that it fell into cold water. When the fragments of lead congealed they became perfectly spherical. Watts is said to have carried out early experiments with his wife's kitchen colander and finding it successful took out a patent.

What is known for certain is that Watts turned his home on Redcliffe Hill, opposite St Mary Redcliffe church into the world's first lead shot tower, taking off the roof, adding a castellated tower and excavating a pit. Eventually he sold his patent to the founder of the Bristol Brewery for £10,000. Production of lead shot continued and Watts' tower was a landmark for nearly two centuries before it was demolished in 1969 to make way for road widening.

With his new-found wealth Watts, like so many other entrepreneurs at the time, decided to dabble in property development in Clifton. The fact that he had no building experience – he was a plumber by trade – did not seem a setback to him. His plan was to build a terrace of up to twenty homes on land jutting out from the lofty rocks above Hotwells. Watts started work in 1790 on the development he called Windsor Terrace but the precarious nature of the site, a

The great retaining wall of Windsor Terrace.

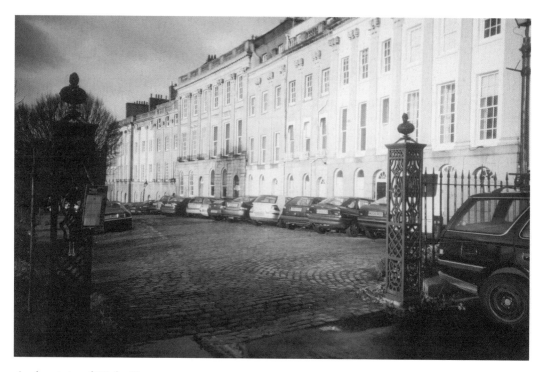

An elegant view of Windsor Terrace.

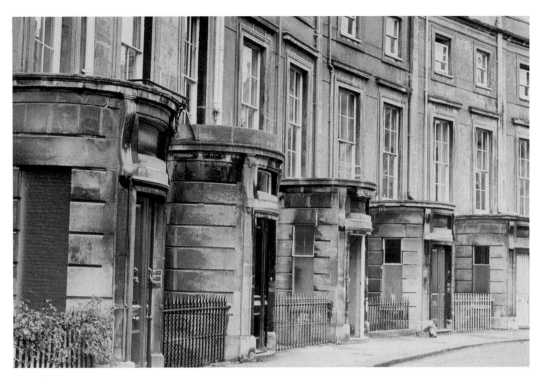

Houses in the Paragon with their curved porches.

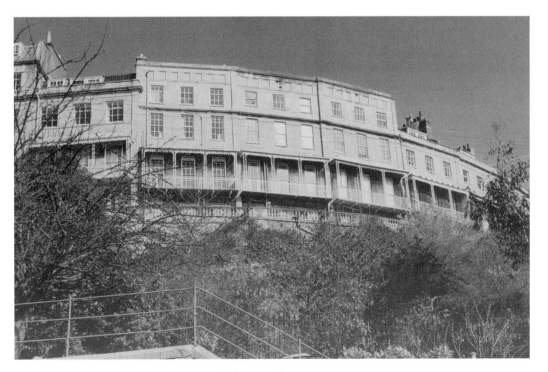

The Paragon stands on an escarpment overlooking Bristol.

promontory high above the River Avon, meant that massive foundations had to be built. This included a 70-ft retaining wall and vaults beneath the terrace. An advert in Felix Farley's *Journal* appealed for, 'Masons and Quarrymen willing to contract by the perch for building a Capital Wall, near the Hotwells, to put their proposals to William Watts by August 14, 1790'.

The work of building the foundations was so costly Watts was declared bankrupt with his terrace unfinished. His retaining wall became known as 'Watts Folly'. Other developers came upon the scene. Nos 5 and 6 Windsor Terrace were built to a design of John Eveleigh of Bath. John Drew of Clifton built other houses to a reduced scale.

He also designed the Paragon nearby, one of the most unusual streets in Clifton, if not the whole of Bristol. The houses have distinctive and elegant, deeply-curved stone porches. A writer of 1872 described this backwater as 'a semi-circular range of houses'. He said that from its spectacular position high up on the escarpment one could view, 'the most delightful scenery of Leigh Woods and the packets plying to and fro'. The packets may well no longer be on the river but the view is still stunning and the Paragon lives up to its dictionary definition of 'a model of perfection'.

WILLS MEMORIAL BUILDING

It is hard to imagine what Bristol would be like without the majestic 215-ft high Wills Memorial Building standing sentinel-like on the edge of Clifton and towering over Bristol. This mock-Gothic building might be the centrepiece of Bristol University's campus but it is also a memorial to one man.

The tower owes its origin to two brothers, Sir George and Mr Henry Herbert Wills, of the tobacco family, who wanted to mark the generosity of their father. It was a gift of £100,000 from Henry Overton Wills that enabled University College, as it was then known, to be granted its charter in 1909 and become the University of Bristol.

Local architect, George Oatley, was employed to build the monument. His design was inspired, apparently, by a dream in which he saw a tower on a hill with shields all around it. Once at his drawing board he took three short weeks to come up with his plans – and that was only working at night. His idea was to provide around fifty rooms in the tower as well as the magnificent Great Hall – probably best known for the degree ceremonies held there each spring and summer – a library, reception room and council chamber. The degree ceremonies are primarily occasions for students and their families who can be seen afterwards posing for photographs outside the Wills Memorial Building. George Oatley gave the tower's imposing entrance hall a magnificent twin staircase. He crowned the building with an octagonal belfry, which houses Great George the sixth largest bell in the country. Weighing nearly 10 tons it sounds the hour and is tolled on the death of monarchs and university chancellors. Great George is only manually swung on special occasions like the centenary birthday of the late Queen Mother, on her death in 2002, and again on the death of Diana, Princess of Wales in 1997. The bell was cast at a foundry in Loughborough and was so big that two lorries were needed to carry it to Bristol. When it eventually arrived after a twenty-four-hour journey, it took workmen sixteen hours to lift it into position.

Construction work on the Wills Memorial Building started in 1914 but was interrupted by the First World War. Work resumed in 1919 and was completed in 1925 at a cost of £501,566 – five times the original budget. On the side of the tower are nine shields representing well known Bristol families, including, of course, the Wills.

Roads around the university were packed as thousands of Bristolians turned out to see King George V and Queen Mary officially open the tower in June 1925. After being welcomed by the

Towering above the city – the Wills Memorial Building.

chancellor, the King described the new building as a 'conspicuous and beautiful landmark'. He said it was a 'great gift so nobly bestowed' which should be 'worthily used for the advancement of learning'. After officially declaring the Wills Memorial Building open, the royal couple were entertained to lunch at the Victoria Rooms.

A proud university saw it not just as part of academia but as a major contribution to the city landscape, and for the next three days it was thrown open to the public.

The King and Queen leaving Bristol University.

The Great Hall was badly damaged by an incendiary bomb on the night of 24 November 1940. Sir Winston Churchill, then chancellor of the university stood among the ruins and prophesised its rebirth. Thanks to Lord Dulverton of Batsford, formerly Sir Gilbert Wills, he was right. Enough prime oak to restore the hall was obtained by Lord Dulverton enabling work to begin in 1959. The task was so great that it was another four years before the Great Hall was restored to its almost original splendour.

George Oatley was knighted for his work and further recognition came from the university itself which conferred an Honorary Doctor of Laws degree on him.

ZOO

The list of founders of Bristol, Clifton, and West of England Zoological Society, to give the organisation its full title, reads like a who's who of eminent Bristolians in the Victorian era. Among those on the list were Isambard Kingdom Brunel, members of the Fry's chocolate and Wills tobacco families, the Duke of Beaufort, and Sir John Smyth of Ashton Court Mansion. Altogether there were 220 private subscribers whose aim was to promote what they described as 'the diffusion of useful knowledge' as well as 'affording rational amusement and recreation to visitors'. Most of the subscribers bought one share at £25 to make their pet project become a reality.

Originally, land for the zoo was earmarked at Arnos Vale, to the south-east of the city, but that site became a cemetery instead. Eventually, a dozen acres of farmland on the edge of Clifton Downs was purchased for a zoo and botanical garden. This opened in 1836 and quickly became

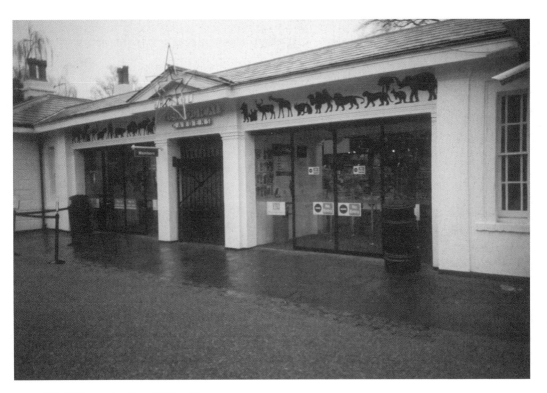

Bristol Zoo on the edge of Clifton Downs.

a focal point of Bristol life. It is the fifth oldest zoo in the world and has the distinction of being the second oldest in Britain after London.

Its animal collection was boosted from time to time by gifts from prominent people. Queen Victoria gave a lioness while the Maharajah of Mysore sent Zebi the largest Ceylonese elephant in captivity. She once snatched a cricket bat from a boy, reduced it to splinters then ate it. Sea captains returning to Bristol Docks brought back strange and exotic creatures from faraway lands.

At the start of the twentieth century the zoo advertised itself as 'the Finest Show in the Provinces'. Apart from the animals and the gardens visitors could be entertained by open-air concerts, firework displays, charity fêtes, singers and jugglers. For the more energetic tennis and croquet courts were available. A carnival week in 1905 raised many thousands of pounds for the Bristol Royal Infirmary. However, in the 1920s all these entertainments were dropped so that the zoo could concentrate on its animal research and breeding. The zoo made history and international headlines in 1934 when its directors announced that Adam had become the first chimpanzee to be conceived and born in captivity in Europe. More 'firsts' were to follow with the first successful British births of a gorilla, black rhinoceros and okapi.

One of the zoo's founders, Dr Henry Riley of Clifton, said to be the first medical practitioner in the West Country to use the stethoscope, became its first secretary. Ever since there have always been close links with the medical profession. So close in fact, that some surgeons at the Bristol Royal Infirmary have even operated on animals. On one occasion two baby bears were admitted to the Bristol Royal Hospital for Sick Children, then on St Michael's Hill, suffering from pneumonia.

An early advertisement for Clifton Zoo.

Many distinguished people have passed through the turnstiles. Lord Macaulay, the English historian and statesman, who visited in 1847, wrote to a friend, 'We treated the Clifton (Bristol) Zoo far too contemptuously. I lounged thither and found more than six penny worth of amusement'. Almost a century later, Queen Mary, who was staying at the Duke of Beaufort's country seat at Badminton, Gloucestershire, during the Second World War, was a frequent visitor.

The war saw the Clock Tower Restaurant becoming a canteen for American servicemen who had moved into Clifton College next door planning the D-Day invasion. Meanwhile, the polar

bear pit had been converted into an air-raid shelter and vegetables were grown in the borders instead of flowers. Fortunately, the zoo escaped bomb damage and proudly claimed that it never closed during the war.

Undoubtedly, its most popular resident was Alfred the gorilla. The zoo bought him for £350 and he lived there from 1930 until his death eighteen years later. At the time he was the only gorilla in captivity in this country. From the day of his arrival Alfred was a big hit, not only with his keepers but also with the visitors. He often met them while being taken by his keeper for walks around the gardens, always wearing his distinctive woolly jumper. Picture postcards of Alfred were sent all over the world, many of them by American servicemen based in Bristol. Such was Alfred's popularity that he even received greetings cards on his official birthday – 5 September. When he died zoo officials announced that Alfred's death was caused by a low-flying aircraft that made him panic. Unknown, though, to his many admirers he had been suffering from tuberculosis for a year.

In more recent years the zoo has developed its educational and scientific roles and is planning to create a £50 million National Wildlife Conservation Park on a 130-acre site in the south Gloucestershire countryside. Here, animals like rhinos and giraffes will be able to roam freely. But the memories of Alfred live on. A likeness has been preserved by taxidermists and is on show in Bristol Museum & Art Gallery and a bust of him can be seen, appropriately, outside the zoo's ape house.

Other local titles published by Tempus

Bristol History You Can See
MAURICE FELLS

This book explores the colourful and fascinating history of Bristol through the visible signs that it has left behind. Once described as 'the most beautiful, interesting and distinguished city in England', Bristol has seen prison riots and shipwrecks, royal visits and hangings: discover the building once called 'the Devil's Cathedral' or the inn where Robinson Crusoe met Daniel Defoe. *Bristol: History You Can See* shows that evidence of the past can be seen in everyday surroundings and will fascinate all who know the area.

0 7524 3931 6

Hotwells and Cliftonwood
SUE STOPS AND PAULINE BARNES

From early drawings of the gorge to photographs of Hotwells and Cliftonwood at work and play, this book brings to life the streets, buildings and businesses that have long since vanished and recalls the characters who populated them. *Hotwells and Cliftonwood* provides a nostalgic journey into the past of the area and will delight all those who have lived here as well as those who have visited over the years.

0 7524 3452 7

Old Inns of Bristol
CFW DENING, WITH A NEW PREFACE BY MAURICE FELLS

Old Inns of Bristol is a fascinating guide to the historic pubs in the city. First published in 1943, the original book is reproduced here, along with an updated preface by local writer and broadcaster Maurice Fells. This book offers the reader an insight into the life of pubs past and present, from the oddly named Rhubarb Tavern to the dockside pubs with their stories of pirates and smugglers.

0 7524 3475 6

Haunted Bristol
SUE LE'QUEUX

This selection of newspaper reports and first-hand accounts recalls strange and spooky happenings in Bristol's ancient streets, churches, theatres and public houses. From paranormal manifestations at the Bristol Old Vic to the ghostly activity of a grey monk who is said to haunt Bristol's twelfth-century cathedral, this spine-tingling collection of supernatural tales is sure to appeal to anyone interested in Bristol's haunted heritage.

0 7524 3300 8

If you are interested in purchasing other books published by Tempus, or in case you have difficulty finding any Tempus books in your local bookshop, you can also place orders directly through our website

www.tempus-publishing.com

BRITISH RAILWAYS

PAST and PRESENT

No 16

BRITISH RAILWAYS

PAST and PRESENT

No 16

Avon, Cotswolds and the Malverns

Hereford & Worcester, Gloucestershire and Avon

Geoff Dowling and John Whitehouse

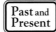

Past and
Present

Past & Present Publishing Ltd

First published in February 1993
Reprinted October 1993

British Library Cataloguing in Publication Data

A catalogue record for this book is available from the British Library

ISBN 1 85895 028 7

Past & Present Publishing Ltd
Unit 5
Home Farm Close
Church Street
Wadenhoe
Peterborough PE8 5TE
Tel/fax (0832) 720440

The research and captions are by John Whitehouse; photographic printing by Geoff Dowling

Maps drawn by Christina Siviter

Printed and bound in Great Britain

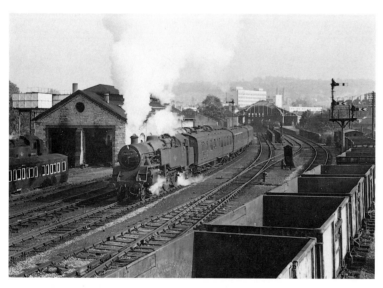

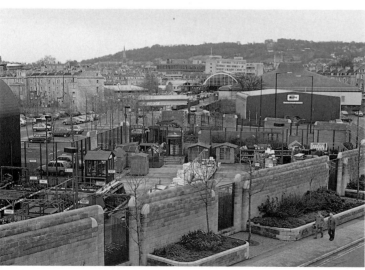

BATH GREEN PARK: The view from the top of the steps of Bath Station signal box looking towards the station. BR 'Standard' 2-6-4T No 80138 has just crossed the River Avon bridge with the 1.10 pm local to Templecombe and is passing the original Midland Railway Shed on the left. Note the old coach body (far left) which was used by the men of Bath Depot for their Mutual Improvement Classes. In the station stands 'Peak' Class diesel-electric No D88 on a local train to Bristol. This view was taken on 20 October 1965, and the redevelopment of central Bath was well in hand, with a slab-sided government office block already obstructing the view of Bath Abbey.

Following closure in 1966, Green Park's future was uncertain, despite having Grade 2 listed building status. Eventually supermarket giant J. Sainsbury stepped in to preserve the building as part of their new superstore complex. The extent of Sainsbury's operation is clearly evident from this view, with car parking and their garden centre occupying the site of the engine shed and goods yard. This photograph was taken from the roof of a partially completed office block and ironically is very close to the position of the original photographer in both location and elevation. In the background can be seen further city centre development, whilst the main retail store is on the right. (See also page 95) *Hugh Ballantyne/GD*

CONTENTS

BIBLIOGRAPHY

Rail Atlas of Great Britain & Ireland *by S. K. Baker (OPC)*
A Pictorial Record of Great Western Architecture *by A. Vaughan (OPC)*
The Railway Heritage of Britain *by Gordon Biddle & O. S. Nock (Michael Joseph)*
The Banbury & Cheltenham Railway 1887-1962 *by J. H. Russell (OPC)*
A Pictorial Record of Great Western Engines *by J. H. Russell (OPC)*
Nameplates of the Big Four *by Frank Burridge (OPC)*
Bradshaws Railway Guide (reprint) *(David & Charles)*
Passengers No More *by Gerald Daniels & L. A. Dench (Ian Allan)*
Branch lines of Gloucester *by Colin Maggs (Alan Sutton)*

Diesel Hydraulic Locomotives of the Western Region *by Brian Reed (David & Charles)*
A Regional History of the Railways of Great Britain, Vol 1 The West Country *by David St John Thomas & Allan Patmore (David & Charles)*
 Vol 7 The West Midlands *by Rex Christiansen*
 Vol 13 Thames & Severn *by Rex Christiansen*
Rail Centres: Bristol *by Colin Maggs (Ian Allan)*
Railways of the Cotswolds *by Colin Maggs* (Peter Nicholson)
The Western Region before Beeching *by Chris Leigh (Ian Allan)*
The Severn & Wye Railway, Vols 1-3 *by Ian Pope, Bob How and Paul Karau (Wild Swan)*

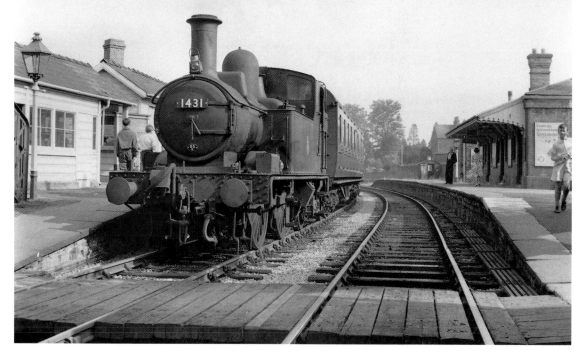

LYDNEY TOWN: A little of the Steam Age lives on in the Forest of Dean. Push-pull fitted ex-GWR 0-4-2T No 1431 stands in the up platform at Lydney Town on 4 June 1960 with an auto-train for Berkeley Road (via the Severn Railway Bridge). The building on the right is of Great Western origin dating back to 1897, whilst those on the up platform are of original Severn & Wye construction. Note, too, the station nameboard of Midland Railway origin, firmly establishing the joint ownership of the line. Lydney also enjoyed the use of two other stations: the Junction Station, again of Severn & Wye origin, and the GW station on the South Wales main line, the two being linked by a spur. The Severn & Wye branch to Lydney Docks crossed the main line at right angles on the flat at the south end of the GW station. Of the three, Town was the most convenient for the local population.

The station area has been redeveloped, but trains (courtesy of the Dean Forest Railway Preservation Society) still pass. Note the original platform face which survives today, being the only connection with the past. The train is headed by a Hunslet 0-6-0ST 'Austerity' returning from Lydney Lakeside to Norchard. The preservation society plans to re-open the station in the near future. *Hugh Ballantyne/GD*

INTRODUCTION

Flushed with success on the completion of our last 'Past and Present' book, we readily agreed to do another. After all, we said, it must be easier the second time - we knew all the pitfalls, all the problems, it would be a breeze!

Wrong! Our chosen area seems to have had more published about it in the past than any other; Bristol books abound, volumes have been written on the Birmingham to Gloucester Railway, and the Forest of Dean has been covered in minute detail. All very well, but it depletes the stock of unused archive material. Not all was gloom though. Along the way we were lucky and made contact with some splendid photographers who trusted us with their material, in most cases irreplaceable original negatives. We hope the end results justify their faith!

As ever when producing a 'Past and Present book', if the line was long closed a running battle took place between photographer and vegetation (or in the case of Gloucester the motor vehicle). Imagine, then, the joy of finding, on the long-mothballed Portishead branch, that the footbridge overlooking Clifton Bridge station was still there, and how short-lived that joy was when we discovered that all the steps had been taken out! At Mangotsfield we had an encounter with 'New Age Travellers' who had set up camp on the old trackbed along which we had to walk to reach the junction. After establishing that we were not council officials, they treated us to a fine display of Indian club juggling.

The area we cover in this volume is one of great contrasts; to the west is the peace and tranquillity of the Forest of Dean National Park with its two small towns of Cinderford and Coleford set deep in the forest, but only a short journey across the Severn Bridge soon brings the traveller into the sprawling city of Bristol with its station, Temple Meads, the hub of our area, from where we visit the seaside towns of Weston-super-Mare and Clevedon.

A brief run of 21 minutes by HST from Bristol takes us on to the magnificent Georgian city of Bath where Brunel had to twice cross the River Avon with his railway and the Somerset & Dorset still lives on in the sensitively restored Green Park station. Elsewhere in the area we briefly visit Hereford, where the GWR and LNWR jointly owned the station, and Cheltenham, to explore the branch as far as Bourton-on-the-Water, so choked with road traffic these days. From Cheltenham it was also possible to travel, by main line, towards Stratford. Genteel Cheltenham, so different to its more cosmopolitan neighbour Gloucester. It was at Gloucester that the Broad Gauge of the GWR met with the standard gauge of the Midland, with chaotic results for the traveller who had to change trains with all his baggage.

At the top of the area is Worcester, cathedral city and gateway to the scenic beauty of the Malverns. From there it is a gentle amble along long-lifted branch lines, back into the Forest of Dean.

The railways in the area have suffered savage cuts over the years. The Forest of Dean had a large network of lines serving a maze of quarries and mines together with a good passenger network; now, apart from the Gloucester to South Wales line skirt-

ing its southern edge, it has nothing, although the Dean Forest Railway does recreate some of the lost scene. Many small towns have lost their railway line or station, often just before they expanded with the shift of population away from larger towns and cities; among these are Tewkesbury, Bromyard, Chipping Sodbury, Monmouth and Radstock. Where the line still exists it is, however, possible to reverse the process. This has happened at Yate, where a new station has attracted much new business; unfortunately, also at Yate the line to Tytherington quarry has had to be mothballed because of the current economic situation.

Main lines that have been lost include the Midland line to Bath and the GW line from Birmingham to Cheltenham via Stratford, although part of both of these lines have attracted preservation societies with, respectively, the Gloucester & Warwickshire Railway Society at Toddington and the Bitton Railway near Bristol.

The aim of this book is not to produce a comprehensive historical or pictorial record of this area - that has been done well before. Its aim is to provide the reader with an interesting series of comparisons of familiar and not so familiar views. We hope that it may encourage an interest in railways away from the usual railway enthusiast body. Indeed, the old trackbeds in the Forest of Dean and the cycleways between Bristol and Bath provide ample opportunity to inspect some of the scenes in this book at leisure. We also hope that it may stir some pleasant memories of a more gentle age, when it was possible to visit towns, villages and beauty spots without the need for a car.

We would like to thank all those photographers who provided us with the 'past' photographs, the true inspiration for the book, who have been credited in the text, and also the land and property owners who have allowed access to their properties when taking the 'present' pictures.

Geoff Dowling ARPS
John Whitehouse

Acknowledgements
Thanks are due to the individuals and organisations that have helped with research, including Chepstow Museum, The Brunel Engineering Trust, Colin Maggs and Richard Strange. As with all such projects, the need to convert the writers' virtually indecipherable scrawl into meaningful text is paramount, and the patience and tenacity of Lorraine Keyte, Pat Neville and Daphne Whitehouse for typing and Jean Dowling for proof-reading is acknowledged with grateful thanks.

GW lines from Worcester

PERSHORE: There were four intermediate stations to the east of Worcester along the Vale of Evesham, the most important of which was Pershore. In fact, the station was located some 1 mile to the north of this busy market town, and enjoyed extensive goods facilities reflecting the important market gardening activities in the area. In this June 1961 scene, goods facilities are evident on both sides of the main line as Class '4F' 0-6-0 No 43940 passes running tender-first towards Evesham. At this time the 'Cotswolds line', as it was known, was part of an important cross-country route which linked the east, via Bedford, Bletchley and Oxford, to the conurbations in the west served by the Birmingham to Bristol main line.

Pershore alone survived when the remaining intermediate stations closed in 1966, albeit in a much rationalised state. The station buildings and goods shed were swept away and the track singled, reflecting the loss of the important freight traffic. Today only the fencing, lighting and remains of the up platform recall its more prosperous past. A stopping service comprised of Class '150/2' 'Sprinter' No 150266 approaches.
Ellis James-Robertson/GD

WORCESTER SHRUB HILL: Worcester was originally by-passed by the Birmingham-Bristol main line, and joined the railway map when the Oxford, Worcester & Wolverhampton (usually known as the 'Old Worse and Worse') laid a connection from the city to the main line in 1850. Two years later the Worcester Loop was completed with a connection for the main line at Stoke Works via Droitwich. Shrub Hill Station for many years had an all-over roof as this undated scene records; it was probably taken at around the turn of the century and well illustrates this impressive station. Despite extensive enquiries, the exact date the roof was removed is also unknown, although it is believed to have lasted into the mid-1930s.

The station today presents a neat and tidy appearance, as Class '158' No 158780 departs with a Cardiff to Nottingham train on 31 August 1991. On the left are two Class '37' locomotives from the Civil Engineer's pool with ballast trains for the next day's engineering work. *Collection of Ellis James-Robertson/JW*

MALVERN LINK: One mile north of Great Malvern is Malvern Link, which is mainly a residential community although nearby common land is a popular recreational amenity. The station, which is situated centrally to both, opened in 1859, being the southern end of 6 miles of railway from Henwick, near Worcester. It had one particular advantage over Great Malvern, which was space, so it was possible to develop goods facilities which are well illustrated in this August 1958 view. '94XX' Class 0-6-0PT No 8427 stands in the goods bay whilst a nine-car formation of Swindon 'Cross Country' DMU triple sets heads north with a Cardiff to Birmingham Snow Hill train. Sidings on both sides of the main line indicate ample traffic.

The station remains in use, but the goods facilities have disappeared, the railway now being hemmed in on one side by an industrial estate and on the other by a caravan park. On a June day in 1989, Class '150/1' 'Sprinter' No 150145 approaches with a stopping service for Hereford. *Peter Shoesmith/JW*

COLWALL: The Malvern Hills presented a formidable barrier to the promoters of the Worcester & Hereford Railway. Indeed, a project by the London & North Western Railway to connect the two cathedral cities with a line skirting the Malverns to the north was defeated only by objectors from Great Malvern and Ledbury, the major intervening towns which would not have been served by the projected line. Tunneling itself caused further delays to the opening, and indeed the original single-bore tunnel was later replaced by a somewhat longer tunnel but of a slightly easier gradient. The enormity of the barrier provided by the Malvern Hills can be well judged from this May 1959 photograph, with Class '68XX' 'Grange' No 6853 *Morehampton Grange* heading an express to Hereford. The train has just passed through Colwall station, which was located at the west end of the tunnel.

Class '156' 'Sprinter' No 156415 typifies the new generation of trains on the line, forming a Hereford stopping service. The scene itself is little changed, with the precariously situated half-timbered cottage in the foreground remaining in excellent condition, whilst the background is dominated by the bulk of the Malverns. The route has been partially singled, from Malvern Link to the junction with the 'North and West' route near Hereford. *Peter Shoesmith/JW*

NEAR LEDBURY: The second major tunnel on the route was at Ledbury. Built as a single bore it is approached from the east by a downward gradient. To combat the potential problem of a runaway train, an escape line was constructed which ran along an embankment at the side of the main line. The runaway line is seen here nearest the camera as Class '35' 'Hymek' No D7083 climbs from the tunnel on 16 May 1964 with the 10.05 am Hereford to Paddington train.

Rationalisation brought singling, thus dispensing with the need for the runaway line and the signal box. In May 1989 Class '47' No 47620 *Windsor Castle* sweeps round the curve heading a Sundays-only Paddington-Hereford express. The locomotive's external appearance reflects its use as a favoured Royal Train engine at the time. *Michael Mensing/JW*

LEDBURY engine shed, located alongside the up platform, was a sub-depot to Hereford (85C) and catered mainly for banking engines to assist freights and the occasional passenger train through the narrow-bore single-track tunnel. The tunnel, 1,323 yards in length, had an adverse gradient of 1 in 80 for Worcester-bound trains. On 11 July 1959 Class '42XX' 2-8-0T No 5243 stands by the coaling stage between duties. Note the small turntable which was installed when the branch to Gloucester opened in 1885, used mainly for turning branch-line locomotives. The banking engine usually operated bunker first in order to provide the crew with some meagre relief from the blast of their own engine in the poorly ventilated tunnel.

The coming of dieselisation brought rationalisation, which eliminated the need for banking locomotives, and the shed closed in July 1964. The area has now become overgrown, although the trackbed can be identified. On the extreme right can be seen the main line leading to Ledbury Tunnel mouth. Ledbury is now one of the few remaining pockets of lower quadrant semaphore signalling on the old Western Region. *W. Potter/JW*

14

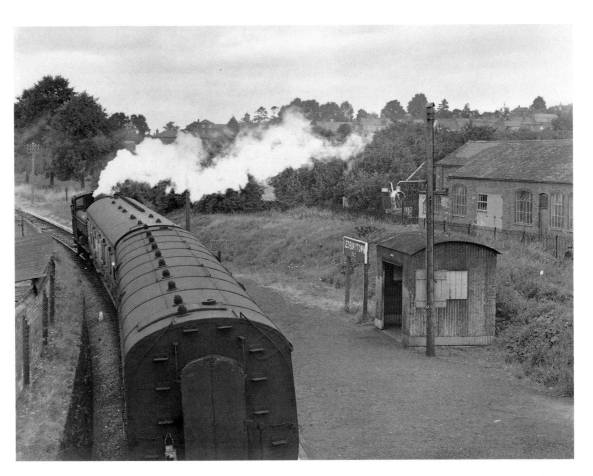

LEDBURY TOWN: Until 1959 Ledbury was a junction, with the branch from Gloucester via Newent and Dymock joining the Hereford to Worcester line to the west of the main-line station. Ledbury Town Halt was sited more conveniently for the town, located within easy walking distance of the main street. However, traffic on the single-line branch was not heavy, with a service of five trains each way per day prior to the Grouping. It was perhaps of little surprise that it became an early closure in mid-1959, ahead of the more swingeing Beeching cuts. On 5 August 1958 a '57XX' series 0-6-0PT stands at the Halt with a train from Gloucester.

All trace of the railway has now gone with partial filling in of the trackbed; even the road bridge at the southern end of the station has been removed. At present a public park and recreational ground occupy the site. The left-hand wall and the right-hand factory and iron fence clearly identify the location.
Peter Shoesmith/JW

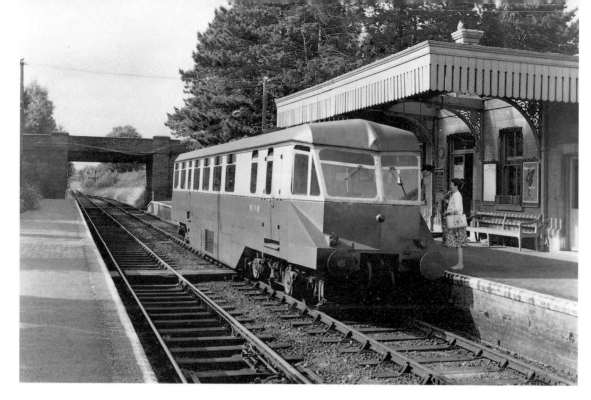

DYMOCK: The charming village of Dymock was some 5¼ miles from Ledbury Town on the line to Gloucester, and its station was situated on a passing loop controlled by one of only three signal boxes on the line. The station building was of typical GW design. In latter years the passenger service was handled mainly by the distinctive ex-GWR railcars, one such being W19W which is seen here pausing at Dymock with the 5.25 pm Ledbury to Gloucester train on 11 July 1959, the last day of the passenger service on the line. The railway from Ledbury to Dymock then closed completely. The lady passenger and the railcar driver are no doubt expressing regret at the loss of the train service.

A retirement home stands on the site of the station building today, and coincidentally the gentleman who can be seen enjoying the afternoon sun happens to be an ex-signalman who manned Dymock signal box just prior to the Second World War. The road overbridge remains, but the course of the railway has been filled in, although the down platform (on the left) survives today as a pathway through the garden area. *Hugh Ballantyne/JW*

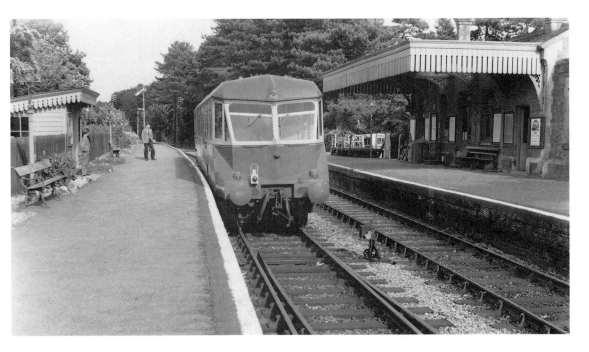

NEWENT was the most substantial town on the Ledbury to Gloucester line, although its station is similar in size to that at Dymock, a much smaller settlement. This view again features railcar No W19W working the 5.25 from Ledbury on the last day of service. The line itself had been in decline for many years; it had once been a through route for GW freight between Birmingham and Gloucester until the opening of the shorter Honeybourne line. Following withdrawal of the passenger service the southern section from Dymock remained open until May 1964 for freight services.

When compared with the neat station scene of 1959, it is difficult to believe that this is the same location today. The trackbed is heavily overgrown, as are the two platforms which are now barely evident. It is quite amazing that nature has repossessed this area so quickly. *W. Potter/GD*

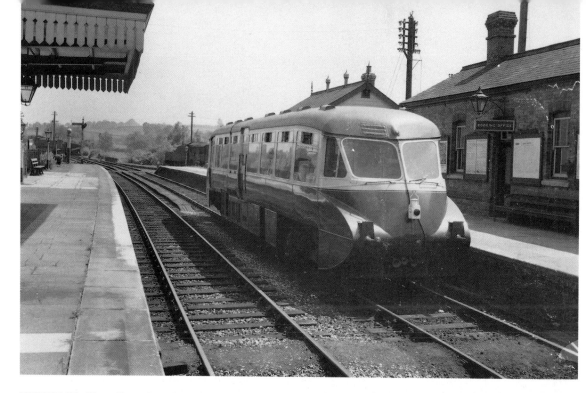

BROMYARD: The railway between Worcester and Leominster (featured on page 22) took many years to complete; the original company was formed in 1861 but the line was not completed until 1897. Roughly mid-distance stood Bromyard, reached from Worcester in 1877. Initial plans to complete the line from Leominster had been abandoned some years earlier, but were later reinstated and the Leominster to Steens Bridge stretch opened in 1884, and to Bromyard, to complete the through route, in 1897. Bromyard itself is a busy market town, but the railway struggled. Closure of the western end of the line between Bromyard and Leominster came in 1952, but the remaining section to Worcester survived until 1964. Nine years earlier, on 8 July 1955, ex-GW railcar No W5W prepares to work the 1.58 pm to Worcester. The railcar was of the early series, introduced in 1935 and distinguished from later units by a more rounded front end and no drawbar gear.

The station area has now been engulfed in an industrial estate, with the road bridge (behind the photographer) the only lasting evidence of the railway. The trackbed is now a roadway. *Hugh Ballantyne/JW*

Hereford and the Welsh Marches

HEREFORD (1): Hereford is a major centre on what is known as the 'North and West' route, which runs from Newport to Shrewsbury and has seen variable fortunes since completion as a through route in 1854. Hereford's importance grew with the completion of rail connections to Ross and Gloucester, Hay on Wye and Worcester. A key operating development was the completion of a spur in 1866 south of Hereford from the Newport to the Ross and Gloucester line giving trains from Newport direct access to Hereford's Barrs Court station, so that north-south trains no longer had to reverse direction. This view is from the end of the northbound platform on 18 May 1957 as 'City' Class 4-4-0 No 3440 *City of Truro* heads '43XX' Class 2-6-0 No 4358 into Hereford with a 'Daffodil Special' railtour. *City of Truro*', accredited with the first recorded attainment of 100 mph in Britain, was withdrawn in 1931 and placed in York Railway Museum. Restored to active use in 1957, in 1961 it was again placed in Swindon Museum, only to re-appear once more in 1985 as part of the GW150 celebrations. Note the British Railways totem on the goods office sign and the footbridge connecting it to the goods shed opposite.

The goods shed remains today, but the goods office has given way to a new trading estate. The avoiding line closed in 1967, but a spur remained to serve a power station and H. P. Bulmers Cider Factory. Bulmers played a key role in the campaign for the return of main-line steam in the early 1970s and a steam centre is located within their complex which is also used to service visiting engines on main-line duty. On 12 October 1992 a more familiar sight approaches Hereford (the Barrs Court name was dropped some time ago) in the shape of Class '37s' No 37274 and 37250 working steel empties from Dee Marsh (near Chester) to Margam. Note that the leading '37' carries the four-black-diamonds logo of the Coal sector of Railfreight. *E. J. Dew/GD*

HEREFORD (2): Barrs Court was an impressive station with two through lines within the station as well as avoiding lines 'around the back'. Looking north on 18 May 1957 there is a fair amount of activity in the station, no doubt to the satisfaction of the train-spotters at the end of the far platform. Indeed, on the near platform one young lad is having a very good look at the footplate of '43XX' Class 2-6-0 No 5377 which is running tender to tender with an unidentified 'Hall'. Waiting in the centre road is BR 'Standard' Class 4-6-0 No 75021.

Except for some cosmetic changes to the footbridge and the removal of the foreground sidings, the area has changed little. The main station building remains as impressive as ever and the train service continues to be buoyant. On 12 October 1992 the 10.04 Manchester Piccadilly to Cardiff Regional Railways service departs formed by Class '158' two-car set No 158817. Behind it two Class '37s' occupy the centre road with the Dee Marsh-Margam steel empties, which will follow the Cardiff train south. *E. J. Dew/GD*

21

LEOMINSTER: Twelve miles north of Hereford lies Leominster, a border market town of some importance. Its growth can, in part, be attributed to its development as a junction town, with the Kington branch of 1857 being the most important. On the other hand, the line to Bromyard and Worcester, as has already been mentioned, struggled for its very life, taking 36 years to progress from inception to completion in 1897. The line to Tenbury Wells and Bewdley would also have been an influence, which left the 'North and West' to the north of Leominster at Wooferton. Accelerating hard from Leominster on a crisp winter's morning is 'Grange' 4-6-0 No 6847 *Tidmarsh Grange* with a southbound goods. The station and signal box are just visible in the background, as is the goods shed on the left. Note the frost on the roof of the coach and the wagons in the goods yard.

A plain double track is all that remains of the extensive railway layout. The station remains open but is unstaffed, while a modern factory unit stands on the site of the goods yard. Heading south is Class '158' No 158839 with the 13.04 Manchester Piccadilly to Cardiff train on 12 October 1992. *Ellis James-Robertson/JW*

ST DEVEREUX: A feature of the 'North and West' line south of Hereford was a string of small wayside stations which served primarily a widespread rural community. St Devereux was a classic example, located 9 miles south of Hereford and at the time of the Grouping served by around five trains daily each way. The station house is lost behind the exhaust of 'Castle' No 5095 *Banbury Castle* which is speeding south with the 1.44 pm Hereford to Cardiff. Note that the station lighting does not appear to have any bulbs or mantles. The station drive is to the right.

The station closed in 1958 along with the neighbouring stations at Pontrilas and Tram Inn. The platforms have been removed but the station house remains, now in private hands. A recent roof extension has been completed and the drive is occupied in part by the garden. Heading south on 17 October 1992 is Class '158' No 158864 with a Manchester to Cardiff train. *Michael Mensing/JW*

Ross, Monmouth and Tintern

BALLINGHAM, on the Hereford-Ross line, was perhaps a typical GWR wayside halt consisting of a single platform and booking office. As with many such halts, it was situated some distance from the place it served; indeed, the hamlet of Carey was closer. On 20 May 1964 Class '43XX' 2-6-0 No 7319 calls with a Hereford to Gloucester train. The pristine appearance of the station gives little indication that closure was only six months away. In earlier days this line was used by the GWR as a pilot scheme to perfect techniques for its gauge conversion programme.

Since closure the station premises have passed to private ownership, and although the building has acquired an additional storey, the base is unmistakably the original booking hall. Note also that the platform has survived and now exists as part of the garden. *Hugh Ballantyne/JW*

ROSS-ON-WYE: After several abortive attempts, Ross finally joined the railway age on 1 June 1855 when the Hereford, Ross & Gloucester Railway opened for business. The line was equally important for passenger and freight traffic, as well as being a diversionary route for express trains when the Severn Tunnel was closed. The station was modernised in 1892, which included the provision of a single-storey building, with twin turrets capped with ornate ironwork. Many years later the design was to be recreated by the Severn Valley Railway with its new station at Kidderminster. Ross prospered in the early years, benefitting further when the Ross & Monmouth Railway opened in 1873. On 3 January 1959 ex-GWR '5101' Class 2-6-2T No 5177 approaches with the 10.25 Hereford to Gloucester train. Note the station nameboard: renaming as Ross-on-Wye had officially taken place in 1933, but by the date of this picture the Monmouth line was only two days from closure.

The goods shed survives today, but the remainder of the station site has been obliterated and is now an industrial estate. The station closed in 1964 upon the withdrawal of rail services to the town. *Hugh Ballantyne/JW*

ROSS-ON-WYE ENGINE SHED stood at the eastern end of the station, situated between the Gloucester line (left) and that to Monmouth. Built in 1871, its allocation seemed to fluctuate between three and five locomotives at any one time. Far larger than this photograph would suggest, the single-road shed measured 91 ft long by 20 ft wide, and once boasted a 44 ft turntable at the front. Ross was a sub-shed to Hereford, whose 85C plate is carried by 0-6-0PT No 4657 in June 1957.

The engine shed survives today, now in industrial use. The foreground area which contained the junction has been cleared and is part of an industrial estate with a new road traversing the location. Note that the right-hand houses have changed little, except for the screen of trees. *W. Potter/GD*

KERNE BRIDGE is located where the wide flood plain of the River Wye narrows into a twisting forested gorge to the north of Monmouth. The station took its name from the nearby toll bridge which was one of only two road crossing points between Ross and Monmouth. The first of two railway bridges over the Wye was also situated just to the south of Kerne Bridge station, whilst the river itself can be seen behind the station building in this August 1965 scene. The station, although in good condition, had by this time been closed for six years. Following the withdrawal of passenger services the crossing loop was lifted, although part of the trackwork is still visible just beyond the brake-van. The train is a Lydbrook Junction to Ross goods, hauled by 0-6-0PT No 3775. Note the drainage points set along the platform face as a precaution against flooding.

The B4228 road from Ross has now encroached slightly after being widened, but the station building remains intact and is utilised as an activity centre. Note that part of the old platform also remains in situ in front of the building. *W. Potter/GD*

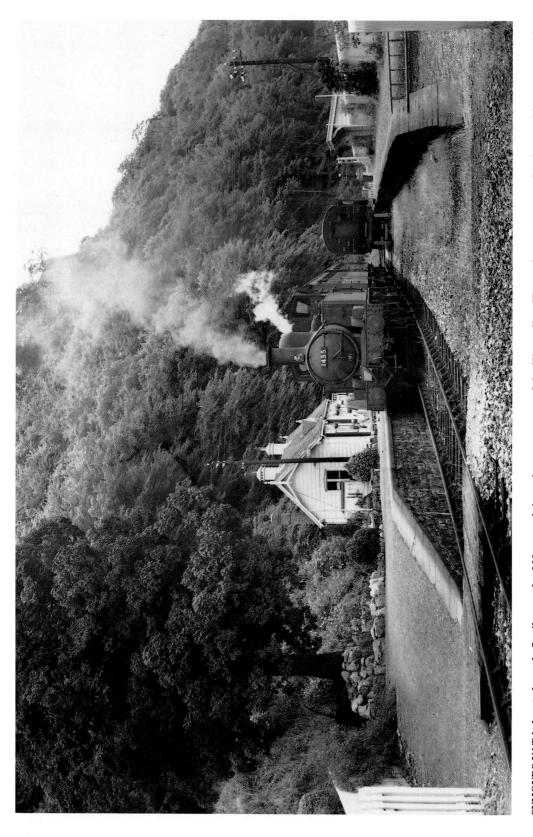

SYMONDS YAT is located nearly 5 miles north of Monmouth in a picturesque part of the Wye valley. The station was next to the river and became a popular destination for tourists and anglers. By July 1957 the loop had been partially lifted and the remaining stub occupied by a camping coach. A Monmouth to Ross two-coach auto-train, propelled by 0-4-2T No 1455, pauses at the station. Note the attractive wooden station building (left) and the basic wooden shelter on the disused platform (right).

The space between the two platforms has now been filled in, with the whole station area being utilised by the local hotel as a car park. Note the old platform edging slabs just visible to the immediate left of the hotel signboard. *W. Potter/GD*

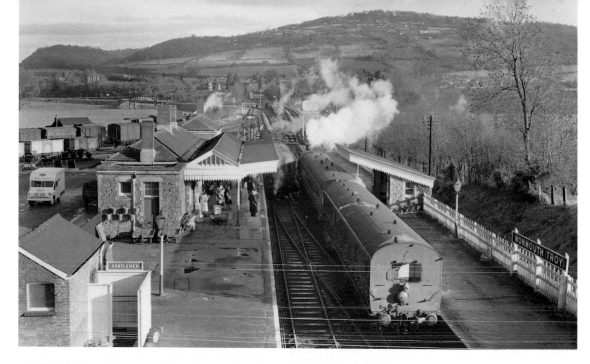

MONMOUTH TROY: It is difficult to believe that two days after this photograph was taken on 3 January 1959, passenger services to Chepstow and Ross-on-Wye were withdrawn and the station closed. On the right is the 11.00 am from Ross worked by '14XX' 0-4-2T No 1455, whilst on the left is '57XX' No 7774 with the Chepstow and Severn Tunnel Junction service. A further pannier Tank No 7712 is employed in the still busy goods yard. Beyond the station can be seen the junction, with the Ross-on-Wye line diverging to the left over the girder bridge, beyond which was Monmouth's second station, May Hill. To the right, crossing the River Wye by a viaduct, is the Chepstow line. Earlier closures had been to Coleford in 1916, and south towards the main 'North and West' line via Raglan and Usk in 1955.

The course of the railway is still evident today, with the branches to Ross-on-Wye and Chepstow clearly identified by the bridges. The station site has recently been cleared: after years of dereliction, the station building itself has been dismantled brick by brick and transferred to the Gloucestershire & Warwickshire Railway, where it has been reassembled at their Winchcombe station. *Hugh Ballantyne/JW*

TINTERN was perhaps the best known of the four stations on the 14³/₄-mile line from Chepstow (Wye Valley Junction) to Monmouth Troy. The area became a popular tourist attraction due to both the scenery and the nearby ruins of Tintern Abbey, with the station being situated roughly 1 mile to the north of the town. The railway hugged the banks of the River Wye for most of the route, crossing from the east to the west bank at Tintern, and back to the east bank beyond Redbrook. This was a very picturesque line, as for most part both river and railway were tightly hemmed in by the steep wooded slopes. Passenger services were withdrawn on 5 January 1959, and freight in 1964. A short spur remained at the southern end serving Tidenham Quarry until 1990. Two days before the withdrawal of the passenger service, '57XX' No 7774 stands in Tintern with the well-filled 11.50 am from Monmouth Troy to Severn Tunnel Junction.

Upon closure the track was lifted and part of the route was converted into a walkway, utilising the station buildings as a recreational and refreshment centre. The signal box also remains, but the island platform has been removed. The railway presence is retained by virtue of two preserved passenger coaches on a short length of standard gauge track together with a miniature railway. *Hugh Ballantyne/JW*

Chepstow and Severn bridges

WYE BRIDGE, CHEPSTOW: The South Wales Railway opened between Swansea and Chepstow in June 1850, and from Gloucester to Chepstow in September 1851. It did not become a through route until July 1852 when the 'gap' was filled by the opening of Brunel's bridge over the River Wye at Chepstow. It was a tubular suspension bridge with two towers 150 feet above low water level. Whilst not the most attractive of designs, Brunel put the lessons learned at Chepstow to good use in his famous Royal Albert Bridge over the Tamar at Saltash, completed in 1859. Wye Bridge remained in its original form until 1962 when it was rebuilt with the train deck supported from below by a lattice girder arrangement. The reconstructed bridge is well illustrated in this April 1980 scene showing Class '47' No 47512 heading north with the 11.45 Cardiff-Newcastle Inter-City service.

Further change has since taken place, resulting in this wider viewpoint: the rail bridge remains unaltered but alongside is now positioned the new road bridge which carries the main A48 Gloucester road clear of Chepstow's winding streets. The steepness of the valley here is also well illustrated. Crossing the rail bridge is Class '47' No 47803 heading Regional Railways' 10.50 Cardiff-Nottingham service on 12 October 1992. The locomotive and stock are on hire from Inter-City due to problems with the new Class '158' DMUs which normally operate this service. *Brian Morrison/JW*

SEVERN RAILWAY BRIDGE: The fate of the Severn Railway Bridge, and the Sharpness to Lydney line which used it, was sealed on the foggy night of 25 October 1960 when the 229-ton petrol tanker *Wastdale* collided with it and demolished two spans. Five lives were lost in the accident, but the loss could have been far greater as a train had crossed the bridge only minutes earlier. The Severn Railway Bridge had opened in 1872 but was secondary to the Severn Tunnel which opened in 1886; while the former dealt mainly with local traffic and was single track, the latter was built at a strategically key position on a main line with double track. Through freight diversions used the bridge when the tunnel was closed as an alternative to the usual route via Gloucester. This is the scene at Severn Bridge station on 6 August 1961, ten months after the accident; all the railway infrastructure remains in place except that access to the bridge is barred by a fence between the stone abutments, and the two missing spans are clearly evident. The Gloucester to South Wales main line runs beneath the stone piers leading to the bridge, and

at the far end the white control room of the swing bridge section can be seen. The swing bridge spanned the Gloucester and Sharpness Canal.

The bridge was demolished completely by 1970 and, except for the lifting of the tracks, Severn Bridge station appears to have been left to rot quietly. The platforms remain in situ, as does, amazingly, the signal box which has now been repossessed by nature in the same way that the jungle would take over a long-deserted colonial mansion! This view looks over the Severn from the remains of the eastbound platform towards the void where the bridge once stood. *C. G. Maggs/JW*

Forest of Dean

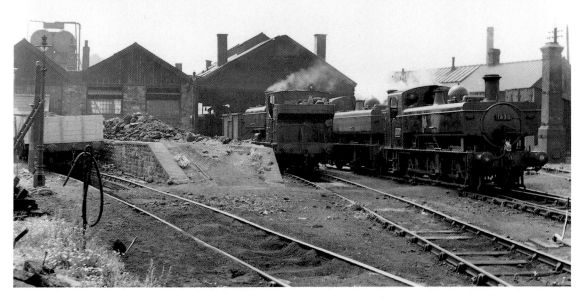

LYDNEY ENGINE SHED: On 7 August 1957 a trio of 0-6-0PTs simmer outside the three-road shed at Lydney, whilst a '43XX' 2-6-0 is visible within the running shed itself. Lydney was a sub-shed to Gloucester (85B) and serviced the requirements of the Forest of Dean system. It dated back to 1865, being rebuilt in 1876 and further enlarged to its maximum size in 1891. To the left is the repair shop, and the general stores are on the far right. The coaling stage is left of centre and once boasted a crane. Note the inspection pits beneath the left-hand wagon and the pannier tank parked next to the coaling stage.

The site today is used for heavy goods vehicles, perhaps reflecting the changed priorities and preferences over the years. Note, though, the Dean Forest Preservation Society's line running in the foreground. (See also page 6)
W. Potter/GD

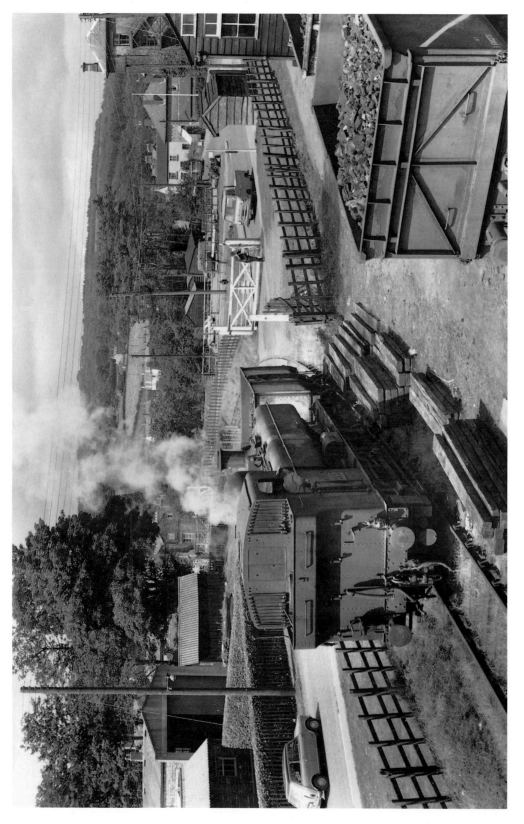

PARKEND: On 6 August 1965 ex-GW '57XX' 0-6-0 No 4698 shunts coal wagons at Marsh Sidings at Parkend; the train is about to cross the main Lydney to Cinderford road. To the right are wagons of domestic coal stabled in the station yard, whilst the black wooden building (extreme right) is the goods shed and dates back to the beginning of this century. Parkend was an early important industrial centre served by tramways until the arrival of the railway in 1868. The passenger station is beyond the right-hand coal wagons and doubles also as the junction station for the nearby Coleford branch.

The course of Marsh Sidings remains clearly evident with rail still in situ as far as the main road. The area beyond also appears to have changed remarkably little, with even the now ancient goods shed still in place, albeit boarded up. Missing today is the bus shelter, but the Mini car, seen on the left of the 'past' scene, can still be purchased new today, some 27 years later - some motor-car! *W. Potter/GD*

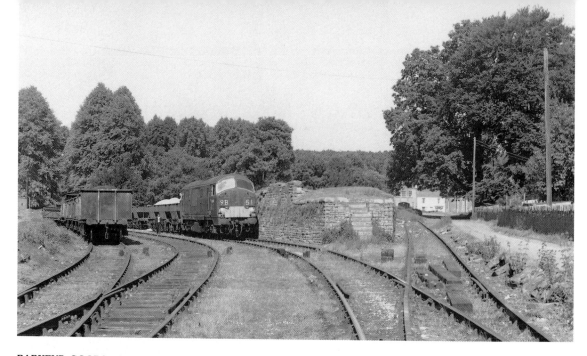

PARKEND GOODS: Marsh Sidings followed the course of the Milkwall Tramway, which was abandoned in 1876, whilst the sidings survived into the diesel era of British Railways. On 10 June 1968 Class '22' diesel-hydraulic No D6319 shunts ballast wagons. After the closure of the Coleford branch, ballast was transported from Whitecliff Quarry by road to Marsh Sidings. The line on the left was used to load coal from several private mines for movement to Newport Power Station. The Milkwall Tramway was located on the right and the Oakwood Tramway terminated at the loading wharf.

The area has now been completely levelled and only the right-hand wall and background buildings, which appear to have changed little, identify the location. *W. Potter/GD*

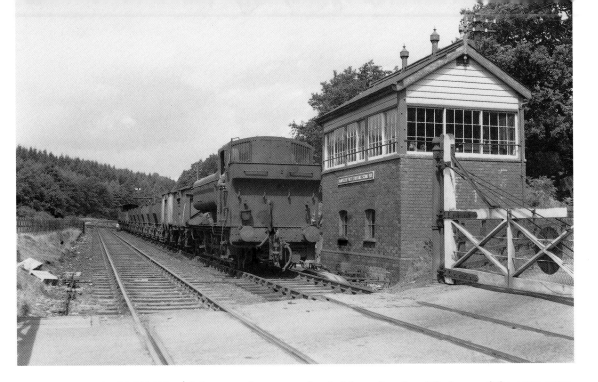

TRAVELLERS REST CROSSING took its name from a nearby, but long-closed, public house of the same name. Situated on the Coleford to Blakeney Road, the signal box not only controlled the road crossing but also served as a block post between Parkend and Coleford Junction. On 6 August 1965 0-6-0PT No 4698 heads south with a consist of ballast from Whitecliff Quarry and empty domestic coal wagons from Coleford. Although by this time long closed, a siding once ran behind the signal box to Parkend Colliery, and a stoneworks was located roughly to the right of the bracket home signal in the background.

Today the location has drastically changed, with only the left-hand fence surviving from the earlier scene. Note that on the right the roadway is elevated above the old trackbeds, and probably follows the course of the old colliery siding. *W. Potter/GD*

MILKWALL: The branch to Coleford opened in 1875, utilising in part the Milkwall Tramway. The only intermediate station was located at Milkwall, which consisted of a single platform and loop. The original wooden station building survived until 1923, when it was destroyed by fire. A more substantial brick and tile structure was then provided, which became the goods office after the cessation of the passenger services in 1929. Goods services were operated both to Coleford and on to the Sling branch, the latter joining the main line at Milkwall. On 18 August 1965 0-6-0PT No 4698 prepares to propel a train destined for Watkins Boiler Works along the branch.

Today's view is taken from a wider vantage point. The course of the Sling branch recedes in the centre whilst to the right is the remains of the distinctive Easter Iron Mines engine house. Note that the right-hand corrugated iron workshop also remains, but the neighbouring unit has had its distinctive curved roof replaced by a more traditional gable. *W. Potter/GD*

SLING BRANCH: Later on the same day, 18 August 1965, 0-6-0PT No 4698 shunts the siding at the British Mining and Colour Works, situated on the branch at Milkwall. Note the chimney on the extreme right which stands on the semi-derelict house that can be seen left of centre in the Milkwall station photograph opposite. An idea of the stiff gradient at this location can be obtained by noting how the railway dips towards Milkwall station while the main road climbs away in the distance. As a consequence it was usual for trains to be propelled along the branch to avoid wagon runaways.

The main part of the old Colour Works remains today, with the only real change being the provision of the new foreground building in place of the loading bay. It would also appear that the course of the railway has been filled in, as there is no trace of the actual platform. In the background the houses remain distinctive, but the property at the extreme right appears to have either been extended or replaced. *W. Potter/GD*

SLING BRANCH, SAND SIDING: Another scene from 18 August 1965, as No 4698 again works the branch, conveying scrap metal from Watkins Boiler Works. The train is passing Sand Siding, a short spur off the 52-chain branch. An inscription on the point lever suggested that the siding dated back to 1878, and probably existed to cater for a nearby sand quarry. In order to use the siding the 'locomotive to propel' rule had to be ignored, although there appears to be little to restrain any wagons deposited in the siding.

The caravan park in the 1965 scene has now given way to more permanent residences, whilst the background trees have grown considerably. The location can be confirmed by the electricity pylons, whose position today pinpoints the course of the railway. Note the street lighting bracket which has also survived, albeit with a different light globe. *W. Potter/GD*

COLEFORD JUNCTION: A busy scene at Coleford Junction on 18 June 1965 as 0-6-0PT No 4698 arrives with the first train of the day from Gloucester and Lydney. It has domestic coal for Coleford (Severn & Wye) station and empty ballast hoppers for Whitecliff Quarry. Note the wagons on the left, loaded with round tanks, which are from Watkins Boiler Works located on the Sling Branch. To reach Coleford a reversal was necessary; the branch can be seen diverging to the right beyond the rear of the train. Passenger trains divided here, with the Cinderford portion continuing north whilst the branch engine would collect the usual two coaches for Coleford (GW). A workman's platform was located roughly at the point from which this photograph was taken, but lasted for only a short time and had been removed by the turn of the century. The signal box dates back to 1925 when the GWR pattern replaced the original Severn & Wye structure.

The entire site today has been cleared, with no trace of the railway remaining. The background caravans mark the point roughly where the Coleford branch diverged. *W. Potter/GD*

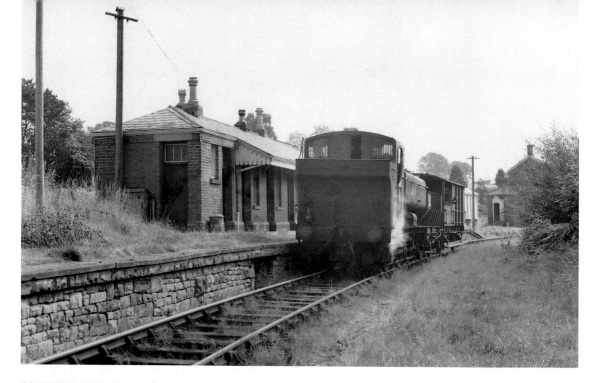

COLEFORD (GW): On 16 August 1965 0-6-0PT No 4698 simmers in Coleford (GW) whilst the crew enjoy a well-earned break. The train consists of one empty wagon for Whitecliff Quarry plus a brake van. The Great Western station dated from 1883, when the line from Monmouth reached the town, but the passenger service was of short duration, being withdrawn in 1916. The Severn & Wye Railway had reached Coleford eight years earlier in 1875, with the passenger service via Coleford Junction surviving until 1929. Whilst in close proximity, interchange between the stations was problematical, initially due to the intense rivalry between the two companies. Operational difficulties remained until 1951 when a new layout was installed which enabled through running on to the stub of the old Great Western Monmouth line, allowing easier access for trains to Whitecliff Quarry. The building on the right is the original Great Western goods shed.

Although the site today is occupied by a supermarket, one corner remains dedicated to the railway. The Great Western Railway Museum is housed in the old 1883 GW goods shed and features the railways of the Forest of Dean. Amongst items of rolling-stock is a Pecket 0-4-0 tank locomotive and a full-size ex-GW signal box which last stood on the busy West of England main line at Cogload Junction, north of Taunton. The museum, which opened in 1988, contains a wealth of information on the local railways and appeals to the general and specialist enthusiast alike. *W. Potter/GD*

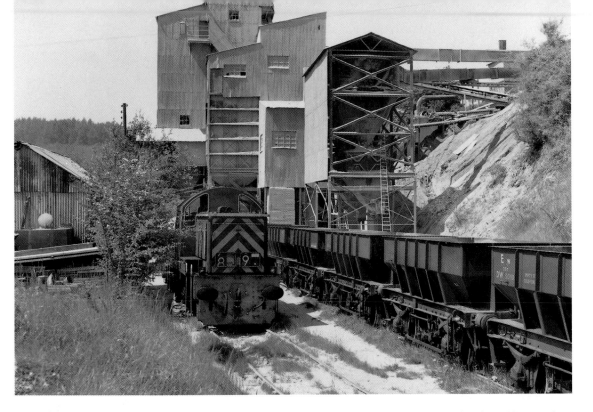

WHITECLIFF QUARRY: Whitecliff Quarry stood on the remains of the ex-Great Western line from Monmouth to Coleford, which closed in 1916. The quarry was located some 17 chains from Coleford, with a short tunnel the only major engineering feature, access being by way of a ground frame. On 31 May 1966 a Class '14' 650 hp diesel-hydraulic locomotive shunts hopper wagons within the complex.

The scene is now one of dereliction and destruction: on the hillside (right) can be seen the remains of the conveyor supports whilst the barren foreground once contained the sidings and the main buildings. The quarry itself closed in 1967. *W. Potter/GD*

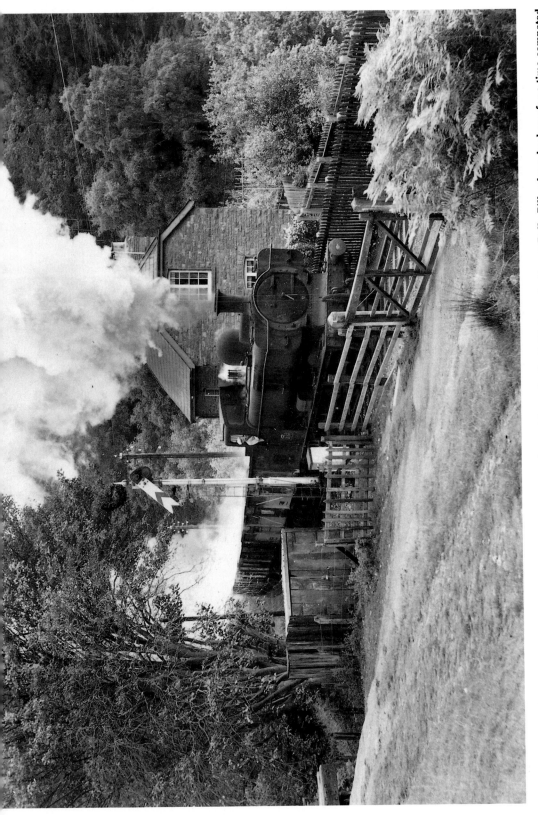

BRADLEY HILL TUNNEL: The Great Western branch to Cinderford diverged from the South Wales main line at Bullo Pill, whose harbour for a time competed with Lydney for the river trade. The branch had a difficult and curvaceous route with the need for three tunnels, one such being at Bradley Hill. On 11 October 1965 0-6-0PT No 3675 emerges under full power from the tunnel with a train of empties for Northern United Colliery. On the far left can be seen the stop block and platform which once served a short siding. Contemporary photographs taken at this point indicate that the siding had been removed within the previous 12 months.

The narrow bore of Bradley Hill Tunnel can be seen in the background of the present-day view, now bricked up. The house shows little change whilst the course of the railway remains evident. A metalled road now crosses the site, following in part the bed of the old siding. *W. Potter/GD*

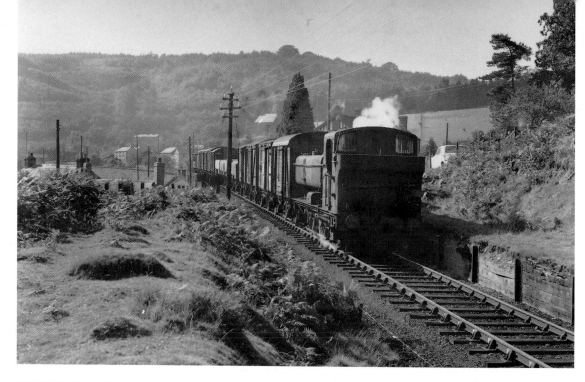

SOUDLEY: A classic branch-line scene at Soudley as 0-6-0PT No 4689 drifts past with a southbound goods comprised mainly of wagons from the Rosedale Plastic Factory at Cinderford. Remains of the long-closed station are plainly evident, with the platform facing still in position. An idea of the steepness of the valley can be gained by noting that the chimneys of the left-hand properties are below the railway whilst the gable roof of the White Horse Inn (behind the locomotive) occupies a much higher vantage point.

The surrounding area has changed little in the intervening years, with the course of the railway still intact. Note that part of the old platform face remains and that the distinctive tree (centre) continues to flourish. *W. Potter/GD*

STAPLE EDGE HALT: A train of gas tar tanks from the Tarmacadam Works at Whimsey approaches the site of Staple Edge Halt, hauled by 0-6-0PT No 9672. To the left of the train is the remains of a siding which once connected the now closed Eastern United Colliery to the main line; note the derelict mine buildings on the far left-hand side.

An industrial unit occupies part of the site today, but note how the conifer tree (centre) has matured over the years from the rather thinner specimen situated to the right of the locomotive's cab in the earlier view. This location is to the south of Ruspidge and close to Blue Rock Tunnel, one of the three major engineering features on this part of the line. *W. Potter/GD*

RUSPIDGE: Although a halt, Ruspidge was the nearest that the Great Western got to Cinderford until its spur from Bilson Junction was opened in 1908; consequently the buildings have more substance than the traditional halt. On 26 September 1965 0-6-0PT No 4698 heads a southbound train from Northern United Colliery, watched by the crossing keeper. The foreground contains a wealth of railway infrastructure with single-span crossing gates and ornate cast lamp-posts being a feature.

Today the location of the railway can still be clearly seen, as can Cinderford in the background. A remaining feature is the power cable pylons which clearly locate the scene today. *W. Potter/GD*

BILSON JUNCTION was situated at the southern end of a web of lines where the old Severn & Wye system met the Great Western near Cinderford. Four separate lines are featured in this September 1965 view: on the extreme right is the spur constructed in 1908 which enabled the Great Western to reach Cinderford Town, whilst beyond that, curving to the right just in front of the background trees, is the line to Whimsey. Ahead, beyond the raft of mineral wagons, is the branch to Churchway, on which stood the Northern United Colliery, whilst crossing on an embankment just behind the wagons is the Severn & Wye line from Drybrook. The signal box is of standard Great Western design, as is the traction in the form of 0-6-0PT No 4689 heading tank wagons from the Tarmacadam Works at Whimsey. Although the tracks to Churchway and Whimsey appear a little unkept, the Cinderford spur is well maintained, which gives the whole scene a timeless atmosphere. In fact, closure was less than two years away.

The lie of the background hills is the best pointer to the location today, as no trace of the railway remains. The mound (left of centre) roughly corresponds to where the wagons were stabled. *W. Potter/GD*

CINDERFORD: Some four months prior to complete closure, Cinderford Town station remains remarkably intact as BR Type 1 diesel-hydraulic No 9503 shunts the daily goods in April 1967. The station, which dated from July 1900 and replaced the original and inconveniently located Severn & Wye facility, still retains its canopy, whilst the goods shed shows signs of activity. Originally planned by the Severn & Wye, the station was actually built by the succeeding joint Midland & Great Western Railway Company. It was not until 1908, with the completion of the spur from Bilson Junction, that the Great Western actually obtained access, thus enabling through running from Newnham and eventually Gloucester.

A housing estate occupies the site today, with BMWs and Vauxhalls replacing Panniers and Prairies! The background does retain some familiar features, however, with the gabled public house and factory remaining. *W. Potter/GD*

52

Ashchurch and branches

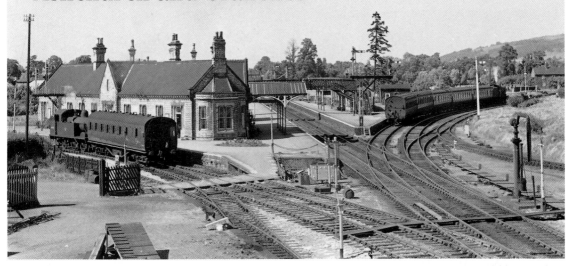

ASHCHURCH was important due to its junction status: on the left is the branch to Malvern via Upton-upon-Severn and Tewkesbury, and on the right the line to Evesham and Redditch, the so-called 'Birmingham Loop'. On a warm July day in 1959 both branch-line trains await departure: the Upton service is in the hands of an ex-MR 0-4-4T with a single coach whilst a Class '2P' 4-4-0 is in charge of the five-coach 'Loop' line train. The station is of classic Midland design, with typical gabled wrought iron and glass canopies. The well at the end of the up platform is where the original signal box stood, having been replaced by a more modern structure off the picture to the right. A serious accident occurred here on 8 January 1929 when a Bristol to Leeds express overran signals.

Ashchurch closed in 1971 and the scene today reveals much rationalisation, with the branch towards Tewkesbury having disappeared completely. To the right, above Class '156' 'Sprinter' No 156413 which forms a Birmingham to Cardiff service, can be seen the remains of the Evesham line, which until recently served Ashchurch MoD depot, whilst in the foreground the goods platform and part of the fence remain intact. Note the distinctive tree, which reveals the site of the main line and Evesham branch platform. *Peter Shoesmith/GD*

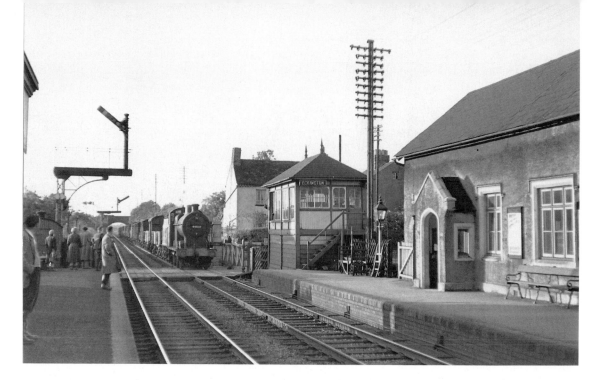

ECKINGTON: Just under 5 miles north of Ashchurch is Eckington, one of four intermediate stations between Ashchurch and Worcester. It was served primarily by local trains and its closure in 1965 was a result of the withdrawal of the stopping services on the route. The station had a distinctive building, almost chapel-like in appearance. At the northern end on the down side stood the Midland pattern signal box which guarded the level crossing. On 7 August 1956 Class '4F' 0-6-0 No 44591 heads a southbound unfitted freight.

Today the station building has survived, although the vestibule has been removed. The platforms, signal box and level crossing have all gone, with a modern footbridge preserving the pedestrian right of way. Approaching is a southbound HST. *Peter Shoesmith/B. M. Williams*

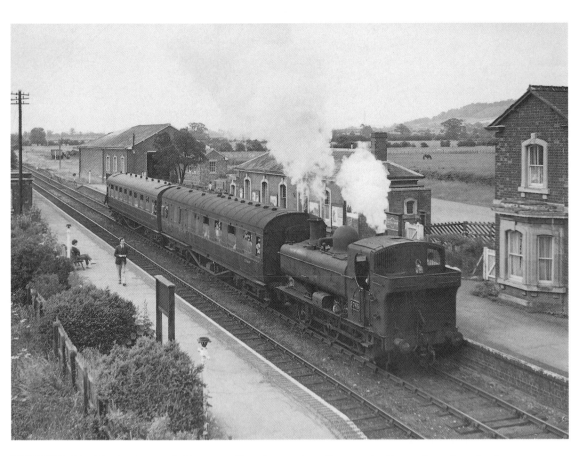

BECKFORD: The Birmingham and Gloucester 'Loop' was primarily a rural railway, the only major towns *en route* being Redditch and Evesham. It served the eastern flank of Worcestershire and owed its existence to pressure from the local farming community and Redditch industrialists for an efficient means to transport their produce to market, as the main line via the Lickey Incline was simply too far away. Completion was in 1868, with Beckford being the most southerly station situated 4 miles from Ashchurch. The station buildings, and particularly the nameboard, indicate the Midland origins of the line as ex-GW 0-6-0PT No 3745 calls on 15 June 1963. This was to be the last scheduled passenger train on the line, with freight services remaining for a further year.

The scene has now altered considerably, but closer inspection reveals that the station house (extreme right) and goods shed remain. Also note how the trackbed has been put to good use as a sunken garden and pond, with the right-hand retaining wall utilising the old platform face. *Michael Mensing/GD*

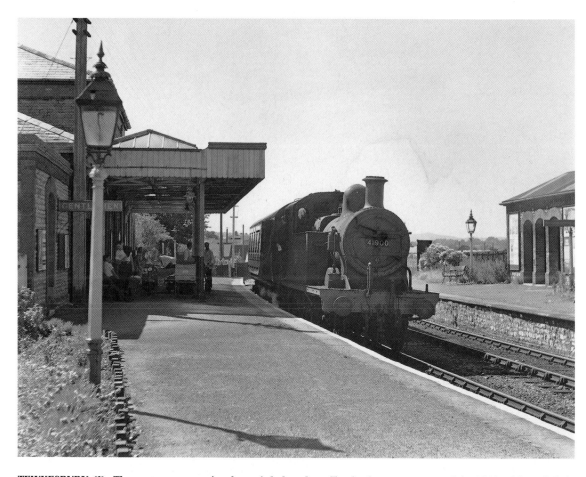

TEWKESBURY (1): The passenger service from Ashchurch to Tewkesbury commenced in 1840, although it is thought that the branch existed prior to that date for the movement of materials delivered to Tewkesbury by river for the construction of the main line. *Bradshaw* of 1922 indicates nine trains per day each way, taking on average 5 minutes to complete a 1³/₄-mile journey between the two stations. On 4 July 1959 push-pull fitted Class '2P' 0-4-4T No 41900 awaits departure for Ashchurch.

It is difficult to locate the site of the station today, as demolition took place after closure in 1964, and nature has taken over. The rather flatter ground running from the centre to the bottom right-hand corner indicates the platform location, with the trackbed beyond recognisable only due to being at a lower level. *Peter Shoesmith/JW*

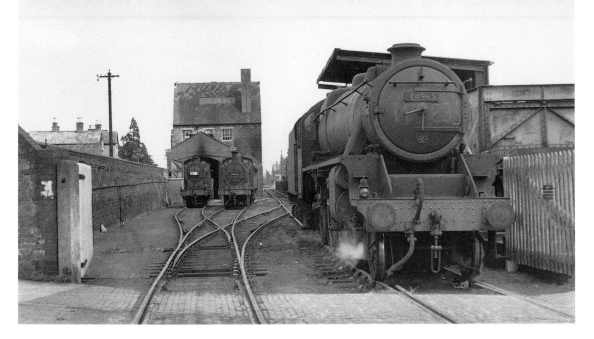

TEWKESBURY (2): The engine shed at Tewkesbury came under the control of Gloucester Depot (22B), and was located at the end of a spur which ran from the station towards the town centre via a goods yard. On 21 May 1956 Stanier Class '5' 4-6-0 No 44965 is being serviced, whilst in the background on the left stands a Class '4F' 0-6-0 and on the right a Class '3F' 0-6-0.

A car park now stands on the site of the engine shed, but the distinctive buildings both to the centre and on the left clearly pinpoint the location today. *Peter Shoesmith/JW*

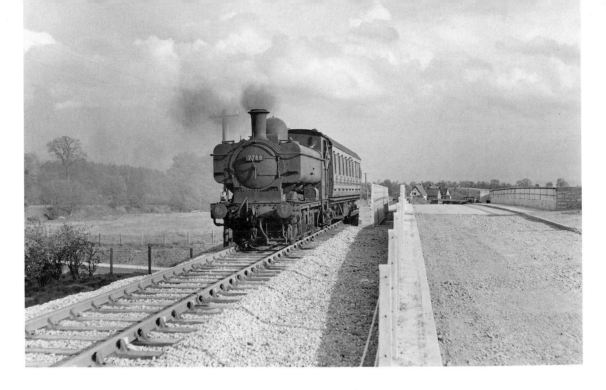

NEAR RIPPLE: Beyond Tewkesbury the branch continued northwards towards Upton-upon-Severn and Malvern Wells, where it connected with the Worcester to Hereford main line. The construction of the M50 necessitated a new bridge to carry both railway and road over the new motorway at a point just south of Ripple; the motorway is just visible here in the bottom left-hand corner as 0-6-0PT No 7788 heads north with an Upton-upon-Severn service in the summer of 1961.

The scene today shows little change except for the lifting of the railway. The trackbed is intact, as is the bridge with its girders still in good condition. *Ellis James-Robertson/JW*

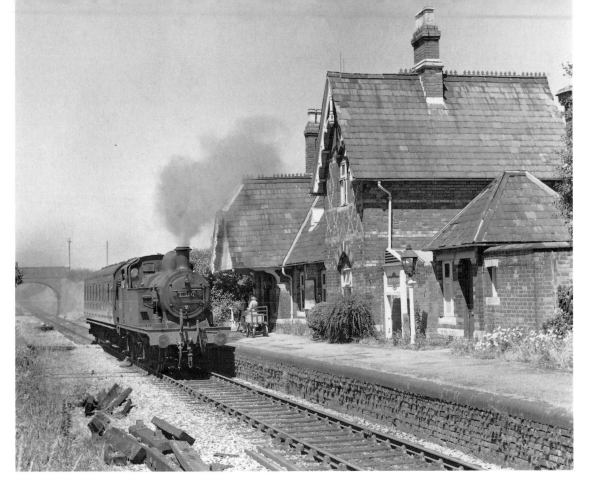

RIPPLE is no more than a village located between Upton-upon-Severn and Tewkesbury, but despite its size it enjoyed the facilities of a quite impressive station. On 4 July 1959 Class '2P' 0-4-4T No 41900 approaches with an Ashchurch-bound service. The line north of Tewkesbury did not boast a frequent passenger service, having only four trains per day each way just prior to 1923 when the Grouping of the railway companies took place. Through trains from Ashchurch to Malvern Link were the first casualty in 1952, with the Upton-upon-Severn service being lost in 1961, whilst trains to Tewkesbury survived until 1964.

Miraculously, upon closure in 1961 the buildings were not demolished and have since been purchased for use as a private residence. Although considerable renovation has taken place, the character of the buildings has not changed and the glory that was once Ripple railway station remains. *Peter Shoesmith/JW (courtesy of Mr & Mrs Fullerlove)*

GW lines to Cheltenham

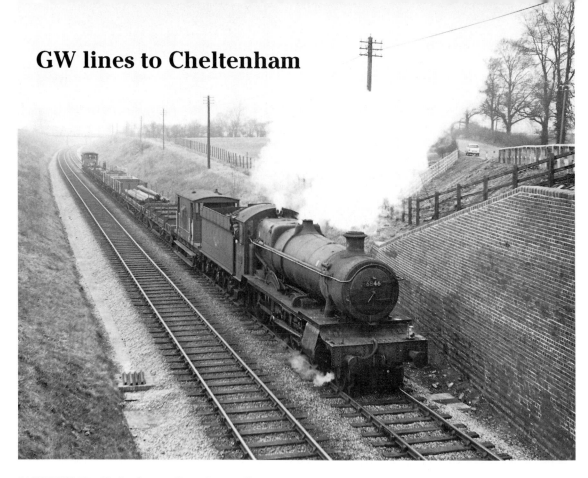

LAVERTON: The Cheltenham to Honeybourne line was engineered by the Great Western to connect with its North Warwickshire Line and provide a through route to Birmingham, freeing it from having to use Midland metals north of Cheltenham. The through route opened in 1908 but the price of independence was a longer way round than the Midland route via the Lickey Incline. South of Honeybourne the Great Western route served mainly rural communities with a dozen intermediate stations or halts. The village of Laverton, the location of one such halt, is

roughly 1 mile north of this scene showing 'Grange' 4-6-0 No 6846 *Ruckley Grange* heading a north-bound Sunday engineering train attending to lineside telegraph poles.

The abutments and retaining wall of the A46 road over-bridge remain in good condition today, and while the track has long been lifted, the course of the railway is still clearly evident. Hopefully in the not too distant future trains will again pass this way, but this time courtesy of the Gloucester & Warwickshire Steam Railway. *Michael Mensing/JW*

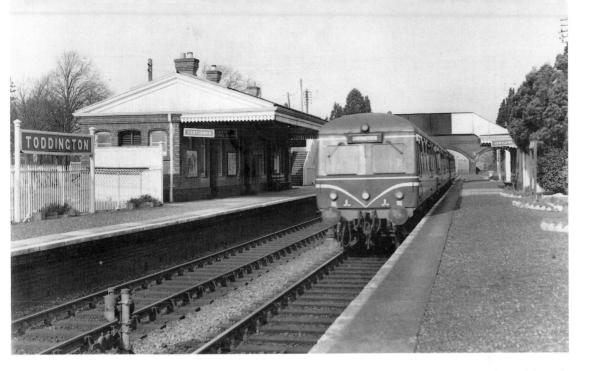

TODDINGTON was an important centre on the route with an impressive passenger station and substantial goods yard which was kept busy catering for the local fruit-growing industry. On 27 February 1960 a Swindon 'Cross-Country' DMU calls at Toddington with the 12.25 Birmingham Snow Hill to Carmarthen train. Local services were withdrawn one week later, and the station was closed, although a through service, together with parcels and freight traffic, survived until March 1968. In latter days the only intermediate signal box was sited at Toddington which was adequate for the dwindling traffic. Effective closure occurred on 15 August 1976 when a freight train derailment south of the station caused extensive track damage.

Between the dates of these two views the station became derelict and the platforms were bulldozed away. However, on the closure of the line the Gloucestershire & Warwickshire Steam Railway was formed, and by 1981 had purchased the trackbed and ultimately recreated this splendid scene today. Presently running an hourly service between Toddington and Gretton Halt, a further 1¹/₄ miles to Bishop Cleeve is due to open in 1993. The Railway's ultimate aim is to reach Cheltenham Racecourse by 1999 before turning north towards Broadway - an exciting prospect for a friendly and ambitious railway that is well worth a visit. *Hugh Ballantyne/JW*

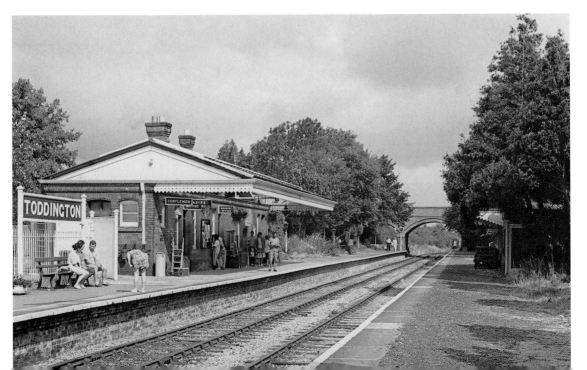

CHELTENHAM ST JAMES'S station was located at the end of a 1¼-mile spur from the Birmingham-Bristol main line at Cheltenham Lansdown. It originally served Great Western trains from the Swindon line, and later Banbury and Southampton services, as well as some trains off the Honeybourne route. The best-known train using St James's was the 'Cheltenham Flyer' which in the 1930s was the world's fastest steam train. The major advantage that St James's enjoyed over Lansdown was its position close to the town centre, giving passengers easy access to all the shops and other facilities. Decline came quickly, however, as train services were either withdrawn or diverted, and closure took place on 3 January 1966.

The station site has been cleared and is now used as a car park. Remaining as a distinctive feature on the left is the spire of the Church of St Gregory the Great alongside which now stand the offices of Mercantile and General Re-Insurance. *C. G. Maggs/JW*

CHELTENHAM MALVERN ROAD: The line to Honeybourne was built from the existing spur to St James's and upon completion in 1908 was served by a new station at Malvern Road, which was sited roughly mid-way between Lansdown and St James's. Malvern Road provided the Great Western with a second outlet in Cheltenham, and it grew in importance when the GWR was able to transfer its West of England traffic to the new through route. Malvern Road had a life span of only 58 years, however, closing on 3 January 1966 along with St James's. This view is from the west end and was taken during the late 1950s as a first-generation Swindon-built 'Inter City' DMU passes with a southbound train. Malvern Road engine shed is prominent in the background, in front of which is a well-stocked goods yard. 'Cheltenham Spa Malvern Road West Signal Box' is on the left and must be a candidate for having one of the GWR's longest name-boards!

The station has long been demolished, and a public footpath now follows the course of the railway. A DIY store and builders yard occupies the site of the goods yard and shed. Note the house situated on the extreme right of the DIY store, which can also be seen between the engine shed and signal post in the earlier photograph. *Peter Shoesmith/GD*

CHARLTON KINGS: On 27 February 1960 '5101' Class 'Prairie' 2-6-2T No 4116 eases into Charlton Kings with the 11.18 am Kingham to Cheltenham (St James's) service. The halt, which was situated on the southern outskirts of Cheltenham, survived until 1962, when the passenger service was withdrawn. Note, however, that the main station building was already boarded up, although generally the location seems to be in reasonable condition. This route, which was completed in 1887, was a scenic cross-country route linking Cheltenham to Banbury.

The site today has been levelled and is occupied by a modern factory estate. The distinctive road bridge remains, however, as does the attractive gabled house on the far left-hand side. *Hugh Ballantyne/GD*

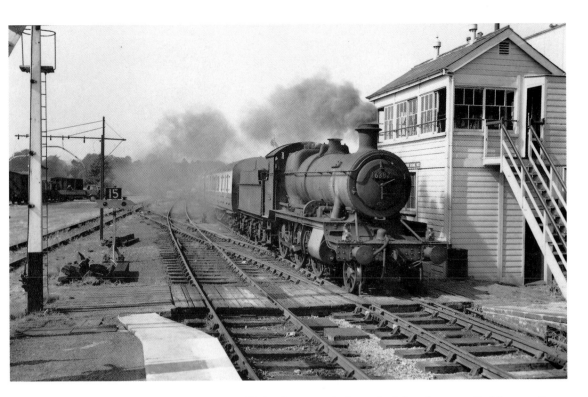

ANDOVERSFORD JUNCTION: Seven miles from Cheltenham was Andoversford Junction, so called because it was the point at which the Midland & South Western Junction line to Cirencester, Swindon and the South Coast diverged from the Banbury line. This through route was completed in 1891, with running powers over Great Western metals from Andoversford to Cheltenham. The passenger service had variable fortunes, but particularly during the war years the line was of considerable strategic value as a through route from the industrial Midlands to the South Coast. As an independent company it was always in competition with the Great Western, with four through services each way just prior to the Grouping. On 7 September 1955, Class '43XX' 2-6-0 No 6387 drifts into the Junction Station (GW) with the 2.00 pm Cheltenham (St James's) to Southampton train. The rival Andoversford & Dowdeswell station (M&SWJ) had closed in 1927, while the through route itself survived until 1961.

A scene of total dereliction marks the location today with only the platform edge (right centre bottom) giving an indication of the railway's former presence. *Hugh Ballantyne/GD*

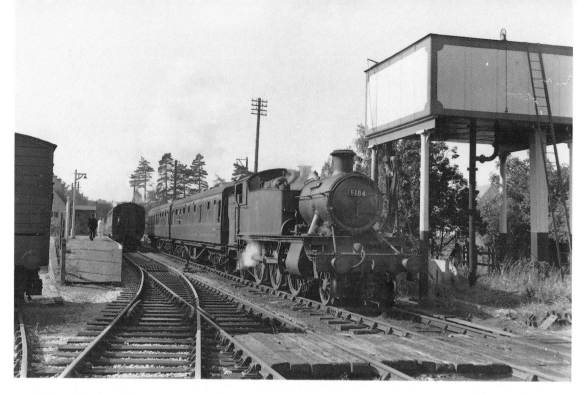

BOURTON-ON-THE-WATER: The through route from Cheltenham to Banbury was actually achieved in three stages, with the opening in 1862 of 6½ miles from Chipping Norton Junction (later Kingham) to Bourton-on-the Water being the second stage; the connection with Cheltenham was not completed until 1881. Bourton-on-the-Water became a tourist attraction, and the station boasted a crossing loop. On 29 September 1962, with closure imminent, Class '5101' 'Prairie' 2-6-2T No 5184 departs with the 10.50 am Cheltenham (St James's) to Kingham, whilst another 'Prairie', No 4101, heads the 11.18 am from Kingham. To the left, beyond the wagon, is sited a goods shed. Amazingly, although the site is being redeveloped with modern housing, the station buildings remain, complete with canopy. A road now covers the actual line, and the road overbridge at the Cheltenham end has been removed. *Hugh Ballantyne/GD*

Gloucester

GLOUCESTER CENTRAL: The Central station of today stands on the site of the original Gloucester stations of the Birmingham & Gloucester and South Wales railways, and was inherited by the Great Western, while the Midland later moved to Eastgate. The station had all the trappings of a Great Western building, being of traditional design - note the ornate ironwork cresting the roof line to the right of the footbridge. Passing through the centre road is '56XX' Class 0-6-2T No 6631 with an eastbound freight in June 1956. The locomotive is a development of an earlier Collett design introduced in 1924 specifically for working the steeply graded South Wales Valley lines.

In 1975 Central again became the main station when Eastgate closed. Because the Tuffley loop through Eastgate has also closed, trains visiting Gloucester on the Birmingham-Bristol axis are now required once more to reverse direction in the station. To improve operating flexibility a 608-yard platform was constructed which can accommodate two trains. To further improve operations the old parcels platforms were reopened to passenger traffic and a new footbridge installed. On 3 July 1986 Class '47' No 47549 *Royal Mail* is re-attached after running round the 11.00 Liverpool-Plymouth express, and will soon be heading south-westwards once more. *Norman Preedy/JW*

GLOUCESTER EASTGATE opened in 1896 enabling Midland trains to have through running between Birmingham and Bristol, thus avoiding the inconvenient run-round required in the old station. Its platforms were sharply curved, as can be seen in this June 1957 view as ex-LMS 'Jubilee' 4-6-0 No 45654 *Hood* restarts the 'Devonian' express, which ran from Bradford to Kingswear. A long footbridge connected Eastgate and Central stations which was a cause of considerable inconvenience, especially to passengers with any quantity of luggage. Eastgate closed in 1975 along with the Tuffley loop, and all services were again concentrated on Central station.

A by-pass and supermarket now occupy the site of Eastgate. The road curves in from the left, following in part the direction of the old station connecting footbridge. The supermarket actually straddles the station site as can be judged by the building (far right) which has survived re-development. *Norman Preedy/JW*

BARTON STREET LEVEL CROSSING was situated just beyond the south end of Eastgate station and was one of five on the Tuffley loop. In later years these crossings were a considerable cause of traffic chaos, which was an influencing factor in the loop being eventually closed. The distinctive signal box straddled both track and roadway and carried the name 'Barton Street Junction'. On 1 June 1963 'Jubilee' 4-6-0 No 45685 *Barfleur* has charge of a Wolverhampton to Paignton express. The locomotive has cleared the crossing and Eastgate is just visible in the distance.

The church (extreme right) is all that remains of the scene today, as a dual-carriageway road now obliterates the course of the railway. Traffic jams are still a feature but now sheer volume of traffic causes the problems! *Norman Preedy/JW*

HIGH ORCHARD BRANCH (1): The importance of Gloucester Docks grew during the early 19th century, eventually being served by branches from both the Midland and Great Western railways. The Midland branch was called High Orchard, and it left the main line at Barton Street Junction. On 21 November 1970 a Metropolitan-Cammell three-car DMU visited the branch with a railtour from Birmingham, and is seen passing California Crossing signal box; the main line from Eastgate is hidden from view by the wall. The branch then skirted Gloucester Recreational Park before reaching the docks.

The High Orchard tracks have long since disappeared, having been closed completely in 1971. Note the row of houses (far right) which serves to pinpoint the course of the old main line, the turn off on the right being the location of California Crossing. *Hugh Ballantyne/JW*

HIGH ORCHARD BRANCH (2): A short freight train is being shunted at High Orchard sidings on 29 March 1963. In charge is ex-Midland Railway Deeley 0-4-0T No 41537, one of two such locomotives (the other being 41535) allocated to Barnwood shed for working into and around the docks. There were only eight members of the class, first introduced in 1907. The docks were situated on the Gloucester & Sharpness Ship Canal and survived until 1989. The Great Western branch from Over Junction served mainly the western side of the complex (Llanthony Dock), although both companies had access to the docks' private railway system.

The factories in the background remain, but the railway sidings have been removed. The centre of the docks complex has been sympathetically restored and is now an attractive recreational complex containing both waterways and packaging museums. The centre also plays host to a number of public events throughout the year. *Norman Preedy/JW*

Golden Valley:
Kemble to Stroud

KEMBLE: The railway arrived at Kemble in 1841, although for many years development around the station area was inhibited due to the opposition of a local landowner. The present station dates from 1872 and is unusual by virtue of the buildings being at right angles to the track. Originally part of the Cheltenham & Great Western Union Railway which ran from Swindon to Cirencester via Kemble, it passed to Great Western ownership in 1844. The GWR completed the through route from Kemble to Gloucester (in 1845) and Cheltenham (in 1847) at which time Kemble became a junction with the branch to Cirencester (the former main line), and later also a branch to Tetbury, constructed in 1889. On 5 August 1962 ex-Great Western '43XX' 2-6-0 No 7327 awaits departure with the 1.20 pm (Sundays) Paddington to Gloucester.

It is pleasing to note that today Kemble has lost little of its charm, remaining virtually intact. The branches have gone, and the line between Swindon and Kemble has now been singled, but the service remains buoyant. Class '150/2' 'Sprinter' No 150278 departs for Gloucester with a stopping service from Swindon. *Mrs Toni Ballantyne/GD*

CIRENCESTER TOWN: Cirencester temporarily found itself at the northern end of the Cheltenham & Great Western Union Railway's Swindon to Gloucester and Cheltenham main line when first opened in 1841. It was some four years later, when the line was extended from Kemble towards Stroud, that it became a branch line of $4^1/_2$ miles in length under GWR ownership. Brunel, and his assistant Brereton, designed the impressive Gothic-style Town station which once boasted an overall roof. On 27 September 1958 ex-GWR 0-6-0PT No 9672 can be seen shunting stock in the station yard. During the following years steam gave way to a diesel railbus service, and although there was a quite intensive service of 15 trains per day, it was not sufficiently popular to prevent the complete loss of the passenger service in 1964, at which point the line closed. A second station served the town on the through Midland & South Western line between Swindon, Andoversford and Cheltenham, which closed in 1959.

Today, Town station is the subject of a preservation order and remains in good condition. The building is still connected with transport, now being used as a bus terminus, while the station yard is put to use as a car park. *Peter Shoesmith/GD*

TETBURY: The 7¹/₂-mile branch to Tetbury was completed in 1889. During its existence intermediate stops were at Rodmarton (opened 1904), Jackaments Bridge (1939-1948 for the local RAF base) and Culkerton (closed 1956). When new railbuses were introduced in 1959, Culkerton was reopened and new halts were opened at Church Hill and Trouble House. The railbus experiment was an attempt to operate rural branch lines efficiently and on 7 February 1964 railbus No 79976, one of five lightweight four-wheeled vehicles built by AC Cars Limited, stands

at the terminus in Tetbury. A basic eight trains per day pattern existed, with a journey time of approximately 24 minutes. Unfortunately the experiment was not fully successful and the service was withdrawn, closure taking place in April 1964. The station building dated back to 1913, whilst a platform extension later took place to deal with consignments of polo ponies for nearby Beaufort polo park. Beyond the station can be glimpsed the goods shed, which closed in 1963 when freight traffic on the branch was withdrawn, and the single-loco engine shed with integral water tower.

Only the station drive exists today, although the site of the building can be judged by the grassed area, now only of interest to dogs! Note, however, the outline of the distant gable (centre) indicating the survival of the goods shed. *Hugh Ballantyne/GD*

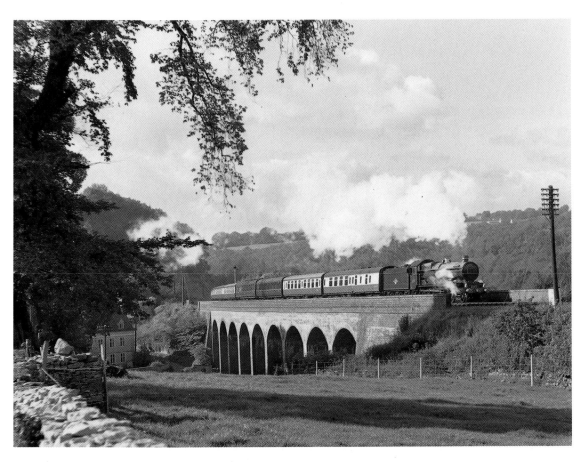

FRAMPTON MANSELL VIADUCT: Beyond Kemble the line climbs to Sapperton Tunnel, after which it drops into the Golden Valley. This has always been a favourite location for photographers, particularly as the graceful nine-arch viaduct blends well with the surrounding valley and buildings of local Cotswold stone. It is also the point where up trains are working hard on the climb from Stroud to Sapperton, as evidenced by 'Castle' 4-6-0 No 5071 *Spitfire* head-

ing a Cheltenham to Paddington express off the viaduct on 18 October 1958. The 'Castle' Class was first introduced in 1923, but No 5071 was of a batch built in 1938; originally named *Clifford Castle*, it was soon re-named after the wartime aircraft.

The viaduct and valley remain unchanged today, except that the bushes have grown somewhat and now restrict the view. The railway remains a distinctive feature, with most passenger services now in the hands of Regional Railways' new generation of DMUs. On 5 September 1991 Class '155' No 155332 heads west with the 14.20 Swindon to Gloucester train. This type of unit is now being split into single-car units to operate on rural low-density lines. Note that refuge points have been inserted along the parapet wall for the safety of permanent way workmen. *Peter Shoesmith/GD*

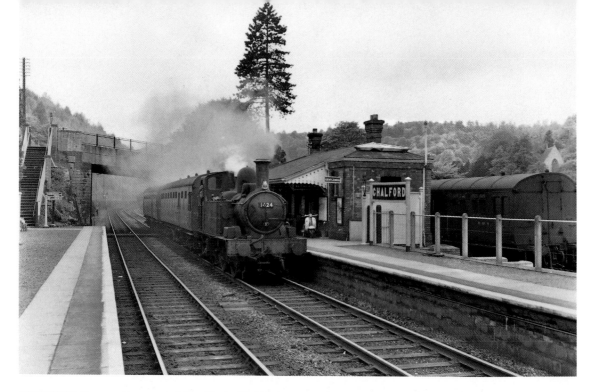

CHALFORD: Seven miles west of Kemble is Chalford, an attractive rural station set deep in the densely-wooded valley. In latter years it was the terminus for the auto-train service from Gloucester, and on 6 May 1961 0-4-2T No 1424 is seen arriving with the 10.08 service from that city. Behind the station building is the goods bay, occupied by W189W, one of a batch of 62 ft 8 in bow-end auto-trailers introduced in 1933.

The station was closed in 1964, since when the buildings and platforms have been removed and the area taken over by a building supplies firm. Passing the old station site in autumn 1991 is a Bristol-based DMU with car 56312 leading, which forms the 14.15 Gloucester-Swindon service. *Hugh Ballantyne/B. M. Williams*

BRIMSCOMBE: A fascinating railway scene is evident at Brimscombe on 7 March 1964. The station, footbridge and signal box can be seen in the background, all of typical Great Western pattern, while in the centre is a one-road engine shed with the unusual feature of the water tower forming an integral part of the whole building - this was a useful way of preventing the water from freezing in winter. Standing in front of the shed and taking water is 'Prairie' 2-6-2T No 4109, the duty banker awaiting the next freight to be assisted up to Sapperton, the ruling gradient being 1 in 74. The locomotive carries the shed code of Gloucester (85B), to which Brimscombe was a sub-shed.

With the station and shed gone, the top corner of the block of flats (top right) is the only feature to link the scene today. The station, along with the nearby Brimscombe Bridge Halt, closed in 1964. In the centre can be seen a white building, which is a public house known as the King and Castle; the outline of a locomotive is just visible on the pub sign in front of the building. This view does illustrate the tight confines of the location as Class '155' No 155332 passes with the 11.56 Worcester to Swindon train. *Hugh Ballantyne/B. M. Williams*

STROUD: Of all the intermediate stations, Stroud is by far the most important. Not only was it served by the Great Western, forming part of the original main line to South Wales prior to the building of the Severn Tunnel, but also the Midland, to a separate station at the end of a spur from Dudbridge on the Nailsworth branch (see following pages). The Great Western route was the most important, though, and its station was re-built in 1914 to provide the appropriate facilities for this bustling market town. The approach from the west carried the railway over a substantial viaduct, and to the east, on the up side, was situated a distinctive goods shed and yard. On 26 March 1964 ex-GW 0-4-2T No 1451 departs with the 1.03 pm Gloucester to Chalford auto-train consisting of a single coach. These trains took over from steam railmotors, which had previously operated the service successfully for many years. The railmotors consisted of a single coach with a small vertical boiler and proved to be a most capable unit.

Little has changed over the years as far as the station is concerned, although the goods yard is now a car park. The goods shed itself has survived, but is not in use. The number of vehicles in the car park gives an indication of Stroud's growing importance as a dormitory town, with commuter traffic to both Swindon and Gloucester. On 5 September 1991 Class '155' No 155311 departs with a Swindon-bound service. *Hugh Ballantyne/GD*

Gloucestershire branches

DUDBRIDGE JUNCTION, NAILSWORTH BRANCH: The branch from Stonehouse, on the main Birmingham to Bristol main line, to Nailsworth was opened in 1867, passing to Midland Railway ownership by 1878. The line had several private sidings with freight services continuing until 1966, although the passenger service was to be one of the last economies of the LMS, being withdrawn 'temporarily' in 1947, never to be reinstated. A spur to Stroud was constructed in 1885, and the junction was at Dudbridge, where on 8 July 1955 ex-MR 0-6-0 Class '3F' No 43373 approaches the signal box *en route* to Nailsworth with a daily pick-up freight. The train had already visited Stroud, the line to which can be seen passing behind the signal box.

The railway layout is still clearly visible today; the cyclist is 'arriving' from Nailsworth whilst the 'Stroud line' diverges to the right. The location of the signal box can be identified by the two trees standing within 'the junction'. *Hugh Ballantyne/GD*

NAILSWORTH: Swindon-built Type 1 diesel-hydraulic locomotive No D9257 shunts the goods yard at Nailsworth on a sunny 3 January 1966; goods services to the town were to last only until 1 June 1966. In the background is the Railway Hotel, flanked on the right by the goods shed and crane. The passenger station, which closed in 1947, was situated on the embankment on the left, positioned thus because plans existed for the line to continue south. It was an attractive building, once used as the headquarters of the Stroud & Nailsworth Railway. At the Grouping there were six trains daily covering the $5^3/_4$ miles to Stonehouse. The locomotive was from a batch of 650 hp units which had a limited life on BR, due mainly to the work for which they were designed disappearing under the Beeching Plan. Following withdrawal, many found gainful employment with the coal and steel industries, and more recently some have found their way into preservation on the growing number of private railways.

The distinctive Railway Hotel remains and on the left the local fire brigade have erected their training tower. The goods shed has been demolished; the building on the right has, however, survived the closure, but was hidden behind the goods shed in the 1966 view. The trackbed of the branch is now utilised for recreational purposes. *Andrew Muckley/JW*

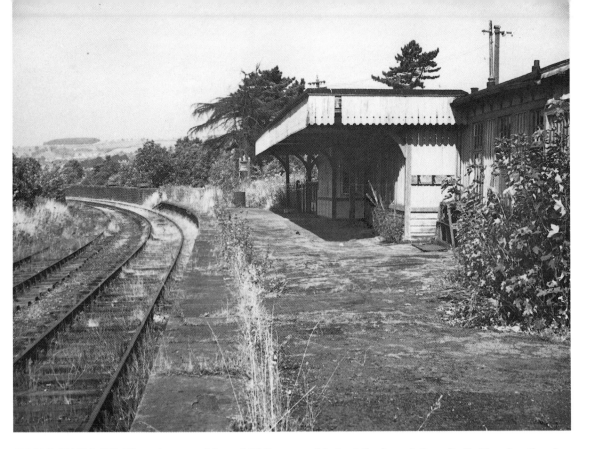

STROUD WALLGATE: The existence of Stroud Wallgate, and indeed the branch from Dudbridge Junction (see page 79), can be attributed to the problems of mixed gauges. Merchandise that was sent north suffered considerable delay and damage with the need for transhipment at Gloucester, where the change from broad to narrow (later called standard) gauge track took place, and this was a source of considerable annoyance to local merchants. Thus encouraged by the prospect of a lucrative source of freight, the Midland, which had already adopted the 'narrow' gauge, opened its own branch into Stroud in November 1885 for goods, and eight months later for passengers. The passenger service was never intensive and was suspended in 1947 as a post-war fuel economy.

However, the service never ran again and closure was confirmed in 1949. Freight traffic continued until 1966. The approach to Stroud Wallgate was by a curved viaduct, the end abutments of which are visible in this August 1964 photograph. At this time the old station was being used by British Road Services. Note that above the oil drum (centre left) one of the station nameboards appears to have survived.

The area around the station has changed considerably, the viaduct having been severed at the station end to make way for a new by-pass, which has also obliterated the station site. However, a large part of the viaduct remains with the arches in commercial use. Note the hill-top woodland to the right of the end abutment - this can be also be seen on the earlier view (far left). *Andrew Muckley/JW*

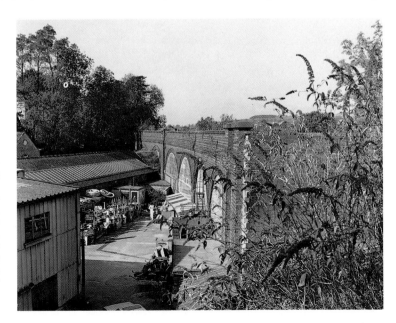

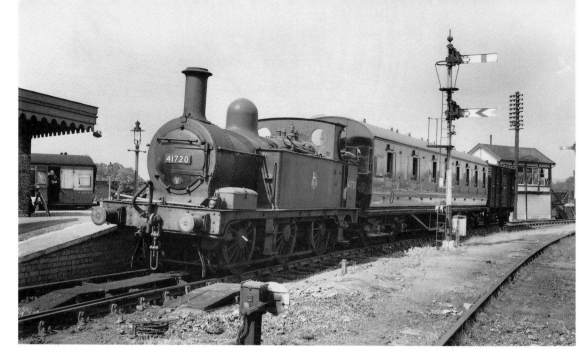

COALEY JUNCTION, DURSLEY BRANCH: The branch to Dursley opened in 1856, diverging from the Birmingham to Bristol main line at Coaley Junction. The station was situated within the junction, serving both branch and main line, as can be seen in this 8 July 1955 photograph. The guard of a main-line train looks out towards ex-MR 0-6-0T No 41720 and its short train, which will form the 4.30 pm to Dursley. Beyond the station on the Dursley side stood the goods shed.

The branch today consists of a short headshunt stopping well before the now rail-isolated goods shed, which none the less survives in good order. A stack of sleepers indicates where the signal box once stood. Passing on the main line is Class '37' No 37207 heading south with an engineers train. The loco carries the colours of the Civil Engineer, nicknamed the 'Dutch' livery as it resembles that of Netherlands Railways. *Hugh Ballantyne/GD*

DURSLEY: Although located near the town centre, the station at Dursley was neatly tucked between two factory buildings. The small but distinctive station building is on the left, the diminutive canopy being a feature. Note how the nearest chimney shows evidence of at least two additions in height to match the more ornate rear double chimney. A typical wrought iron lamp-post stands in the foreground and the platform bench seems in need of attention. Prior to the Grouping the branch had seven passenger trains each way daily, taking 9 minutes for the $2^1/_2$ miles to Coaley Junction. On 8 July 1955 ex-Midland 0-6-0T No 41720 awaits departure with the 4.10 pm service. The locomotive, together with sister engine No 41748, was a feature of the branch for some years, both retaining their open-backed cabs.

The site of the station is clearly evident today, although all trace of the buildings has gone. The left-hand gabled factory roof is the most distinctive feature common to both views, while on the right the traditionally styled factory has given way to a modern utilitarian unit. *Hugh Ballantyne/GD (courtesy of Petters Ltd)*

SHARPNESS BRANCH: The Sharpness Branch, which opened in 1875, was intended to form a through route via the Severn Railway Bridge to Lydney, also serving the nearby Sharpness Docks. The branch was 4 miles in length, leaving the Bristol main line at Berkeley Road. Rationalisation had taken place as long ago as 1931 when singling took place, which is evident from this 26 September 1964 scene, as Class '14XX' 0-4-2T No 1453 heads the 4.15 pm to Berkeley Road at Sharpness. The passenger service ceased later that year, some four years after the through route had been severed following the demise of the Severn Railway Bridge (see page 34).

Only the road overbridge at the north end survives to identify the station site, although the platforms can be identified beneath the thickening undergrowth. Ironically, the branch survives in part to serve the Nuclear Power Station at Berkeley, which is now in the early stages of de-commissioning. The closure of the branch can be predicted, although that day remains some years hence. *Hugh Ballantyne/GD*

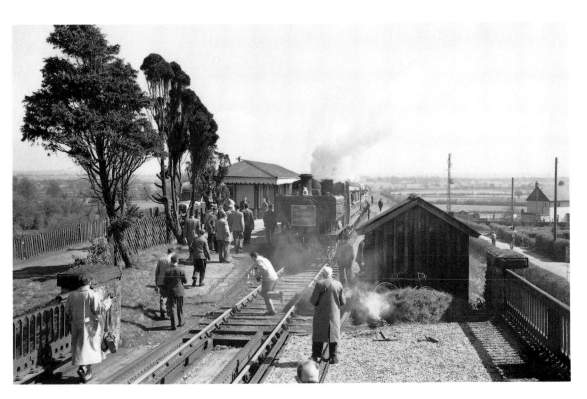

TYTHERINGTON, THORNBURY BRANCH: In 1872 the Midland completed a 7½-mile branch from their main line at Yate (see page 89) to Thornbury, with intermediate stations at Iron Acton and Tytherington. It was not a busy passenger line with three trains per day each way in 1922, and it is of little surprise that the service was withdrawn in 1944. Complete closure came in 1966; some ten years earlier, on 15 April 1956, the 'REC Severn Venturer' railtour traversed the branch hauled by 0-6-0PT No 1625. The tour has paused at Tytherington for a 'photo-stop' and the station seems still in good repair despite having been closed for 12 years.

After closure the track was lifted, only to be reinstated in 1972 to serve the large ARC Quarry at Tytherington. Using rail recovered from the old Midland main line around Mangotsfield, and following the strengthening of bridges, the branch again saw traffic for the conveyance of limestone from the quarry. The present economic down-turn has caused the line to be mothballed, although there was a short burst of activity in the latter half of 1991, albeit only temporarily. the distinctive tree marks the location of the station and in the foreground is one of the new bridges installed to accommodate the heavier trains. Note the avenue of trees which has grown up on either side, effectively screening the railway from the expanding residential quarter of the village.
Hugh Ballantyne/Robin Banks

Midland main line to Yate

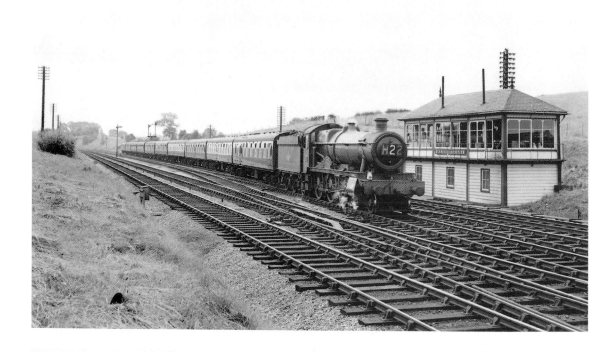

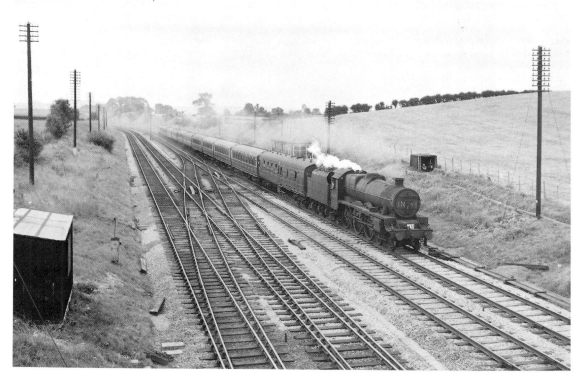

STANDISH JUNCTION: Quadruple track typified the main line between Gloucester and Standish Junction; in fact, it was two sets of double track running in parallel. Metals to the west belonged to the Midland and to the east were Great Western. At Standish Junction three things happened: the two routes split, the Midland to Bristol and the Great Western to Swindon, and the junction allowed Great Western southbound trains to cross to the Midland and head for Bristol, and vice versa.

Left On 20 July 1963 an unidentified 'Hall' working a northbound express crosses from Midland to Great Western metals under the watchful gaze of the signalman in the typically Midland Standish Junction signal box. Note the LMS upper and GWR lower quadrant signals towards the rear of the train.

Below left With its train reporting number crudely daubed on its smokebox door, 'Jubilee' No 45602 *British Honduras* heads for Gloucester with the 9 am Paignton-Leeds on 9 August 1964. The signal box is behind the leading coach, and part of the train consists of Eastern Region stock. To the right of the locomotive is a shelter where the signalman apparently parks his motor-scooter.

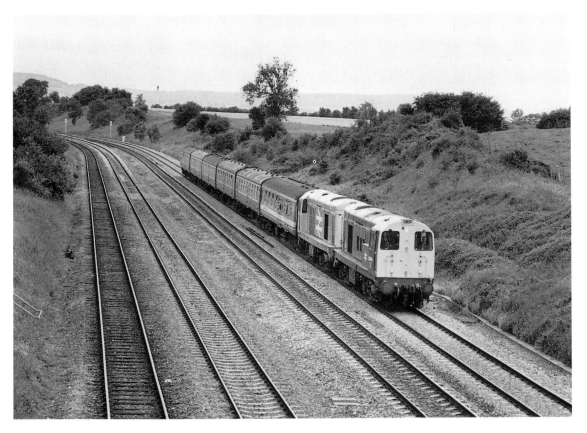

Above Today the junction is situated on the Gloucester side of the road bridge, beyond which the route is now reduced to double track only. Passing the site of both signal box and crossovers are two Class '20' locomotives, Nos 20084 and 20170, heading an enthusiasts' special to Birmingham on 1 July 1990. *Hugh Ballantyne (2)/GD*

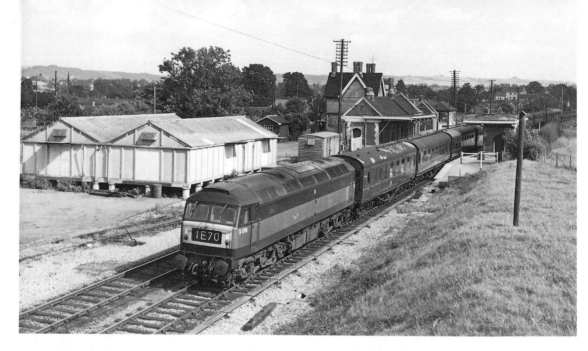

CHARFIELD, one of several intermediate stations between Gloucester and Bristol, is probably best remembered for a horrific crash which occurred on the night of 13 October 1928 when the Leeds to Bristol Mail ran through adverse signals and collided with a freight train. To compound matters, the Mail was then deflected into the path of another northbound goods. Gas, then used for carriage lighting, ignited and added to the carnage, with the resultant blaze raging for hours. Fifteen people perished, of which two were children travelling alone and who sadly were never to be identified. The station itself was served primarily by local services and was closed in 1965 when the trains were withdrawn. By 31 July of that year closure had already taken place as Brush Type 4 (now Class '47') No D1795 passes at the head of the 1.00 pm Paignton to Sheffield service.

The station buildings on the down side remain and the surrounding area is now used by a motor-car main agent. Buildings opposite on the up side have been demolished. However, following local residential growth and an identified need for commuting into Bristol, the station is to re-open in the near future with finance being provided by the local authority. For the moment, though, the encroaching trees along the embankment dictate a more head-on viewpoint as Class '47' No 47812 approaches with the 10.37 Paignton-Edinburgh train on 24 August 1991. *Michael Mensing/JW*

YATE: An unusual occurrence at Yate on 17 October 1965 as 0-6-0PT No 6435 leads 'Castle' 4-6-0 No 7029 *Clun Castle* and a Birmingham to Bristol Stephenson Locomotive Society special off wrong-line working. The pannier tank was on transfer to the Dart Valley Railway and private ownership. *Clun Castle* was also later destined for preservation at the Birmingham Railway Museum and an active main-line career. The original station at Yate had closed earlier that year, and the branch to Thornbury, which diverged to the left, closed in the following June.

By September 1991 Yate had been transformed: the station has re-opened as a 'park and ride' facility mainly aimed at Bristol commuters and plans exist for platform extensions to accommodate longer trains. The line to Thornbury had been reopened as far as Tytherington Quarry in 1972 (see page 85), although present low demand has caused the branch to be mothballed. On the main line Class '47' No 47802 approaches with the 08.40 Liverpool-Paignton. *Hugh Ballantyne/GD*

Bath and the S&D

BATHAMPTON: Looking towards Bath from the east, the elegance of the Georgian terracing, for which the city is renowned, can be seen along the horizon, as Churchward designed 2-8-0 No 4707 approaches with a Westbury-bound freight on 15 September 1962. Consisting mainly of four-wheeled wagons, it contrasts sharply with the high-capacity vehicles typical of today. Note the bracket 'banner' repeaters which give advance warning of the goods loop situated prior to the junction with the Westbury line which at this point is less than 1 mile distant. The locomotive was introduced in 1919 and is one of only nine examples built.

Bath continues to dominate the horizon today but vegetation has grown considerably, necessitating a slightly different viewpoint, as can be judged by the position of the fence. The train is one of the few Regional Railways locomotive-hauled services, the summer 07.58 Cardiff to Weymouth, with Class '37' No 37254 in charge on 29 August 1992. The Civil Engineers livery on the Class '37' contrasts with the attractive Regional Railways colours on the coaching stock. *Hugh Ballantyne/GD*

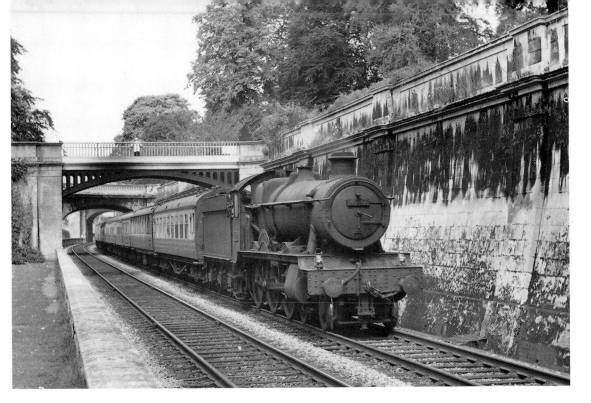

SYDNEY GARDENS, BATH, a short walk from the centre of the city, were laid out in the 18th century as Bath was becoming a well-known and genteel spa. Designed to a high standard, the gardens were intended to match the best on offer elsewhere, particularly in London. Incredibly, especially in relation to today's attitudes, the railway was allowed to pass along the eastern boundary which resulted in the present attractive location from which to watch trains go by. On 4 August 1957 'Hall' 4-6-0 No 4947 *Nanhoran Hall* approaches Bath with a down express.

The gardens retain their timeless charm today, with perhaps the most notable change being the reduction of soot on the bridge and retaining wall. An IC125 service led by Class '43' No 43160 eases through the gardens in preparation for the Bath stop. These units entered squadron service on the Paddington to Bristol and South Wales services in 1976 and have been the most successful concept in rail travel in the UK for many years. *Peter Shoesmith/GD*

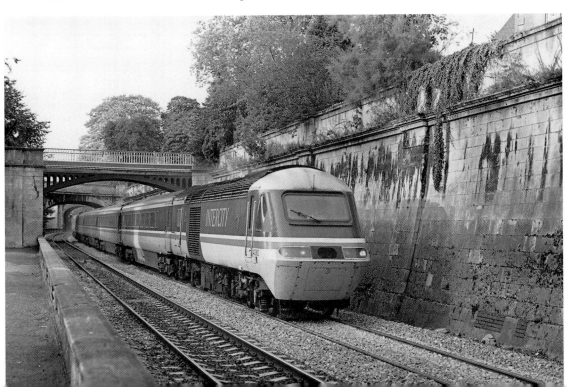

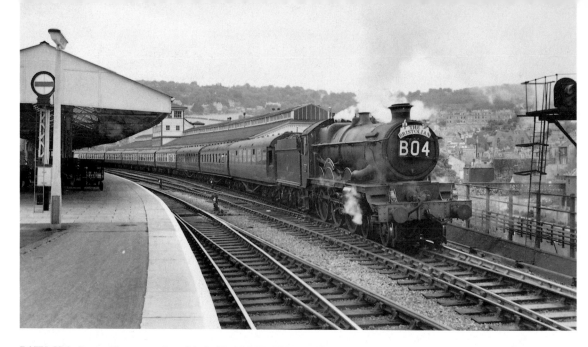

BATH SPA: It would appear that this is 'Castle' No 7006 *Lydford Castle* departing from Bath Spa with the down 'Bristolian' on 14 July 1962. In fact, the train is the summer Saturday equivalent, the 8.45 am to Weston-super-Mare, which ran to a slower schedule, but at the time was one of few regular steam-hauled services; for effect, Old Oak Common Depot added the pleasing touch of using the 'Bristolian' headboard. The normal rake of chocolate-and-cream-liveried stock has been strengthened by three maroon vehicles, the leading coach being an example of ex-GWR 1938 'Centenary' stock. Above the fourth coach is the distinctive elevated signal box, so positioned to afford a good view for the signalman over the long sweeping curve on which the station is situated. The sidings between the main running lines provided stabling for local trains laying over between turns. In the foreground is evidence of the recent extension of the up platform where the tarmacadam takes over from paving stones. Like many other Great Western stations, Bath had an overall roof when first built, but this was removed in 1897.

Today the basic structure remains; note also that the base of the old elevated signal box, which closed in January 1968, is still in situ. A floral display stands where the sidings were located as Class '43' No 43174 leads the 16.45 Paddington to Bristol Temple Meads IC125 service from the station along the elevated stretch of railway, which is a feature as it passes through the centre of Bath. *Hugh Ballantyne/GD*

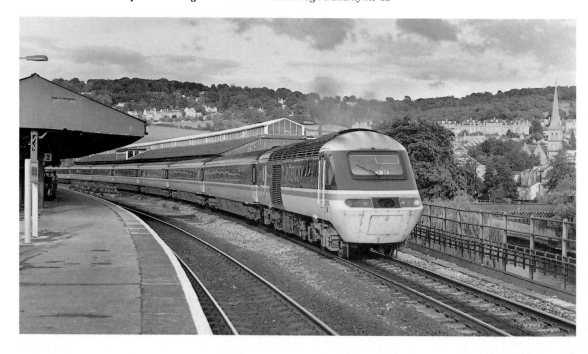

OLDFIELD PARK was the first station west of Bath and catered for local traffic. Passing non-stop on 5 September 1970 is Class '52' No D1038 *Western Sovereign* in charge of the 13.40 Weston-super-Mare to Paddington express. First introduced in 1961, and nicknamed either 'Westerns', as all their names were so prefixed, or 'Thousands', after their numbering sequence of D1000 to D1073, they represented the ultimate design in the Western Region's diesel-hydraulic traction policy. The other Regions had decided on diesel-electric traction and thus the out-numbered hydraulics became non-standard and candidates for early withdrawal. The 'Westerns' were the last class to go, surviving until 1977 and enjoying an Indian Summer of popularity with the enthusiast and operator alike. Six examples have been preserved, although *Western Sovereign* was not so lucky, being an early casualty in 1973.

By August 1992 the general scene at Oldfield Park has changed little, but closer examination will reveal the removal of the up loop and subsequent encroachment of vegetation beyond the retaining wall. The down loop remains, nowadays for the use of trains of domestic waste from the nearby Avon Refuse Collection Yard. Class '43' No 43101 heading the 17.15 Bristol Temple Meads to Paddington express passes non-stop. *Hugh Ballantyne/GD*

TWERTON TUNNEL, BATH: Emerging from the castellated western portal of Twerton Tunnel on 14 July 1962 is BR 'Standard' 2-6-2T No 82037, heading the 1.12 pm Calne to Weston-super-Mare summer Saturday holiday train. Although very much a symbol of BR standardisation, the locomotive is on home territory, being a product of Swindon Works and part of a class of 45 engines introduced from 1952. Twerton itself is a suburb to the west of Bath, and lost its connection to the railway system in 1917 with the closure to its station. This was situated on an embankment on the Bath side of the tunnel, and after closure was used as an outlet for a number of commercial purposes.

Today the scene has changed little, with the loss of the signal box being the most notable feature. The train consists of china clay slurry tankers from Salisbury to Gloucester hauled by Railfreight Distribution Sector Class '47' No 47079, previously named *George Jackson Churchward* after the famous Great Western Railway Chief Mechanical Engineer. *Hugh Ballantyne/GD*

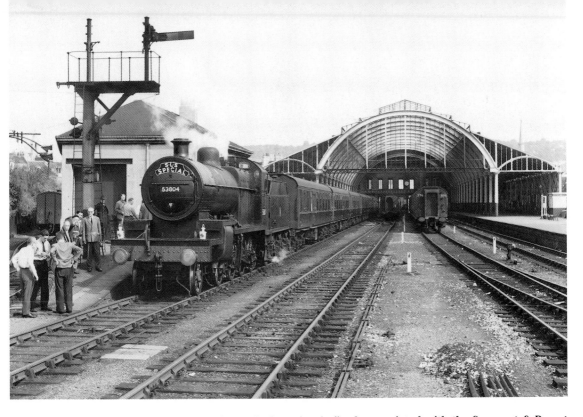

BATH GREEN PARK: The name of Bath Green Park station is firmly associated with the Somerset & Dorset Railway, although in fact it was originally the Midland Railway's terminus for its line from Mangotsfield. Having an impressive frontage, overall roof, two platforms and centre roads, it could on occasion be stretched by traffic demands. This was particularly so on summer Saturdays when holiday trains from the Midlands and the North would have to re-engine before heading south over the S&D. A more relaxed atmosphere is, however, evident on 11 September 1960 as S&D '7F' No 53804 stands at the head of an SLS Special bound for Templecombe. These fine locomotives were introduced in 1914 and were the most powerful on the line until the arrival of BR Standard '9Fs' in 1960. Eleven locomotives were built for the S&D and their Midland ancestry is plainly evident. The last member of the class was withdrawn in 1964 and two have found their way into preservation and main-line running.

Since its closure in 1966 the old station has been renovated to a high standard by J. Sainsbury and is used for exhibitions as well as car parking. (See also page 4) *Ellis James-Robertson/JW*

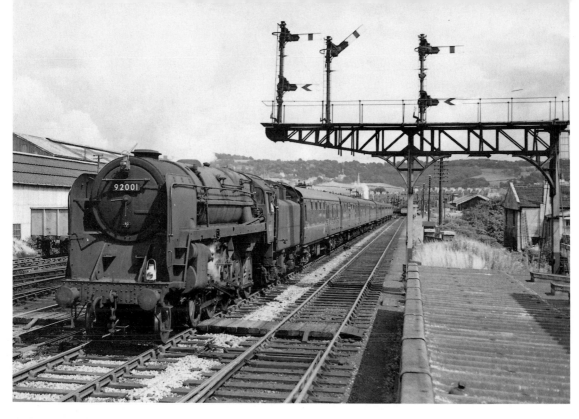

BATH JUNCTION (S&D): For the first half-mile from Green Park the S&D had to run over Midland metals before gaining its own line at Bath Junction. This view looks back towards Green Park; the station signal box is just visible behind the left-hand signal gantry post. Bath Junction signal box is situated behind the photographer, and the signalman there has given the S&D road to Class '9F' No 92001 heading the 7.45 am Bradford to Bournemouth West train on 14 July 1962. The locomotive was one of four '9Fs' drafted to Bath for the summer service and they were to prove most successful over the difficult gradients of the S&D, obviating the need to double-head the heavier trains. The tablet catcher is in position beside the cab steps, and the fireman can be seen awaiting the successful gathering of the single line tablet from the apparatus alongside Bath Junction box.

The trackbed is now partly used as a car park for the factory on the left and in the background the row of terraced properties remain distinctive by virtue of their pronounced chimneys. *Hugh Ballantyne/GD*

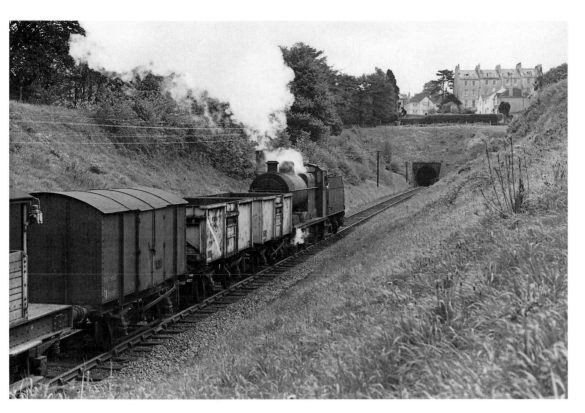

DEVONSHIRE TUNNEL: From Bath Junction the S&D line curved round to the south-east and climbed away at a ruling gradient of 1 in 50. This presented a stiff challenge to southbound trains, with the frequent need for banking locomotives to assist the heavier trains, particularly freights. Towards the top of this formidable climb was the additional obstacle of Devonshire Tunnel; its narrow bore and adverse gradient caused a most unpleasant environment for enginemen working southbound trains, particularly on the footplate of the inner locomotive when double-heading or when working the banking engine. The crew of ex-S&DJR Class '4F' 0-6-0 No 44558 should not suffer unduly, however, as their locomotive is working tender-first towards the tunnel mouth on 13 May 1964 with a short freight.

Today vegetation has closed in and the course of the railway is used as a walkway and cycle trail. The tunnel mouth is hidden behind the trees and bushes (centre). The severity of the gradient is still evident to visitors. *Michael Mensing/JW*

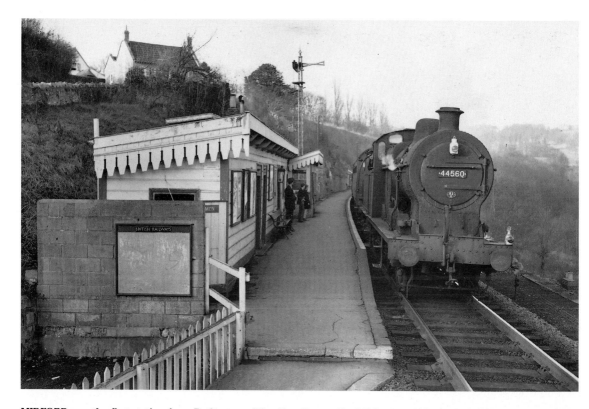

MIDFORD was the first station from Bath, some 4½ miles distant. On 1 February 1964 Station Master Cooper watches ex-S&DJR Class '4F' 0-6-0 No 44560 draw to a halt with the 3.20 pm from Bath to Templecombe local service. This was the last day for the station to be manned; it was to become an unstaffed halt until closure on 5 March 1966, the day on which the Somerset & Dorset Railway closed for ever. The signal box, from where this view was taken, remained until the end. Note the unusual S&D 'calling back' signal, which was used to allow up trains to set back off the single line on to the double-track section that commenced on the nearby viaduct. The locomotive is carrying the distinctive S&D lamp configuration for passenger trains, consisting of top bracket and left-hand buffer beam.

Today the platform remains in situ, the block wall corresponding to the similar structure in the 1964 view, although it appears to have been lengthened. The foreground, where Midford signal box once stood, is now the car park for the Hope and Anchor public house.
Hugh Ballantyne/JW

MIDFORD VIADUCT: This is a classic S&D scene, showing the down 'Pines Express' entering the double-track section that commenced on Midford viaduct and continued to Templecombe. In the background is Midford station, whilst running beneath the S&D viaduct, also on a viaduct, is the Great Western's Camerton to Limpley Stoke line which closed in 1951, but is famous as the location for filming *The Titfield Thunderbolt* in 1952. The 'Pines Express' was the principal train on the route, running from Manchester to Bournemouth. On 15 August 1959 a combination of ex-LMS and Southern Railway power had charge of the train, with Class '4F' No 44424 leading

unrebuilt 'West Country' 4-6-2 No 34102 *Lapford*. Southern 'West Country' 'Pacifics' were not allocated to the line, but were loaned to cover high seasonal demand.

By necessity, today's viewpoint is slightly different as the outlook from the road is now totally hidden by trees. The viaduct remains and the buildings right of centre are located above the site of Midford station and correspond to those above the viaduct in the 1959 photograph. *Hugh Ballantyne/JW*

GW lines around Bristol Temple Meads

BRISTOL TEMPLE MEADS (1): Brunel's original terminus at Temple Meads opened in August 1840 with the completion of the main line to Bath. However, it was to be a further ten months before the through route to Paddington was inaugurated. The design of the magnificent train shed was a typical Brunel masterpiece, the 72-foot-span roof appears to be supported by hammerbeams which are, together with the colonnade, constructed entirely in timber; however, the roof is a cunningly disguised cantilever structure. Although medieval in appearance, the building was functional, containing offices, booking hall, boardroom and stabling facilities. It was later extended in 1865-78 by the architect Sir Matthew Digby Wyatt. Trains used the terminus for 125 years, in latter days predominantly

Midland services. Closure came on 12 September 1965, since when most of the building has been used as a car park. This view, taken on 27 July 1965, shows the run-down building just prior to closure. The area beyond the wagons is the old engine shed above which the office accommodation often had the benefit of steam heating!

The building now enjoys Grade 1 listed status, being over 150 years old and still in virtually its original condition. BR has leased the building to the Brunel Engineering Centre Trust who have embarked on a painstaking restoration project which will turn the old station into a museum and exhibition hall. It was playing host to a model railway show in November 1990 when the 'present' photograph was taken. The old engine shed has been partitioned off, and a picture of Brunel now surveys the scene.
W. Potter/GD

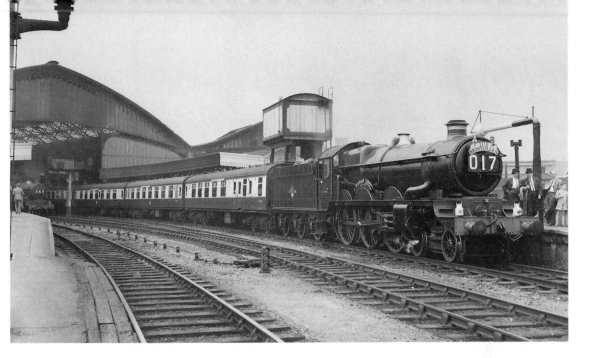

BRISTOL TEMPLE MEADS (2): Prior to 1878 Temple Meads consisted of Brunel's terminus and the Bristol & Exeter station which was positioned at right-angles to Brunel's train shed; a curve connected the two lines, and it was along this curve that a new through station was built in 1878. It was also a joint station, serving the Great Western, Midland and Bristol & Exeter Railways. The major feature of the new station was a superb 125-foot span overall roof which remains in situ today. At the eastern end the new roof joined with the new portal to the terminus station, as seen in this photograph taken on 12 June 1959. Standing in platform 9 is the last steam-hauled up 'Bristolian', with 'Castle' No 5085 *Evesham Abbey* in charge. The headboard contains the city crests of both Bristol and London.

The overall roof has recently been refurbished, but the view in general has been blighted by the Royal Mail's overhead conveyor system for transporting mail bags from the platforms to the sorting office next to the station on the south side; Temple Meads is a major inter-change point for mail trains. Note also that the nearest platform (now number 5) has been extended. Departing from what was once platform 9 is Class '47' No 47825 *Thomas Telford* with the 12.08 Plymouth-Manchester Inter-City service. *Hugh Ballantyne/JW*

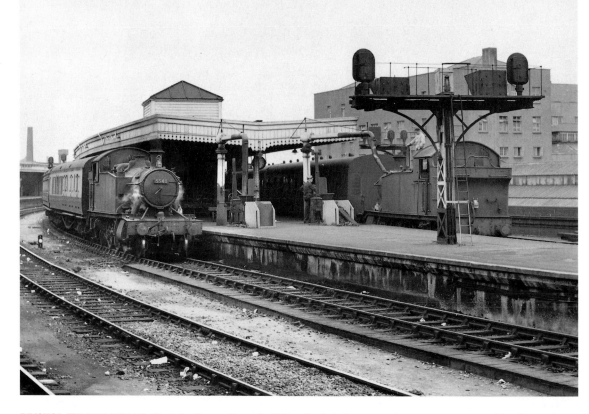

BRISTOL TEMPLE MEADS (3): A further major rebuild took place between the wars, encouraged by Government subsidy to create jobs during the Depression. The result was a major expansion on the south side, beyond the original train shed and stretching into the nearby cattle market. Five new platforms were created as well as substantial infrastructure work in the vicinity. The enlarged station was not quite ready for the Great Western's centenary celebrations in 1935, but the occasion was marked by the inauguration of a new high-speed train between Bristol and London, the 'Bristolian', which departed from Temple Meads for the first time on 9 September 1935. More mundane traffic occupies the new platforms 1 and 2 in this 1950s view, in the shape of '45XX' 2-6-2Ts Nos 5540 (on the left) and 5546 (taking water on the right). The locomotives are operating local services, probably on the Radstock line.

The faded appearance of the old platforms reflect that they are no longer used for passenger services, and see only parcels traffic nowadays. A full renumbering of the platforms has taken place, reversing the old system so that now the low numbers are in the old station (north) and high numbers cover the more recent platforms of the 1935 extension. Modern signalling has enabled platforms to become bi-directional. On 14 October 1992 Class '43' power-car No 43148 is at the rear of the 15.15 IC125 service to Paddington. The Post Office sorting office is the modern building on the right. *Peter Shoesmith/GD*

BATH ROAD ENGINE SHED (82A) occupies the site of the old Bristol & Exeter depot built alongside that company's locomotive works. It was rebuilt in 1934 with a new ten-road shed, repair shop and coaling plant which was topped by a 135,000-gallon water tank. On 9 July 1960 a variety of ex-GW and BR Standard types can be seen outside the shed as 4 pm approaches. Bath Road closed to steam on 12 September of that year with the remaining locomotives being transferred to either St Philips Marsh or Barrow Road.

The depot was completely rebuilt at a cost of over £700,000 and reopened on 18 June 1962 as a diesel depot, since when most types of BR diesel traction have been serviced or repaired there. The old repair shop has been retained (left) whilst the new motive power depot stands on the site of the coaling plant. On the right part of the old steam shed has been retained next to which is the new office block. Parked around the depot are a selection of Class '47s' and '37s' in the liveries of Inter-City, the Civil Engineer and the Parcels Sector. *Hugh Ballantyne/JW*

DR DAYS BRIDGE JUNCTION: An unidentified 'Hall' winds around the curve at Dr Days Bridge Junction with a northbound train, taking the South Wales route from Bristol, which increased in importance with the opening of the Severn Tunnel in 1886. Merging from the left is the spur from North Somerset Junction on the Paddington main line, which allowed London trains direct access to the South Wales route without the need to reverse at Temple Meads. Thus it was possible to improve schedules to South Wales and avoid the long journey via Gloucester (it was to be a further 17 years before the direct line to South Wales via Badminton opened). To the right of the signal box are the extensive carriage sidings.

The junction has now been totally remodelled, with the line from Temple Meads now passing through the site of the carriage sidings. As an approximate guide, the bushes in the 'V' of the junction mark the site of the signal box. Class '47' No 47824 heads north with the 12.16 Paignton to Manchester service. *G. F. Heiron/JW*

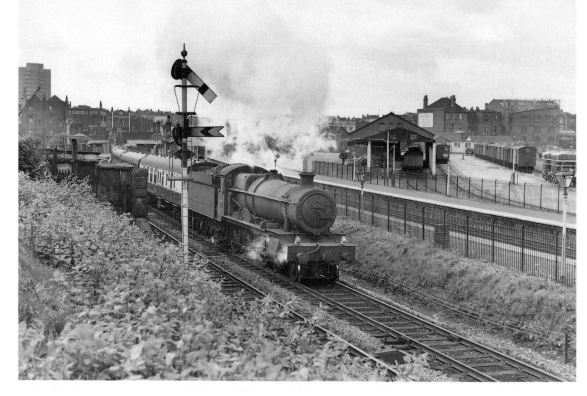

LAWRENCE HILL: The Bristol & South Wales Union Railway of 1863 not only provided Bristol with a suburban train service but eventually, with the opening of the Severn Tunnel, a further main-line connection. (Originally the line ran to New Passage on the Severn where a steamer connection was made to South Wales.) Lawrence Hill was the first station from Temple Meads, 1 mile distant, the buildings being just visible above the first coach of the express hauled by 'Grange' 4-6-0 No 6810 *Blakemere Grange*. To the right is an extensive goods yard and shed, whilst off the picture to the right, on an embankment, is the Midland main line. *Blakemere Grange*'s crew would be working hard to get a good run at Filton Bank.

In 1984 the route from Dr Days Bridge Junction to Filton Junction reverted to double track. The goods yard has closed and is now used as a car park, but a cement terminal has been established which is rail connected. Heading north through the station is Class '43' No 43071. *David Wall/JW*

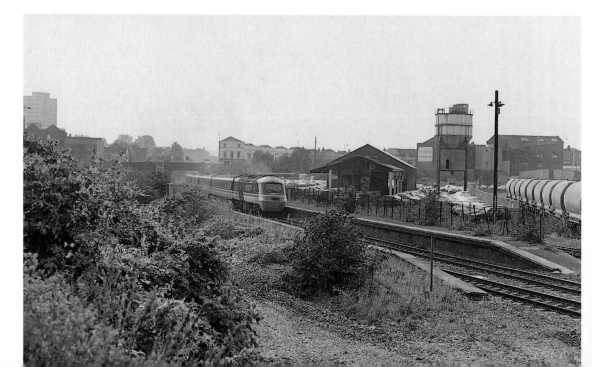

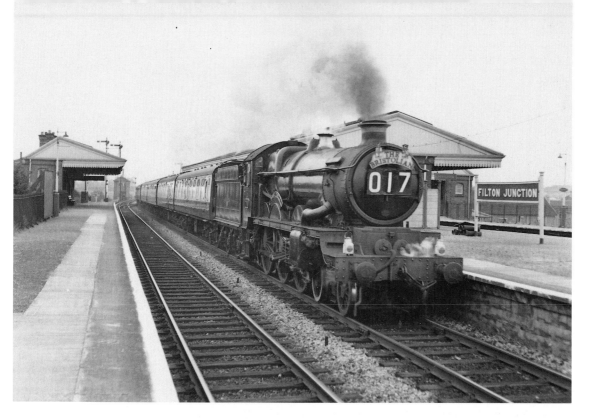

FILTON JUNCTION: Having negotiated Filton Bank, the driver of 'Castle' No 7019 *Fowey Castle* will be easing his locomotive for the long curve into Stoke Gifford. The train is the up 'Bristolian' on 19 May 1959. Filton Junction was a substantial station with the tracks on the far side leading to Patchway and the Severn Tunnel. A spur was also provided to the Avonmouth line.

Not quite, but nearly! The platform from which the 1959 photograph was taken has now been removed and the line to Stoke Gifford can be glimpsed on the extreme left. The view today is taken from the end of the island platform looking towards the Patchway line as Class '158' No 158815 pauses with the 12.01 Bath-Swansea train, one of only seven to serve the station on weekdays. The basic platform shelters give a good indication of its decline, although the wrought iron fences are a reminder of better days. *Hugh Ballantyne/GD*

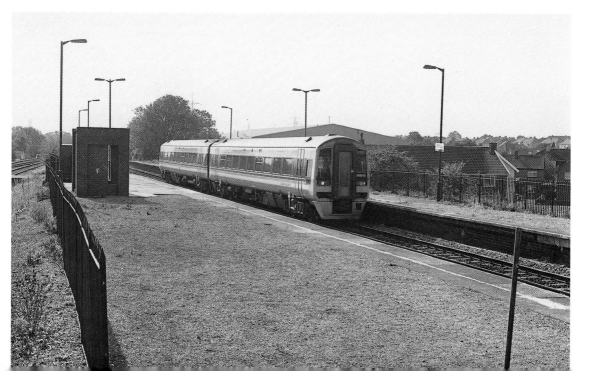

The Midland in Bristol

BARROW ROAD ENGINE SHED: This late 1950s scene conveys well the atmosphere of a large steam shed. Barrow Road was the Midland Shed in Bristol, located to the east of Temple Meads and a few yards along the same road that spans Dr Days Bridge Junction. Its allocation was smaller than the two Great Western depots, and in January 1954 had charge of 55 locomotives. This is the view looking over the parapet of Barrow Road bridge, which conveniently overlooked the shed and the Midland main line (extreme left). A mixture of ex-Midland and LMS types can

be seen, along with a couple of ex-GW pannier tanks. One engine of note, parked between the left-hand chimney and the lamp-post, is 'Jubilee' No 45690 *Leander* which after withdrawal was rescued from the scrapyard and completely restored to main-line condition. An active main-line career followed, and the locomotive is now at the Severn Valley Railway awaiting overhaul.

Barrow Road Shed closed in November 1965 and was demolished the following year. This is the scene today from Barrow Road bridge today with the whole vista having changed. Off the picture to the right is the remains of the old line to St Philips Station (closed 1953) which survives today for trains to reach the household refuse collection terminal located on the branch. *G. F. Heiron/GD*

KINGSWOOD JUNCTION: The Midland exit from Bristol was equally as difficult as the Great Western's line via Filton, with a stiff climb to Fishponds. Midway was Kingswood Junction where, on the right, ran the line from Ashley Hill Junction (on the Clifton Down-Avonmouth branch). In May 1964 'Castle' Class 4-6-0 5091 *Cleeve Abbey* battles against the gradient with an express for the Midlands. The locomotive carries the reporting number 1M37: the figure 1 indicates that it is a class 1 train (an express), the M that its destination is on the London Midland Region and the 37 is the train identification number. Diesels had the benefit of a neat four-character blind system, but the fast diminishing stock of steam locomotives often had their number chalked on the smokebox door - on No 5091 the code 1V51 has not been cleaned off from a previous working, the V indicated a working destined for the Western Region.

It is difficult to imagine that a railway ever ran through the location today. The old main line is a cycleway, partially hidden by the hedge, and a new housing estate has been built on the land that was occupied by the junction, with the course of the Ashley Hill line off to the right behind the white stuccoed house. The only clue to the past is the row of terraced houses in the left background. *David Wall/JW*

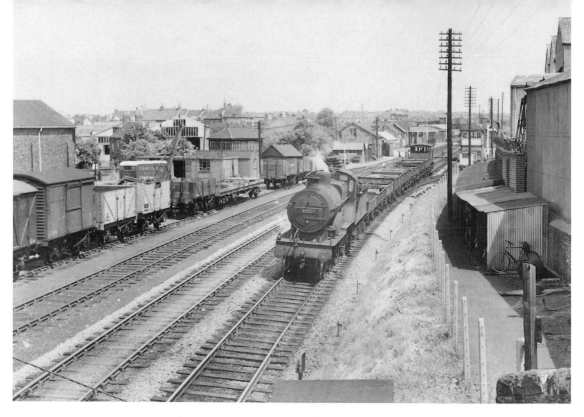

FISHPONDS: The first Midland station from Temple Meads was Fishponds, some 3 miles distant. It was mainly served by local stopping trains and was built in traditional Midland style; on the left is a goods yard of sufficient size to justify its own signal box. Drifting through the station is ex-MR 4-4-0 No 40501 on a short freight. This design of loco dated back to 1912 and, in various forms, was common all over the Midland system.

The site of the goods yard has now been totally cleared, and the road overbridge in the distance is all that indicates the location of the station, of which the platforms remain. The actual railway formation is a much-used cycleway. *E. T. Gill/GD*

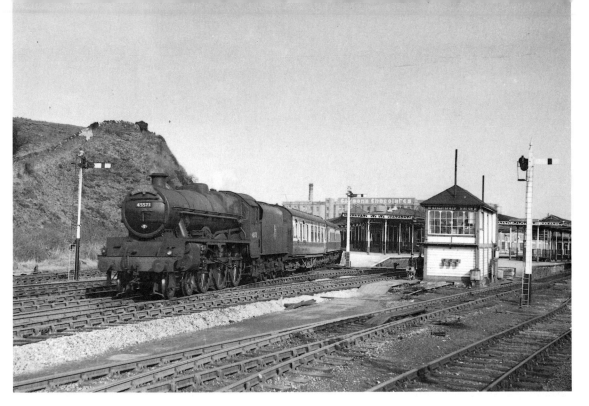

MANGOTSFIELD: At the Bristol end of Mangotsfield station, the Gloucester and Bath lines converged at West Junction. This view dates back to the late 1950s and shows 'Jubilee' 4-6-0 No 45573 *Newfoundland* heading the southbound 'Devonian'. In the background is Carsons Chocolate Factory, a well-known landmark, behind which ran a chord between the Gloucester and Bath routes to create a triangle of lines. The station had four platforms, with the main building situated within the junction, and was of classic Midland design.

The station closed in 1966, and has been partially demolished, with the platforms and some walls of the building remaining. A cycleway now follows the Bath route and in the background is the outline of the chocolate factory, although nowadays it is used for other purposes. *G. F. Heiron/JW*

MANGOTSFIELD NORTH JUNCTION: Rounding the curve from the station at Mangotsfield North Junction is 'Jubilee' 4-6-0 No 45577 *Bengal* heading a northbound express for Birmingham. The train consists of coaching stock painted in the then standard 'blood and custard' livery. Coming in from the left is the chord from the Bath line, and the rear of Carsons Chocolate Factory can be seen above the first coach. Mangotsfield North Junction signal box is on the left.

It is still possible to walk the old trackbed from Mangotsfield station site to North Junction, and the chord to Bath is also accessible. All trace of railway infrastructure has, however, gone, but the outline of the chocolate factory remains a feature. *G. F. Heiron/JW*

WESTERLEIGH (1): The Midland Railway's main goods yard was situated at Westerleigh on the north-east outskirts of Bristol, near Yate. The sidings were laid on the east (down) side and consisted of 24 roads split between two yards. They were closed in February 1965, the traffic being transferred to the nearby Stoke Gifford Yard. Although on different routes, a spur from the Midland at Yate to the Great Western Badminton line just north of Westerleigh gave equally easy access to Stoke Gifford. On a warm August day in 1964 a relief to the northbound 'Cornishman' passes Westerleigh hauled by 'Castle' 4-6-0 No 4082 *Windsor Castle*. The photographer's vantage point is the steps of the signal box.

Traffic was reintroduced to Westerleigh in 1985 when Avon County Council opened a rail-served household refuse disposal point. Later, in 1991, a new Murco oil distribution terminal opened, bringing regular oil block trains from West Wales. On 10 August 1992 Class '60' No 60025 *Kinder Low* draws the 17.45 return empties to Robeston out of the Murco terminal. Also on site is a BR Civil Engineers depot. *David Wall/Don Gatehouse*

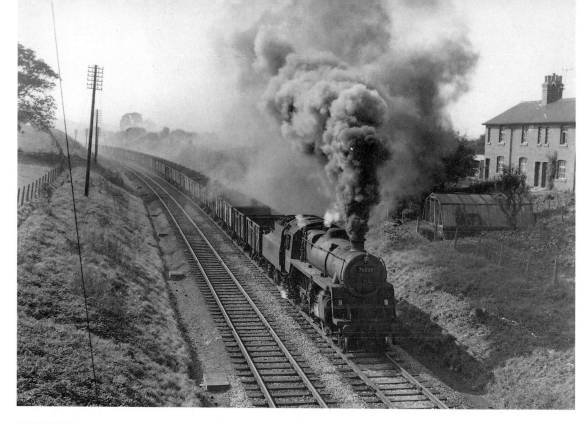

WESTERLEIGH (2): At the north end of the yard the line enters a shallow cutting on the approach to Westerleigh village. This view was taken on a sunny day in May 1964, but not a good washing day for the occupants of the ter-raced houses due to the volcanic exploits of BR Standard Class '4' 2-6-0 No 76038 as it lifts a long raft of wagons from the yard.

The line is now singled as traffic is reduced to the daily household refuse train, a thrice weekly oil train plus traffic to the Civil Engineer's depot. Note how the end terraced properties have been combined and extensively renovated. *David Wall/JW*

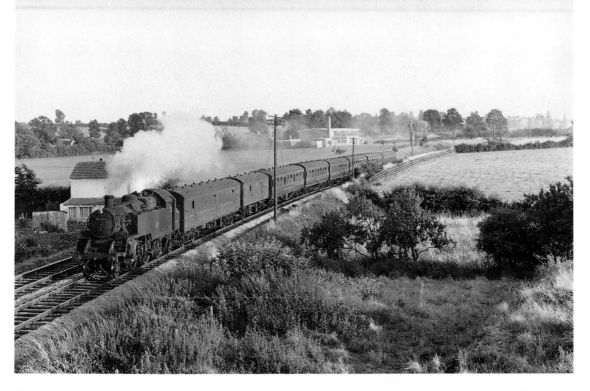

NEAR WARMLEY: The line from Mangotsfield to Bath Green Park was upgraded because of its growing importance as a cross-country route via Bath and the Somerset & Dorset. The Midland was thus able to establish a valuable traffic flow from the North and Midlands to the South Coast. The line also served communities on the northeast side of Bristol, and this scene is just to the south of Warmley with BR 'Standard' 2-6-2T No 82001 leading a Bath Green Park-Bristol via Mangotsfield train in August 1964. Bath to Bristol via the Midland was 3 miles longer than the Great Western alternative, and it was to be the latter which ultimately survived.

The Midland line lost its passenger service in 1966 and closed to freight in 1971. The vegetation has now closed in, but the trackbed is still in good use as a cycleway. On the right a new housing estate has been built and the school remains visible in the background. To the south of this spot, at Bitton, a preservation scheme exists. Known as the Avon Valley Railway, it offers a steam service at weekends and is well worth a visit. *David Wall/JW*

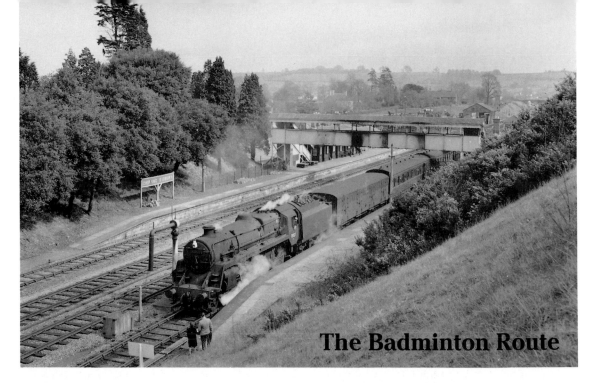

The Badminton Route

CHIPPING SODBURY: BR Standard Class '5' 4-6-0 No 73027 is admired by father and son as it pauses at Chipping Sodbury with the 11.23 am Swindon to Bristol Temple Meads stopping service on 25 March 1961. Beyond the footbridge on the up side is a busy goods yard with a substantial goods shed. The yard was closed in 1966, some time after the passenger station had closed following the withdrawal of the local service.

The platform on the up side remains, as does the typical Great Western station building; the latter, like the goods yard, is used by the Civil Engineers department, although the centre of the yard is a caravan store. Both fast lines remain in use but the down platform loop has been removed, although the up loop has been retained for access to the goods yard. Class '43' No 43027 leads the 12.00 Paddington to Swansea IC125 service on 11 September 1991. *Hugh Ballantyne/GD*

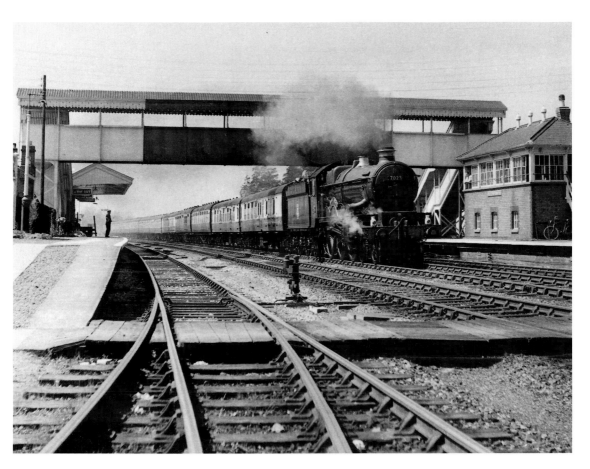

COALPIT HEATH was one of two stations between Westerleigh and Stoke Gifford on the Badminton route. Typically for the Great Western it was a quite substantial station serving a small community and was an early closure in 1961. However, a few years earlier everything seems in good order as 'Castle' No 7023 *Penrice Castle* hurries by heading the 8.00 am Pembroke Dock-Paddington express. Coalpit Heath had been reached by Bristol's first railway, a horse-drawn tramway from the River Avon at Avonwharf in 1835, built to transport coal from local mines.

The station building survives on the down side, and note how the old canopy has been retained as part of a post-closure wooden extension. The platforms also survive, with the gap beneath the far platform locating the site of the signal box. High Speed Trains are usual on this stretch of line, working to London and the North via Birmingham. On 14 October 1992 Class '43' No 43014 heads the 09.25 Penzance to Edinburgh through the station. Note that the power-car has buffers, one of the few so fitted as part of push-pull working trials with electric locomotives. *G. F. Heiron/GD*

STOKE GIFFORD YARD opened with the advent of the Badminton route in 1903. Situated at the eastern edge of Filton Junction, it had ideal access to Bristol, Avonmouth, South Wales, the Midlands and London, and was enlarged in 1914 to provide 14 up roads and 10 down roads. The yard is not, however, at full capacity in this May 1964 photograph, which shows BR Standard Class '9F' No 92118 departing eastbound with a rake of mineral wagons. In the background is a BR Class '08' shunter and an ex-GW '47XX' Class 2-8-0.

The yard closed in October 1971 and much of the land on the up side was used for the car park to serve the new Bristol Parkway Station, which can be seen in the background. Opened in 1972, it soon became very successful and has been a model for similar stations around the country. A measure of its popularity can be gained by the sheer size of the car park, although Saturdays are quieter, as this view taken on 12 October 1992 indicates, with Class '43' No 43157 passing at the head of the 12.20 Bristol-York service. The station is also a major interchange point, serving both the Paddington-South Wales main line and the important South West-North via Birmingham cross-country route. The sidings that remain in the old down yard now belong to the Civil Engineer's Dept. *David Wall/JW*

Lines to Avonmouth

STAPLETON ROAD (NARROWAYS HILL) JUNCTION: A Class '63XX' Type 2 diesel-hydraulic locomotive leads a lengthy mixed freight on to the Avonmouth line at Stapleton Road in May 1964. The class were introduced from 1959 onwards and were intended for intermediate passenger and freight duties. Their career span was, however, short, the first withdrawal being in 1967, and the class was extinct by January 1972. The final member, No 6357, had been in service for only six years and one month when it was withdrawn on 12 December 1968. After leaving the South Wales main line, the Avonmouth branch climbs to Ashley Hill Junction and heads west via Clifton Down Tunnel before joining an earlier line from Hotwells (beneath Clifton Suspension Bridge) at Sneyd Park Junction. The spur to Hotwells closed in July 1922 to make way for the Portway, a major road development to the docks.

In the present-day view a two-car DMU with motor brake No 53948 leading heads on to the now sin-gled branch at what is known today as Narroways Hill Junction. The branch was singled as part of the Bristol resignalling scheme which was completed by 1972. *David Wall/GD*

119

SEA MILLS: After emerging from Clifton Down Tunnel, the line enters the western end of the Avon Gorge before reaching Sea Mills, situated on the bank of the River Avon at a point where it is joined by a minor tributary. The background houses indicate that this is a prosperous area of Bristol. The train is an afternoon service from Bristol Temple Meads to Avonmouth on 16 June 1958 hauled by an ex-GW 'Mogul' 2-6-0 No 5311, and consisting of suburban stock.

Singling took place in 1972 with the introduction of the Bristol resignalling scheme, which also involved the removal of the down platform. Today all trains use the remaining platform which has contrasting styles of waiting shelter. In September 1991 a two-car DMU consisting of Nos 54097 and 53602 arrives with a Bristol Temple Meads to Severn Beach service. The main station building (off the picture to the left) still survives. *E. T. Gill/GD*

AVONMOUTH DOCK: In order to serve Avonmouth Dock a loop was created off the main line which by-passed Avonmouth station and allowed direct access to the considerable sidings and the docks' internal railway. At Gloucester Road Crossing the loop was very close to Avonmouth station, where both railways ran parallel, the two lines crossing Gloucester Road just a few yards apart. On 9 June 1964 diesel-hydraulic Type 2 No D6356 eases a mixed freight over the level crossing. Note the large dockside warehouse and concrete silo in the background and the wartime air raid shelter next to the signal box.

All traces of the railway have now been removed, the lower viewpoint being dictated by the crossing footbridge having been dismantled. The warehouse, silo and air raid shelter, however, remain. The docks are still active - indeed, they are set to see a large increase of traffic when the new coal import terminal is completed.
E. T. Gill/JW

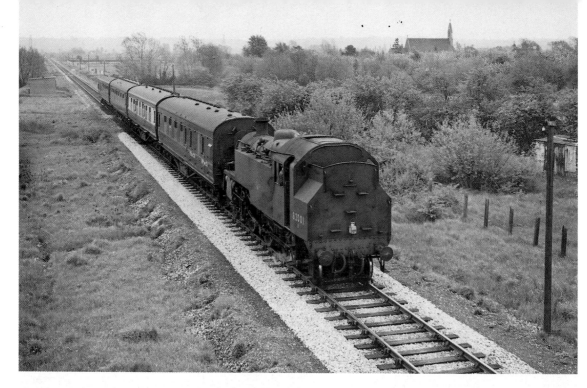

CROSS HANDS HALT: The extension of the railway to Pilning via Severn Beach opened to goods in February 1900, but the passenger service did not commence until 1922. The line crossed the Severn Tunnel close to its eastern portal, and utilised part of the old route to New Passage Pier. On 9 May 1958 BR Standard Class '3' 2-6-2T No 82001 approaches Cross Hands Halt with the 5.20 pm Bristol Temple Meads-Severn Beach train, which will have travelled via Patchway and the main line before taking the low level line at Pilning. Note also that the train consists mainly of LMS stock, which is a reminder of the Midland Railway's influence in this predominantly GW area.

The distinctive church pin-points the scene today, and the course of the railway is still clearly evident. *Michael Mensing/JW*

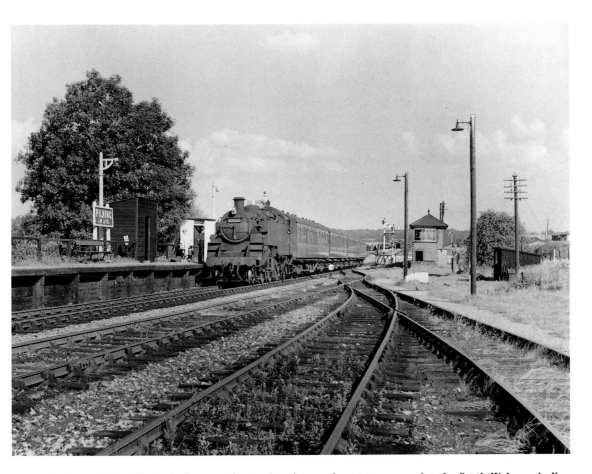

PILNING (LOW LEVEL): Pilning had two stations only a few yards apart, one serving the South Wales main line whilst Low Level accommodated the Severn Beach and Avonmouth trains. The branch left the main line at the eastern end of the stations, with the branch falling away slightly before crossing the Pilning Road and entering Low Level station. This was a rudimentary affair consisting of one wooden platform and a couple of buildings, the nearest being a timber-built waiting shelter. Whilst most northbound trains terminated at Severn Beach, seven services continued through to Pilning just prior to the withdrawal of the train service in November 1964; freight continued until 1968. On 28 June 1960 BR Standard 2-6-2T No 82044 draws to a halt with the 5.50 pm Bristol Temple Meads to Severn Beach and Avonmouth train.

The station area has now been developed, but note that the crossing gates remain (in the background, right of centre) in the position to which they were returned after the passage of the last train. Pilning main-line station remains open, just, with a service of one train each way per day. *E. T. Gill/GD (courtesy of Mr Stocker)*

HENBURY: The opening of the Badminton route created the need for a more direct access to Avonmouth, which resulted in the Filton line being opened in 1910. The branch was one component of a three-way junction, whereby the main line from Badminton gave access to Temple Meads to the south, and to South Wales via the Severn Tunnel to the west, and vice versa. Thus trains from both London and the Midlands could reach Avonmouth without the need to pass through Bristol. Henbury was one of four passenger stations on the line and presents a neat and tidy appearance in this late 1950s view as 0-6-0PT No 3748 pauses with an Avonmouth train. Judging by the number of passengers leaving the station, the train was well used.

After losing its passenger service in 1964, the line reverted to freight-only operation and was singled as part of the Bristol resignalling scheme. Recently, Avonmouth has been identified as the western gateway for imported coal, with Didcot Power Station being a prime destination. To cater for the projected dozen-plus trains per day, the branch is again being doubled. At Henbury, part of the old platform has been cut away in preparation for the extra track as Class '60' No 60024 *Elizabeth Fry* passes with a train of liquid petroleum gas from Furzebrook to Hallen Marsh on 30 June 1992. *E. T. Gill/GD*

HALLEN MARSH JUNCTION: The line from Filton via Henbury joins the Severn Beach route at Hallen Marsh, which as can be seen from this July 1986 view is situated in the heart of the Esso petroleum plant at Avonmouth. At that time the area was controlled by manual signal boxes and lower quadrant semaphore signals. Hallen Marsh signal box was of typical Great Western design and is in contrast to the hi-tech plant on the horizon. The train is the 17.25 ICI Severnside to Dringhouses (York) freight consisting of empty vans for Rowntrees Chocolates in York, and the distinctive 'Cobra' potash wagons returning empty to Boulby on the North East coast above Whitby. Hauled by Class '37' No 37125, the train is winding off the Severn Beach line prior to running round and heading north via Filton.

Only six years separate these two views, but by 1992 the semaphores have gone, Hallen Marsh signal box has been demolished and the track rationalised. The train is the same as that seen at Henbury on the previous page. The Class '60' is BR's freight locomotive for the future, introduced to compete with the American designed and built and designed Class '59s' which are heavy-haul locomotives privately owned by Foster Yeoman and ARC. *GD/GD*

Bristol Harbour lines

BRISTOL HARBOUR LINES (1): The Canon's Marsh goods branch opened in 1906 and served the north side of Bristol's Floating Harbour, which had been cut from the Avon to allow vessels to navigate nearly to the city centre. The branch ran from Ashton Junction, on the Portishead line, over a swing bridge at the entrance to the Floating Harbour, then along the northern perimeter of the harbour to Canon's Marsh itself. Ashton Swing Bridge had two levels - the upper carried the roadway and the lower the railway. It was last opened in 1936 and became a fixed structure in 1953. The sidings at Canon's Marsh ran close to the cathedral, which can be seen on the far left of this February 1959 scene as 0-6-0PT No 3776 heads towards Ashton Swing Bridge with a goods train. The branch at this point is sandwiched between the harbour and main road. Note the dry dock on the far side of the harbour, which was destined to become the home of an illustrious vessel.

The branch closed in June 1965, with the course of the railway at this point now a pleasant promenade with good views of the harbour and its star resident, Brunel's SS *Great Britain*, which is now being restored after a dramatic rescue from the Falkland Islands. The ship is open to the public, and one of many attractions in the area. *E. T. Gill/GD*

BRISTOL HARBOUR LINES (2): Cumberland Basin is at the western end of the Floating Harbour and close to Ashton Swing Bridge. The railway curves sharply at this point, negotiating a level crossing before reaching the swing bridge. On 20 November 1963 '63XX' Type 2 diesel-hydraulic locomotive No D6351 stands at the signal cabin awaiting the road over the level crossing before proceeding to Ashton Junction. The Floating Harbour forms the backdrop with the twin towers of the cathedral just visible above the rear cab of the locomotive.

The 1963 photograph was taken from a now demolished footbridge, so today's view is from a vantage point further back. It does, however, permit the location of the level crossing to be included (foreground) as the railway ran between the two nearest houses. Note the building with the gable at the end of the waste ground, which is the same structure as that in the 1963 view, to the right of D6351. Considerable re-development has taken place around the harbour, with the masts of the *Great Britain* and the cathedral visible in the background. *E. T. Gill/JW*

Portishead branch

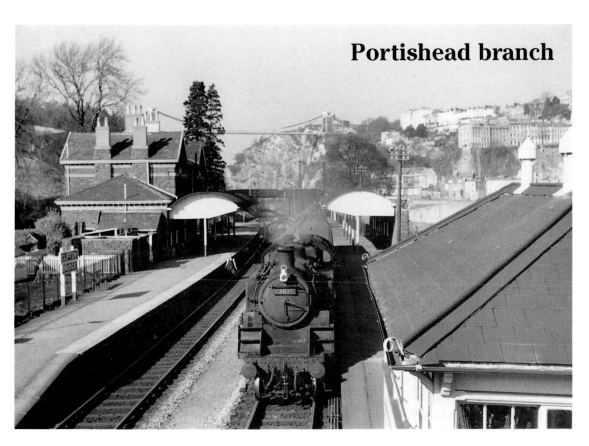

CLIFTON BRIDGE: The Portishead branch, which opened in April 1867, was 11½ miles in length from Bristol Temple Meads. It left the Exeter main line at Bedminster Junction and wound its way through the Avon Gorge, passing beneath Brunel's Clifton Suspension Bridge. Clifton Bridge Station was located at the entrance to the gorge, which can clearly be seen in the background spanned by the impressive bridge. On 16 March 1961 BR Standard 2-6-2T No 82035 awaits to depart with a Temple Meads-bound service. The station had an impressive building, with platform canopies of an attractive 'half barrel' design. The River Avon runs to the right of the station whilst in the background is the Hotwells district of Bristol, which was the destination of the original line from Avonmouth.

The viewpoint remains the same but what today's photograph does not reveal is the absence of steps on the footbridge causing the photographer to balance precariously on the metal lugs which once supported the step planking! The location is now tightly hemmed in by trees although one platform is visible plus some of the track. The station house has gone but still dominating the background is Brunel's famous bridge. *E. T. Gill/GD*

PILL: Beyond the gorge and some 7½ miles from Temple Meads is Pill, an area now expanding due to the proximity of the nearby M5 motorway. Back in February 1962 modernisation is also apparent as a DMU consisting of units Nos 55032 and 56292 working the 1.15 pm to Bristol crosses with the 1.00 pm Bristol-Portishead service hauled by 0-6-0PT No 7729. Passenger services survived until September 1964, and as recently as 1985 the branch was used for a steam shuttle service as part of the GW150 celebrations.

The cutting is now very overgrown, and the right-hand platform has disappeared beneath trees and bushes. The left-hand platform has fared a little better with the edging slabs still visible. Note that the track is still in situ: essentially the branch is mothballed, as plans for a Metro tramway or light railway system have been discussed. Some years ago a scheme was considered to link the branch to Royal Portbury Dock, but this came to nought. *Hugh Ballantyne/JW*

PORTBURY was the penultimate station on the branch, although it was remote from the settlement it served. The station house is an impressive two-storey building with a small goods yard which ran behind the building at the Bristol end. On 13 November 1958 the branch-line train approaches hauled by 0-6-0PT No 9626. Note the signal box and semaphores in the left background. Portishead itself was 2½ miles distant; its original railway station was taken over by the enlarged power station during the Second World War, and a new station opened in 1954, the first new peacetime station to be completed. Today even this has been totally obliterated beneath a petrol filling station.

The station house at Portbury is now in private hands and has seen a number of improvements. A lawn covers the site of the goods yard, but the overgrown track and platform are still evident, although the M5 motorway now separates the station from Portbury itself. *E. T. Gill/JW*

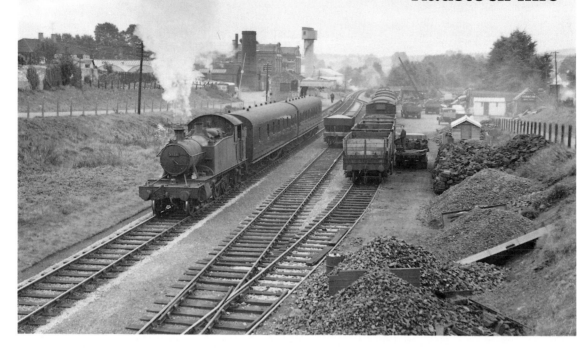

BRISLINGTON: The Bristol & North Somerset Railway from Bristol to Radstock and Frome opened in 1873, and was absorbed into the Great Western in 1884. Stations served local communities along the essentially rural route, although the movement of coal from the North Somerset coalfield was another important source of traffic. Brislington was the first station from Bristol, and was situated some 2¹/₄ miles from Temple Meads. The facilities provided were basic, consisting of one platform and station building to cater for a low-density service. Opposite is the goods yard which is a hive of activity, catering for general merchandise as well as domestic coal. On 24 October 1959, ex-GW 2-6-2T No 5536 departs for Bristol with the 10.50 am service from Frome.

Remarkably the station remains largely intact today. The platform edge can clearly be identified whilst the station building appears in relatively good order, only the canopy having been removed. Note also the telegraph poles which have also survived. *Hugh Ballantyne/JW*

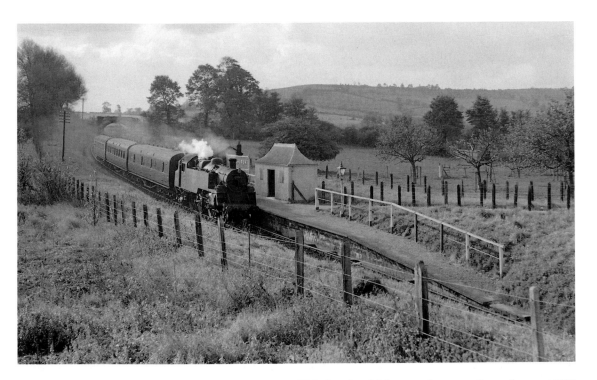

WHITCHURCH (AVON): A classic rural station scene at Whitchurch, which opened as recently as January 1925 and served the nearby village. Its GWR heritage is typified by the 'pagoda' waiting room situated on the single-platform halt. However, the traction by 31 October 1959 was of definite BR origin, with Standard Class '3' 2-6-2T No 82040 drifting to a halt with the 10.50 am Frome to Bristol Temple Meads service.

Although the foreground has been cleared, obliterating any sign of the railway, the background hill and left-hand tree identify the location today. The bridge, visible behind the train in the 1959 view, remains, although now totally hidden by vegetation. It is also likely that the distinctive foreground tree (right) and that partially hidden by the pagoda shelter are the same. *Hugh Ballantyne/JW*

133

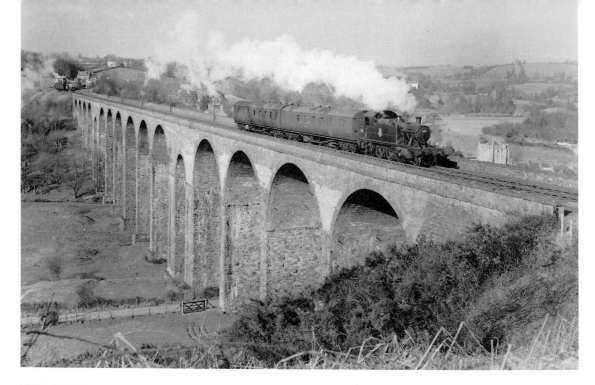

PENSFORD VIADUCT: The major feature of the line was a 16-arch stone viaduct bridging the valley at Pensford. The village is located on the far side of the viaduct, as indicated by the church tower just to the right of the loco-motive buffer beam. Pensford station can be seen at the far end as an ex-GW 2-6-2T No 5508 heads south with the 2.53 pm Bristol Temple Meads to Frome service on 14 March 1955. The viaduct was built to accommodate double track, and although the line catered for the extensive North Somerset coalfield, doubling never proved necessary. Following the demise of the passenger service in 1959, freight remained until July 1968, closure then being has-tened by a serious landslip near Pensford.

The viaduct continues to dominate the scene today, remaining in good order. At the far end, the site of the sta-tion and goods yard show evidence of redevelopment. *Hugh Ballantyne/GD*

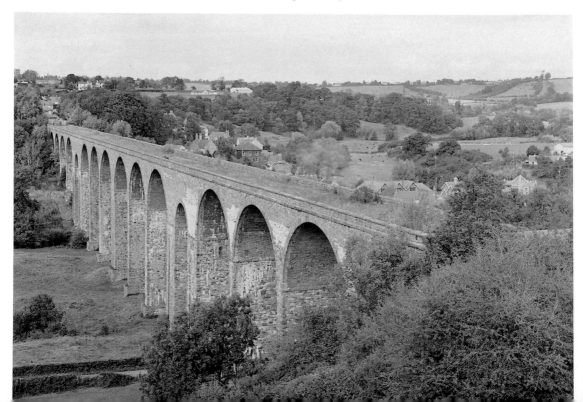

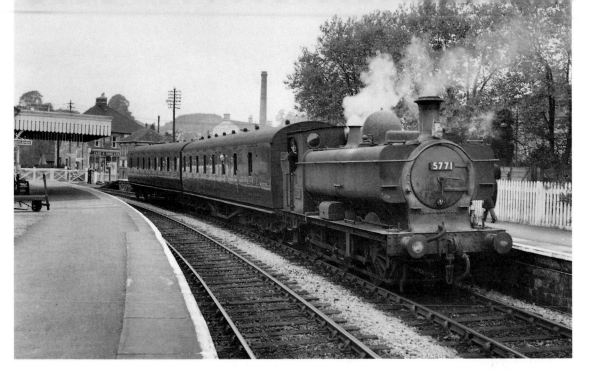

RADSTOCK: The passenger service survived until 2 November 1959, and nine days earlier 0-6-0PT No 5771 stands in Radstock (GW) with the 2.53 pm Bristol to Frome service. The GWR station was in the centre of the town; at that time Radstock still had two stations, as the Somerset & Dorset station was only a short distance away. Radstock was also a centre within the North Somerset coalfield, where the last colliery to close in 1973 was at Writhlington, situated close to the town.

The right-hand platform survives, and by necessity our viewpoint today is from there, as the left-hand platform is now situated somewhere in the middle of dense undergrowth. Note that the distinctive shop, which was situated next to the level crossing, remains. *Hugh Ballantyne/JW*

Bristol to Weston-super-Mare

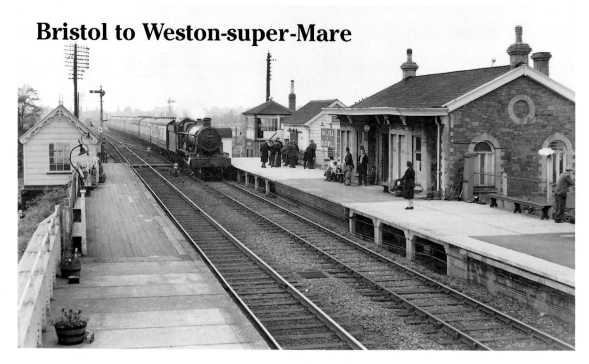

NAILSEA & BLACKWELL is located 7^1/$_2$ miles south of Bristol on the Exeter main line, and dates back to the opening of the Bristol & Exeter Railway in 1841; the stone building is of original B&E construction. Approaching on 5 May 1959 is 'Hall' Class 4-6-0 No 5926 *Grotrian Hall* heading the up 'Merchant Venturer', which ran from Weston-super-Mare to Paddington via Bristol. The station is sited on an embankment, and recent attention to the up platform is evident. A varied bunch of passengers await their train, including what appears to be a permanent way gang (at the signal box end), judging by their shovels. The lady nearest the camera appears to be signalling to the train, but alas the photographer did not report the outcome!

The only surviving building today is the shelter on the down side, although the windows have been filled in. All the original buildings on the up side have been removed, leaving the traveller to compare the respective delights of old and new-style waiting accommodation. As with Yatton (opposite), the station caters for a growing demand from Bristol commuters and has recently been provided with a new car park. On 17 September 1992 the 13.54 Bristol to Taunton train approaches formed by a Class '101' 'Heritage' DMU set. *E. T. Gill/JW*

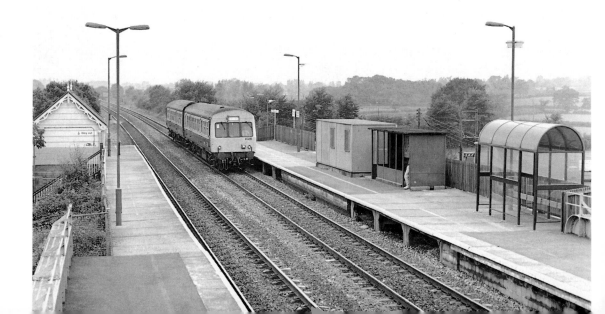

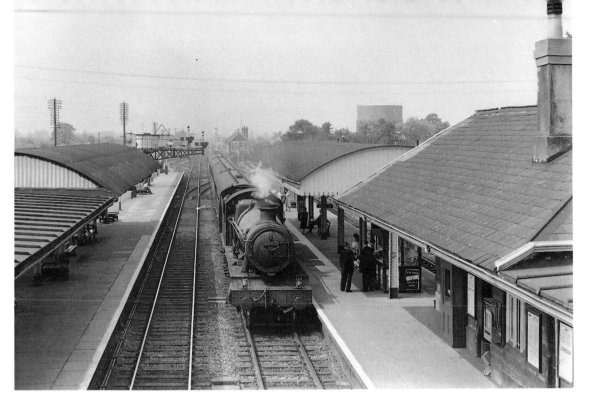

YATTON (1): In a view taken from the station footbridge looking south, we see 'Hall' Class 4-6-0 No 6940 *Didlington Hall* arriving with the 11.28 am Bristol service on 4 June 1960. On the right is the main station building, which is again of original B&E design. The 'half barrel' platform canopies are slightly unusual, and note that the station still boasts a platform newspaper kiosk. The signal box is of non-standard Great Western design, with the ornate barge-boards being a feature. It was also a particularly busy box, with the main line, two branches and goods yard to regulate.

The up side of the station remains virtually unaltered today, but the original down platform canopy has been removed. However, the station is maintained in good condition and caters for increasing commuter traffic for Bristol. On 17 September 1992 Class '158' No 158822 hurries past with the 12.00 Paignton to Cardiff service. *E. T. Gill/JW*

YATTON (2): Yatton's importance can best be judged by noting the station nameboard, which proclaims 'Junction for Cheddar Line and Clevedon'. The Cheddar line, with roughly seven services daily, was the least active, as the Clevedon branch peaked at roughly 30 daily return journeys. Behind the nameboard can be seen 0-4-2T No 1412 standing in the Clevedon bay platform; the Cheddar platform is on the extreme right, with the goods yard adjacent. Passing through on the main line is Class '28XX' 2-8-0 No 2875 heading a southbound fast fitted freight. Note the exceptionally long bracket on the platform-sited signal gantry, necessary due to the protruding canopy.

Today the Clevedon bay remains, but the Cheddar line platform and goods yard now serve as a car park. The station nameboard still refers to 'Yatton for Clevedon', although the only connection now is by road. On 17 September 1992 Class '158' No 158829 eases away from the Yatton stop with the 12.55 Cardiff to Taunton train. The '158s' are the most modern units in service with Regional Railways, and were introduced to work semi-fast 'Express' services, particularly on cross-country routes. *E. T. Gill/JW*

139

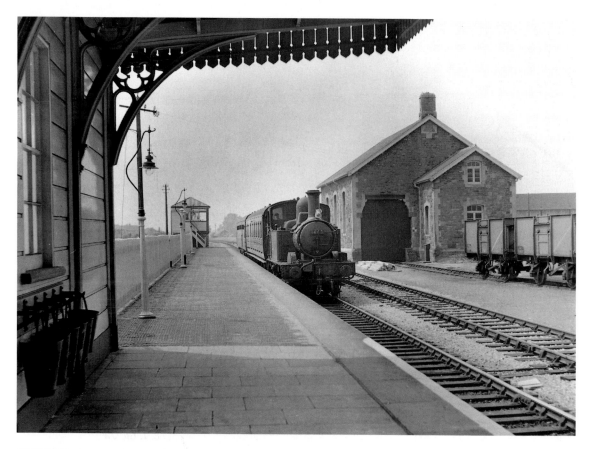

CLEVEDON (1): Clevedon is situated on the Somerset coast and is within 15 miles of Bristol. In July 1847 a 3½-mile branch to Yatton was opened to connect with the main line and thus provide an excellent link to the developing city of Bristol. However, the lack of a good beach meant that Clevedon could not rival Weston-super-Mare, but none the less it prospered as a dormitory town. In latter years there was an intensive shuttle service to Yatton, amounting to as many as 30 return trains daily operating from before 7.00 am to after 11.00 pm. The Great Western station was situated close to the town centre and comprised a single platform with awning, booking hall and water tower. On 4 June 1960 ex-GW 0-4-2T No 1463 arrives from Yatton. The signal box stands at the end of the platform and controls access to the adjacent goods yard. Note the impressive and substantial goods shed of GWR design, while the wagons probably conveyed domestic coal. On the platform just beyond the end of the awning is an attractive goose-necked gas-lamp, so typical of the time.

The branch closed on 3 October 1966, and today the station site is occupied by a supermarket, this Sunday afternoon view of the car park is not representative of normal activity! One feature that remains to connect the two photographs is the terraced housing on the right; in the 1960 scene part of the roof and the upper windows of the same block can be glimpsed beyond the right-hand wagons.
E. T. Gill/JW

140

CLEVEDON (2): This view taken on the same day shows No 1463 standing in the platform with the two-coach auto-train from Yatton. The auto-train method enabled the locomotive to push as well as pull, being driven from a cab in the rear coach when pushing, thus avoiding the need to provide run-round loops and minimising operating costs.

An inspection of the houses on the background hill will confirm the location, as the right-hand building now hides the row of shops to the right of the station nameboard in the 1960 photograph. *E. T. Gill/JW*

CLEVEDON (WC&PR): Clevedon was the headquarters of the Weston, Clevedon & Portishead Railway, which was better known affectionately, and probably a little irreverently, by its initials, 'the WC and P'. Opened to Weston in December 1897 and Portishead in September 1907, the line had a chequered history resulting mainly from financial difficulties. Indeed, for most of its existence it was operated in receivership under the stewardship of the legendary Col H. F. Stephens, who specialised in running independent railways. The WC&P ran for some 14¼ miles, with 12 stations plus several 'request' stops. *Bradshaw* of 1922 indicates four daily return journeys plus a further five intermediate services. This classic location involved street-running through a part of Clevedon, aptly known as Station Road. In July 1935 Manning Wardle-built 0-6-0ST No 3 *Weston* passes W. H. Smith's Circulating Library with a four-wheel passenger vehicle in tow. Note the steps to enable passengers to alight at roadside halts.

The modern Clevedon seems to have changed little, with the buildings in Station Road showing no significant alteration. It is good to see that W. H. Smith retains its prominent corner position. *The late S. W. Baker, collection of C. G. Maggs/JW*

WESTON-SUPER-MARE: The railway was a major factor in the growth of Weston-super-Mare as both a seaside resort and dormitory town for Bristol. Initially, though, the people of Weston were not too keen on the railway and allowed the main line from Bristol to Exeter to pass them by, being content with a mere branch to serve their needs, opened in 1841. Demand, however, led to the branch being doubled by 1866, together with the provision of additional excursion platforms. The layout changed drastically in 1884 when the branch was converted into a loop with the provision of a new through station, called 'General', while the existing Locking Road became the excursion station. This classic scene dates back to the late 1950s as 'King' Class 4-6-0 No 6018 *King Henry VI* eases a rake of chocolate-and-cream coaches from General station, heading for Bristol and Paddington. Note the activity in Locking Road, partly obscured by the exhaust.

Rationalisation commenced in 1964 when the Locking Road excursion platforms closed, followed by singling of the loop in 1972 as part of the Bristol area resignalling scheme. A much simplified layout exists today with, ironically, Locking Road now a coach and bus park. The branch has seen recent investment, with General station being refurbished and new stations opened at Weston Milton and Worle to cater for commuter demand. In April 1990 Class '155' No 155313 departs from Weston with a train to Bristol. Note the unchanged skyline. *G. F. Heiron/JW*

INDEX OF LOCATIONS